个

On French Art Since World War I

PARIS
WITHOUT
END

by Jed Perl

NORTH POINT PRESS · SAN FRANCISCO · 1988

The quoted materials in the text are from the following works:
From *Functions of Painting*, by Fernand Léger, translated by
Alexandra Anderson, Viking Press, 1973. From *Fernand Léger*,
by Peter de Francia, Yale University Press, 1983. From *Picasso's
Mask*, by André Malraux, Holt, Rinehart & Winston, 1976. From
The Left Bank, by Herbert Lottman, Houghton Mifflin, 1982.
From *The New Art of Color: The Writing of Robert & Sonia
Delaunay*, Viking Press, 1978. From *Arp: 1886-1966*, Jane
Hancock and Stephanie Poley, editors, Minneapolis Institute of
Arts, 1987. From *Every Force Evolves a Form*, by Guy Davenport,
North Point Press, 1987. From *Ada or Ardor: A Family Chronicle*,
by Vladimir Nabokov, McGraw-Hill, 1980.

TO DEBORAH

Acknowledgments

Parts of this book have appeared in different form in *Art in America*, *The New Criterion*, and *Vogue*.

I wish to express my gratitude to Hilton Kramer and Erich Eichman, Editor and Managing Editor of *The New Criterion*, for affording me extraordinary freedom to develop my ideas about modern and contemporary art.

Thanks also to Susan Bergholz, for her enthusiasm and her trust.

CONTENTS

PARIS
WITHOUT
END

MATISSE

The Cathedral
and the Odalisque

For many years Matisse had a studio on the Quai St. Michel, with windows overlooking the Seine and the facade and towers of Notre Dame on the Cité. The paintings that Matisse did of Notre Dame between the beginning of the century and his departure for Nice toward the end of World War I have become famous for the way they dissolve a classic view into ever more radical designs. In 1900 the towers turn green against a pinkish sky; in 1914 the whole facade is reduced to a few black lines inscribed on a surface of deep, glowing blue. It's easy to forget, as we look at these daring modern compositions, that Matisse's eyes were focused on one of the masterpieces of French Gothic architecture. During the French Revolution the anticlerical mobs had virtually obliterated the thirteenth-century sculpture on the facade; but the beauty of Notre Dame endured, and for Matisse Notre Dame's fine Gothic proportions—the whole west front like a great abstract bas-relief— had a wonderful resonance. As he wreaked his changes on the old cathedral, he was also finding his way into the heart of the heart of the French tradition.

From the Quai St. Michel, Matisse looked out at the original Paris of the Cité, with its history going back to early Christian times.

We tend to think of modern art as being born in the Paris of the late nineteenth century, with its circuses and gas lights and dance halls, but the roots of modern art also reach deeper—into the merger of north and south, the Gallic and the Roman, that had fertilized France for a thousand years. This confluence of north and south can be seen in the very center of the Grand Gallery of the Louvre, where Louis Le Nain, the painter of the comfortable, matter-of-fact farmer class of France, confronts Nicolas Poussin, who brought into French art for all time the south, with its gods and classical geometries. Le Nain and Poussin balance one another. In Le Nain's northern verisimilitude there's a hint of the sensuous three-dimensionality of classical sculpture, while Poussin's Greco-Romanism is shaped by a Frenchman's cool intelligence. To come to Paris at the beginning of the twentieth century was to come not just to Cézanne, but to the longest living artistic history that Europe had to offer. Picasso lived for some years in a seventeenth-century building on the rue des Grands-Augustins, a building that figures in Balzac's *Chef-d'oeuvre inconnu*; and during World War II Picasso wandered along the Seine, and painted Notre Dame and the bridges, and the Cité with its little park, Le Vert-Galent, and its monument to Henri IV.

In 1945 an interviewer asked Matisse to speak about the Frenchness of French art, and the old man replied, "Moderation is the characteristic of French art. It is found everywhere in France." He went on to tell how, when he had been abroad recently, a foreigner had said, "How lucky you are to return to Paris where everything is so beautiful and so fine." At first Matisse was skeptical about the claims this foreigner was making for Paris. "In returning to my home I am going to pass by the avenue de l'Opéra," he said. "I don't see what it can have that is particularly French; it seems to me that this character of the street is everywhere." But, Matisse concluded, "This foreigner was right. In this avenue which appeared to have grown up a little haphazardly, all was well-placed. . . . I could breathe an air of tranquility." Tranquility, moderation: these are at the center of the French artistic experience. They're what pull the barrier-speaking Fauve to focus on an old gray

4

Gothic facade; and they're what cool the heat of Picasso's expressionism, and push it toward larger and larger miracles of form.

There's something infinitely reliable at the center of French art; something that attracts artists, that they want to make contact with. In painting as in literature it has to do with the example of the Academy: the long line of history, officially sanctioned, which may not always sponsor the greatest masterpieces, yet gives form to the succession of styles, images, ideas. The Academy is a conservative institution—in the best sense, and, increasingly after 1825, in the worst sense of the word. Modern art defined tradition outside of the Academy; but where would modern art have been without the Academy to take its stand against? For the modern artist tradition consists of many separate trajectories, all utimately intertwined. Matisse's great comment about Ingres and Delacroix: "They forged the same links in the chain." And of course Delacroix, the romantic, had written in his journal after seeing Courbet's *Artist's Studio*, which had been turned down by the jury of the International Exposition of 1855: "I . . . discovered a masterpiece in the picture which they rejected; I could scarcely bear to tear myself away." In history—the mental history of tradition, which is given material form in the galleries of the Louvre—the bad always falls away; great opposites eventually converge; and the cause of beauty is carried along.

The artists of early twentieth-century Paris—the major ones among them—had the confidence that arises from coming into this great patrimony without much of a struggle. As Gertrude Stein wrote, "Paris, France is exciting and peaceful." Paris, because of its centrality, gave artists the strength to be intuitive, skeptical, ferociously individualistic. Paris was a place, but also an idea, liberating in its largeness. And so it was in Paris that most of the essential revolutions of twentieth-century art had their beginnings.

Matisse, Braque, and Picasso led the world into abstraction. But the character of the Parisian mind made it inevitable that these artists would recoil from abstract art as soon as the denial of nature suggested aspirations that veered too much toward the mystical or sublime. A discomfort with the pro-

cess of abstraction begins to show itself in the French avant-garde in the years around World War I. Increasingly, the paintings of the pioneering generation turn naturalistic, as well as pale-complexioned, silver-toned. Cubism had already had a gray-and-tan period; but the new subdued style—which is disrupted by flashes of overly bright color, like party makeup put on in a pinch—is more self-conscious, more a carefully prepared pose. The elegant grays that unite much of the new work of Braque, Derain, Léger, Matisse, and Picasso call to mind something polished, beautifully designed: a figure composition by the eighteenth-century painter David, or a late landscape by Corot. And the retrospective glance of the modern artist, who has already reformed tradition by his own hand, is interesting precisely because it suggests misgivings, second thoughts, unease. In the work of artist after artist, the elements of the natural world, broken up in the Cubist years, come back together into more easily recognizable forms. The new style can accommodate Léger's machine-age men and women; Picasso's crisply outlined Grecian types; and Derain's and Matisse's studio interiors and landscapes, with their thinned-out pigments and their reminiscences of a sun-bleached southern afternoon. All of this is in some way neoclassical, and like much neoclassicism, it's fueled by a melancholy sense that the present can never quite measure up to the past.

For the artists who made their mark before the war, the twenties didn't necessarily bring a falling-off in quality; tastes, though, were turning eclectic, nostalgic. A new generation—the generation of Mondrian and Kandinsky—was pressing forward with abstraction, and pressing the cause of modern art beyond Paris, in Holland, Germany, Russia. In Paris the social setting of advanced art was becoming more complex. Matisse and Picasso were aware that for the first time they were reaching a wide audience, and it's unclear whether their increasingly frequent reversions to nature were cause or effect. In the prewar period there had been a small group of dealers, collectors, and connoisseurs—Apollinaire, Jacob, Kahnweiler, the Steins, Vollard—with an idiosyncratic outlook and a willingness to stand up to popular taste. The fashionable figures who took up the banner of the avant-garde during and after the war are more difficult to appraise. Cocteau, Diaghilev,

Poiret, Misia Sert are somewhat masked by their high-society ties, by their obsession with chic. Still, critics who see the radicalism of the prewar Parisian avant-garde as moving toward conservatism in the postwar years probably miss the extent to which the artists, many on the brink of middle age, were undergoing a valuable process of reevaluation and self-renewal.

The artistic bohemia of the early years of the century had had its own rigid conventions, and by the time of the war many of the principal artists were restless, weary of the round of life in Montmartre and Montparnasse. World War I ushered in a period that looked back to a lost simplicity, had a taste for the voluptuous, and delighted in the surfaces of things. It was time to live a life of fashion and luxury, with overtones of the world of Fragonard, of Watteau. Some were curious about Italy and about Rome, "a city made of fountains, shadows and moonlight," which Picasso visited in 1917 with Jean Cocteau and the Ballets Russes. By 1918 Picasso had taken up the life of a gentleman on the rue La Boëtie, near the newly fashionable galleries of Paul Guillaume and the brothers Léonce and Paul Rosenberg. And Matisse, at the end of the war, had loosened his ties with the city's avant-garde, and was spending a good deal of the year in the resort world of the Côte d'Azur.

In Matisse's paintings of the early twenties the young women who sit in the Nice hotel rooms and apartments where the artist is making his home actually look a bit depressed, as if they've endured too many of these long, dull mornings and afternoons. The model's quiet mood may mirror some feeling on the part of the artist; but then again Matisse doesn't particularly emphasize her blank-eyed stare. We're intrigued by a mismatch between the subject of the bored young woman, the old-fashioned interior with its shutters overlooking the promenade des Anglais, and what might be called the content, which is Matisse's excitement at being able to paint all of this. We know he's excited because he's painting so many variations on each Niçoise theme. He's trying things every way possible, studying the model, the shutters, the view, from many angles, at many times of the day.

Matisse, the great revolutionary who only fifteen years earlier had ripped the mask of naturalism from art, may be playing a bit of the devil's advocate

as he puts the mask ever so gently back on. He paints landscapes in the silvery greens and grays of Corot, as if to suggest that the Impressionists were wrong about the colored shadows. He doubles back into the methods of the first half of the nineteenth century, and this return must be reckoned with, even if we've arrived at the paintings with the idea firmly planted in our minds that the past is open, that there's no reason not to work in the old way. But then, of course, it's not "the old way." Who had ever painted landscapes from the inside of a car, as Matisse did toward the end of the war years, or oscillated between modelled and unmodelled form as speedily, from painting to painting, month to month? The head of the artist's daughter in *Portrait of Marguerite Asleep*, obviously based on the somnolent women of Courbet (one version of which Matisse owned), is a tour de force of gray-tan-white sculpted flesh. The difficult transitions from the neck to the chin and then up and around the cheekbones are masterfully done; and yet the flatness of the elements around the head (the bedclothes, the pillows, the patterns on the pale yellow wallpaper) and the immediacy of the brushwork keep reminding us that this isn't Courbet, isn't the nineteenth century. You can feel jangled in front of this painting, caught between thoroughly modern passages, and others that push the image into the distant past. This jumbling together of periods, styles, manners is frequently nowadays called "postmodern," but of course the date on the painting is 1920.

Portrait of Marguerite Asleep, which was in the National Gallery of Art's magnificent 1986–87 show, "Henri Matisse: The Early Years in Nice," had been exhibited only once in the past thirty years, and hadn't been illustrated in a book in a quarter of a century. This is by no means atypical of the Matisse paintings of the early twenties—really all of the twenties—and thus the simple fact of the National Gallery's enormous exhibition (171 paintings) was a kind of miracle, a crown atop the group of shows that in the previous half-decade had been devoted to the School of Paris since World War I. The National Gallery show was specked and dabbed and then, in its latter part, packed with masterpieces. The final three rooms, containing the deeply colored interiors and odalisques of the second half of the decade, were as dazzling as the treasury of a medieval cathedral.

"Matisse: The Early Years in Nice" was organized in the name of scholarship—to complete the record. The curators, who probably wouldn't have considered the project fifteen years ago, may in some half-conscious way have believed themselves to have awakened in the morning after modernism; but they hadn't, at least from the evidence of the catalogue they produced, really stopped to analyze this feeling. They'd just put the dates in order and let the museum officials get the publicity mills rolling. That the forgotten "anti-modern" Matisse of the twenties should after all these years have received the blockbuster treatment was surely as strange as its having happened to poor, mad van Gogh. Here was Matisse trying things, questioning everything about his art except the necessity of going on, switching manners with ferocious speed. And one wanted to get in tune with all of this. But the atmosphere of the show, with its tape-recorded tour by the museum director and its people hawking things at the end, thrust the work too far into the limelight, and was out of tune with the artist's introspective mood. It wasn't only that there were too many people at the National Gallery, many of whom had come expecting another Matisse—the Matisse who simplifies everything and flattens everything out. There may also have been too many paintings hanging in one place at one time. For those of us who'd been thinking about these paintings for years, the show had the impact of something that had been simmering, suddenly turned onto high and boiled, boiled, boiled.

Matisse had painted a series of pictures of the model in the studio on the Quai St. Michel overlooking the Seine in 1916–17, and he continued with this motif in the hotel room on the promenade des Anglais, where outside the window there was the narrow Mediterranean beach with its occasional palm trees. ("Palm trees," Nabokov says, "are all right only in mirages.") There she is: the model in the room, or, when Matisse's daughter Marguerite visits, two women in the room. The scenery is unexceptional, a trifle fusty. The furniture gets moved around a bit; the shutters are opened or closed; the women look out the window, sit on the balcony; the light varies, from blue to gold. The model's face, though occasionally smiling, more often has the abstracted look of the professional doing a job. She's sitting, standing, re-

clining by the hour, pinned to a place (by the window overlooking the Mediterranean or, later in the decade, amid the Moroccan draperies) that is clearly not her own. Though many of the poses the model takes during the early years in Nice are fairly simple, any pose is difficult to hold for a prolonged period of time, and a certain sense of strain is reflected in the woman's resigned mood. There's often an uneasy relationship between the model and her environment. Matisse has no interest in ordinary life. He's a middle-aged man studying the alien beauty of youth.

Matisse's matter-of-fact approach gives the paintings—and even more so some of the drawings—an amazing erotic potency. Nipples, breasts, thighs are caressed, petted with the brush or pencil or pen. He parallels effects we know from pornography, but unlike the pornographic artist, who deals in predetermined types, Matisse is constructing each form from the bone and muscle up. In the fabulously detailed lithographs of odalisques from the mid-twenties, Matisse is in love with every part, and must attempt the complete nude. Matisse takes the woman over (he's the master) but he's also the model's slave (the harem girl's slave), giving full value to her every turn.

Certainly you'd have to go back to Watteau to match the small-scale intensity of *The Painter and His Model*, done in Nice in 1919. This is the most elusively colored of all Matisses: a vision of palest pinks and mauves, trapped in a honeyed, yellow-golden light. Horizontal, just over two feet wide, just under two feet high, it has the intimacy of some Watteaus. There's the same air of a delicate, complicated project carried off with a pretense of idiotic ease. At center is the model, naked and relaxed in a chair. Everything flows from her: to the left is the bespectacled painter, sitting on a black bentwood chair, hard at work; to the right, toward the foreground, a crowded tabletop. There are flowers, chairs, wallpapers, pictures, curtains, each given a unique importance.

How, one wonders, did Matisse do this painting? Did he paint the model from life, himself from imagination; or did he have someone sit in for the figure of the artist? The job of piecing it all together must have been (as it was in the Watteaus) most complicated. The 1919 *Painter and His Model* has been unfavorably compared with the 1917 *Painter and His Model*, a vision of black

lines and extreme simplification. The earlier canvas carries its composition on its sleeve, is about its own production; the distortions are needed to make the composition cohere. In 1919 there's no less of a challenge, and it's met on no easier terms. On more difficult terms, I'd say, for now a mood of lyric ease, a light touch of the brush, is used to lock together a structure of total clarity. How odd, how difficult the space here is: a plunge into depth at the center, a pulling-out at the sides. And what a reconciliation of many things is brought off: the slinky youthfulness of the woman; the lean, comically severe figure of the artist; velvety anemones in a black vase; and all the rest. Often told is the story of Matisse's visits in these years to Renoir, and the old man's comment, "When you set a black down on the canvas it stays in its place." The 1919 painting—whose feathery strokes recall the last, most beautiful of the Renoirs—is a masterpiece of color weights and rhythms. The dull profusion of the Nice hotel room is a challenge, and Matisse rises to meet it.

Why do people dislike the Matisse of the twenties? It begins early, in 1919, when Jean Cocteau reviews the show at Bernheim-Jeune (Matisse's first in six years) and complains that "The atmosphere of Bonnard, Vuillard and Marquet reigns. The window of one of Vuillard's rooms opens on one of Marquet's seas." (Of course, Matisse had been a bit unpopular in vanguard circles even before he went to Nice. He was a disappointment, for he'd held off from Cubism, from the systematic—or so it seemed—smashing of the object.) "Matisse," Cocteau writes, "works without deep discipline, without those hidden geometries of Cézanne and the old masters." This is a common complaint. To Alfred Barr *The Painter and His Model* of 1919 seems "minor and casual." Nice is said to be a time of "relaxation." Apparently, experimentation is heavy black lines, large areas of flat color; relaxation is soft washes, many small areas. And relaxation is also the odalisques, the sexy women of the twenties.

The inwardness of the paintings attracted wealthy collectors but it was— and has remained—in conflict with avant-garde taste. The small size and intimate internal scale of the Nice paintings recall the tradition of Watteau, Chardin, and Corot, and contrast with much of Matisse's work both before

and after the twenties, when he's so concerned to burst the bounds of the easel, reach out to a mural idea, loosen line from color or color from line. Rather than flood the canvas with a single tone, Matisse here pits colors against one another. Blue, Matisse's beloved empyrean hue, is demoted to a supporting role, and the paintings draw their strength from the dissonances set off by combinations of reds and oranges and greens.

Much of the power of these paintings, with their cacophony of patterns, their odd, kitschy interiors, comes out of the struggle the artist has had to go through in order to master the complicated decor. Matisse is negotiating many difficulties, and there's the paradox of the difficulties' (the patterned wallpapers, Mediterranean vistas) being associated with luxury in the viewer's mind. The paintings are actually characterized by the very opposite of the quality for which they're generally indicted, which is an excess of ease. We have here the odd baggage of the nineteenth-century studio, which has persisted, partly through Matisse's example, into the life painting studios of today as the melange of draperies and pots and fruits that the instructor presents to the students with the assignment, "See what you can do with this." It's something to be gotten through (it sinks most students—and most mature artists, too); but Matisse eats it all up. Especially in the second half of the decade, he stays away from the easy, flowing arrangements, the ones that can be taken in with a single move of the eye. And his struggle to realize certain poses echoes the model's difficulty in holding them. He tackles extreme foreshortening (the student's nightmare), or the reclining or seated pose in which the model has one leg bent tightly up, breaking the flow. Or he disrupts the unity of the figure with items of clothing—jackets, pantaloons.

Matisse has studied the Persian miniatures of the fifteenth and sixteenth centuries, with their dozens of pockets of space marked off by different patterns. In the sweet-and-sour-colored *Interior with Phonograph*, a zigzag path takes us over stripes and shadows and around sharp corners toward a little surprise: the head of the artist, a speck of face reflected in a distant mirror. He's trapped, like a potentate in his palace, amid the profusion of the two-room studio in the apartment on the place Charles-Félix. Matisse injects a dose of Eastern exoticism into the flat events of Niçoise life. The two women

in white in *The Moorish Screen* are really rather banal, what with their slouching twenties poses (Matisse always gets those period details); but the weight of the East is upon them, and so they become two points of rest, two quiet areas amid the lock up of patterns that transform their afternoon chat into a legend from the Arabian Nights.

For Matisse, who turned fifty in 1919, the Côte d'Azur offered an escape from family intimacies. Many of the women in the paintings of the twenties were lovers as well as models, and filled a gap left in the artist's life by his increasing estrangement from Mme Matisse during and after the war. To this day Matisse's family preserves a respectable silence about the marriage; and it would be nice to know something more about these models and their relations with Matisse (what they talked about, whether they ate breakfast together, things like that). But Matisse (who, unlike his friend Picasso, had little interest in psychological portraiture) doesn't satisfy our curiosity about his young women, and they're probably destined to live on in the same obscurity as the mistresses of Raphael and Watteau, who are revealed by little more than the look in their eyes, or some particular way of holding themselves.

One can sympathize with Lawrence Gowing's claim, in his book on Matisse, that "the object of love was never wholly real to Matisse." And yet the artist-model relationship is real to him—as a kind of obsessive transaction. If Matisse is a sexist—and I might as well just say it, because it's what I feel, if not in front of the paintings, then back at home, when I think about them—he's a most self-aware sexist. He's quite conscious of living in the age of the flapper, of the free-spirited gal, and the fitfulness with which he sustains the old pictorial fictions of Muse, or Odalisque, or Visitor to the Studio keeps reminding us that he knows time is running out on the model's complicity, on her willingness to be immobilized before the artist's gaze. Still, by some sort of imaginative leap he joins his models to the women of Delacroix, Ingres, Courbet, Corot, and Renoir. He may not tell us anything about his young women as human beings, but he manages to gain them a place in— what would one call it?—the Myth of Woman in French Art. And this has, for Matisse, and for us, as much reality as Venus had for Titian.

Matisse likes to wrap his models up in the whole nineteenth-century ro-
mantic dream of a place beyond Europe. But he also wants to short circuit
and allegorize this North African world. He wants to carry its unique ways
of seeing into a modern drama of form and space. Matisse won't paint a triad
of odalisques, as Delacroix did in the *Women of Algiers*, or a bevy, as Ingres
did in the *Turkish Bath*. The masterpiece, with its implications of a complete
fiction, is replaced by something fragmentary—a model (or two) in the stu-
dio, and a few pieces of cloth. In the *Odalisque in a Gray Culotte*—as small
and precious as a Perisian miniature—the soft pink-gray of the reclining
nude, with her marvelously full arms and torso, is tiny in relation to the ex-
plosion of draperies and stuffs, a great vertical cascade of red and blue and
yellow stripes.

In every inch of the *Women of Algiers* Delacroix had transformed the
touristic, the voyeuristic, the Oriental into something experienced firsthand.
The dark-complexioned women, the hookah, tiny curled slippers, thickly
patterned rugs, are by turns alien, exotic, beautiful, trashy, ordinary, even
dull. Delacroix speaks in his journal of a perfection that "does not come from
an exact imitation of nature," but from "a mind that has selected and sum-
marized." Matisse is piqued by Delacroix's being able to turn Romantic
sleaze into French poetry; for Matisse the same operation is even more of a
challenge, because the sleazy bric-a-brac is now retro-sleaze, not just pop
nostalgia, but nineteenth-century pop nostalgia. To see in Paris, in the span
of a day or two, Delacroix's *Women of Algiers* (at the Louvre) and Matisse's
Decorative Figure on an Ornamental Ground (at the Pompidou Center) is to
experience not a borrowing, but an occupation.

Have Matisse's variations on the odalisque theme made the narrative ele-
ment in Delacroix's and Ingres's paintings seem less important? Or didn't it
matter especially to begin with? Many of Matisse's props (the mirror on the
wall, the cushions) could have been borrowed from the set of Delacroix's
Women of Algiers. The contrasts of various colors, different patterns, first
stated in Delacroix and Ingres, are pitched higher by Matisse. Matisse un-
derstands Orientalism as a "painting problem"—and in this he may not be
all that far from the fundamental attitude of Delacroix and Ingres. Indeed,

Matisse may understand those nineteenth-century masters better than they understood themselves. Where they adapted flat Eastern patterns to Western ideas about space, Matisse lets the depth-defying Oriental motifs fly free. And then he does whatever he must to permit the figure to defend itself, hold place. He's extending the discoveries of Ingres, who in the *Odalisque with Slave* built the nude out of one unbroken corkscrew curve, so as to balance the explosion of the decor. In Matisse's *Decorative Figure* the woman, as solid as a block of bronze, challenges another sort of heaviness, the heaviness of pattern. And knitting the two kinds of heaviness together is something else—a surprising lightness, a delicacy, a daintiness almost, in the handling of the paint.

Before and after the odalisques, Matisse tends to bring a painting to life by simplifying nature. Here, though, the complexity of the accoutrements is left intact. Matisse mediates, but he doesn't choose one thing over another. Matisse in the twenties is toying with illusions, as is Picasso in *The Three Musicians* of 1921. There's a dry, sardonic side to this playfulness. In 1941 Matisse observed of the hotels he'd lived in off and on since the twenties that they were "fake, absurd, terrific, delicious." His absorption in the rococo-revival kitsch of the Riviera and his love affair with the Orientalist stuffs and trinkets of Ingres and Delacroix sounds a bit like the Surrealists' passion for the kitsch of nineteenth- and early twentieth-century Paris. The odalisques of the twenties are dream visions; but they're also at-home experiences, experiences of models in the studio.

Matisse's work of the twenties is about nature and culture, and how his household gods, the French artists of the nineteenth century, had looked at the world. While Matisse did more than any other artist to demonstrate the value of decoration for modern art, the purely decorative was something he couldn't ever quite accept. He liked to abstract from nature, but abstraction as such rarely interested him. (When at the end of his life he did large-scale cutout paper designs, he stressed their being decorations, not pictures.) Matisse and the rest of the School of Paris were opposed to any art that referred to itself, to its own conditions. We may be a bit surprised by Picasso's state-

ments against abstraction, or Matisse's claim, in the introduction to a book of portraits he published later on, in 1954, that the Northern School, with its realistic detail, is the model for portrait art. But surely this loyalty to nature is the life-giving force that kept these artists in forward motion as the years went by.

In Matisse's *Conversation under the Olive Trees* of 1921, the two women stand in the middle of a lawn and are overwhelmed by the gray-green olive trees and the deep backdrop of Côte d'Azur hills. While Matisse's brush-work has a casually modern look, he knits the various parts together with an attention to the how and why of nature that's wilfully old-fashioned. The composition, which is formal in a self-consciously naive way, recalls some of Corot's late figures in a landscape, which in their turn echo Claude Lorrain. As for the details of the twenties costumes (fringed shawls, flowers in the hair, a parasol, a certain cut of high-heeled shoe), it's hard to know if they're meant as a contemporary touch or a throwback to the verisimilitude of Courbet, Manet, and Baudelaire's Painter of Modern Life. In *The Conver-sation under the Olive Trees* Matisse manages to make the figures stand in the landscape and convince us of the truth of those women in that place. The significance of the informal genre subject (two women having a chat) is an enigma we can neither clear up nor set aside. What ultimately absorbs us in many of the paintings of the twenties is their singularity—how much they differ from one another.

The heroic period of modern art, buried with the war dead, gave way in the twenties to self-conscious seriousness, mood swings, romantic frivolity. In an essay on Derain, published in 1923, the critic Elie Faure spoke of the overwhelming impact of the war. Matisse hadn't served, but it could be said of him, as well as of Derain (whose affairs Matisse helped keep in order), that before the war he'd believed himself a hero, and meant to be like no one else. But afterward, in middle age, "one is willing, at the risk of looking like everyone else, to be oneself."

From the poor, hardworking young artist with the loyal wife or mistress in the pre–World War I years, we turn to the satisfaction of desires on an epic

scale—Matisse's many beautiful models in a Nice hotel and Picasso's Felli-
niesque parade of mistresses and wives. Who is Matisse or Picasso in 1925 or
1935? Are they the suave masters exhibited in the fashionable London and
New York galleries, or the experimentalists we know from the Barnes mu-
rals and the pages of *Cahiers d'Art*? How do we account for all the shifts in
style? Personal psychology may loom larger as time goes on, and we don't
really want to overlook "current events." Picasso, Matisse, Braque, Léger—
and all the more so Derain, Dufy, Rouault—are implicated, willy-nilly, in
the headlong rush of the century. Purity is as impossible in 1925 as it was pos-
sible in 1905.

In a still life of 1924 Matisse includes a book with the name Pascal clearly
printed on its cover. This may confound us, until we read, in a 1918 letter
from Apollinaire to Picasso: "Is there today anyone more fresh, more mod-
ern, more exact, more laden with richness than Pascal? You appreciate him
I believe, and rightly. He is a man we can love." This is a return to French
classicism, to the sobriety of perfect crystalline fragments of prose. The
thoughts of Pascal, with their careful judgments, their theological system,
hold experience at a distance, and anatomize it:

> Those who are accustomed to judge by feeling have no understanding
> of matters involving reasoning. For they want to go right to the bottom
> of things at a glance, and are not accustomed to look for principles.
> The others, on the contrary, who are accustomed to reason from prin-
> ciples, have no understanding of matters involving feelings, because
> they look for principles and are unable to see things at a glance.

Isn't this the predicament of the artists of the twenties, caught between feel-
ings and reason, trying one, then the other, back and forth?

Visiting Nice today, one can see, in the curve of the promenade des Anglais,
and the little palm trees, the view Matisse painted. The city is resonant with
the heavy comedy of resort-area architecture. It's a place at the border, at the
edge of the Mediterranean, from which a great artist could contemplate an

assault on several traditions—the French, the Oriental. Still, Matisse didn't believe too much emphasis ought to be put on Nice as a period—a distinct time—in his art. Interviewed by the publisher Tériade in 1951, he said Nice was just one place among many:

> I worked at Nice as I would have worked anywhere.
>
> Windows have always interested me because they are a passageway between the exterior and the interior. As for odalisques, I had seen them in Morocco, and so was able to put them in my pictures back in France without playing make-believe.

DERAIN

*Angles are the
Fate of a Form*

André Derain's art and life sit before us like the contents of an old, battered steamer trunk. Open the lid and you find several dozen great paintings and many interesting ones, along with the yellowish souvenirs of a life that was controversial and, as the decades rolled on, lived in increasing obscurity. Derain, who was born in 1880 and died in 1954, has his place in the history books. And yet his long career, compounded of fashion and scandal and engaging friendships, remains very little known. His name keeps appearing in unexpected places. One sees an interview with André Breton, praise by Duchamp, a eulogy by Giacometti, a review by Clement Greenberg. Derain is a member of the family that set off from post-Impressionism, and we keep talking about him—even if with irony and disapproving shakes of the head—because like De Chirico he remains, no matter what he did and where he went, one of the company of modern art.

The few little monographs and catalogue essays that have been devoted to Derain in the past thirty years tend to begin confidently, with an account of his early years in Paris. We hear of the friendship with Maurice de Vla-

minck, who Derain's parents felt was a bad influence; and then with Matisse, who was a decade older and a father figure of sorts. Derain's Fauvist landscapes of 1905 and 1906 have a brilliant formal order—they're like van Goghs with the psychodrama removed. This young man knows how to bring out the rhythms of a motif; he can pull a scene together; and yet he never goes wild with the expressive possibilities of paint, as Matisse does during the same years. Derain seems more hemmed in by what he sees in front of him, and when, three or four years later, he moves into the orbit of early Cubism, it's as a sort of conservative who's unwilling to ever really let the subject explode. What's touching in the angular, brownish Derains of the 1910–15 period is how considerate the artist is of the image before his eyes. He's obviously attracted to early Christian art and to Cézanne's canvases; what he likes is how the simplifications in those works convey the artist's modesty before the world. When Derain paints an old French church it's not just a cultural artifact, but an object of faith—the center of the life of a town.

Derain's authority among the young artists in the years just before World War I probably came at least in part from his refusal to flirt with abstraction—his refusal to break with tradition to that degree. And so it wasn't strange that in the years after the war, when Picasso and the others had pulled back from abstraction, Derain found himself in perfect harmony with some of the great revolutionaries of the prewar years. It's difficult today, with Derain's reputation sunk so low, to believe that along with Matisse and Picasso he once formed the ruling triumvirate of School of Paris art. And yet he did, he did. This moment of Derain's greatest fame is commemorated in the Jean Walter and Paul Guillaume Collection, which is rich in the works done in twenties Paris, and is now permanently installed in a series of serene, light gray galleries in the Orangerie in Paris.

Guillaume was one of those bright figures of the time around the war; a friend of Apollinaire's, much involved in the vogue for African art. (His large collection of primitive sculpture is now in the Musée de l'Homme.) He was Derain's dealer, and his collection of modern paintings—with its Derains and Picassos and Matisses, its Renoirs and Cézannes and Soutines and Le Douanier Rousseaus and Marie Laurencins—reflects the luxuriant he-

donism of French art in the first decades of the century. Guillaume died young, in 1934, and his wife, who some time later married the architect Jean Walter, kept the collection together and preserved, even through her later acquisitions, its period flavor. There are marvelous Nice-period Matisses; and one of the greatest of the luminous Picasso nudes of the early twenties, an early fifth-century B.C. woman, rescued from an imagined antiquity. These hang along with Derain's *Harlequin and Pierrot*, two melancholy musicians who dance before an empty sky. The figures in the paintings that Derain, Picasso, and Matisse did around this time share a peculiar, distanced mood. These painted men and women, with their vacant stares, seem only half alive. In the case of Derain, the faces on the portraits are sometimes overly worked, squeezed for sentiment, and this rather interferes with the beautiful turns and twists of the draperies in the *Portrait of Mme Guillaume*, or with the interesting angles in *The Painter's Niece*, in which the girl is standing, one knee up on a chair, in the proper white dress and tights and black shoes of an old-fashioned *jeune fille*.

The Guillaume Collection was assembled at the time when the imagination of the School of Paris turned back to the Louvre. Of course no one in the avant-garde could forget that the Louvre represented not only Tradition but also Official Taste—the Salons had, in the nineteenth century, been held in the Louvre. Still, when many of the paintings that had been in storage during the war were rehung, the Chardins and Le Nains and Corots looked fresh, like a sign of renewal. The past was rediscovered, only in the wake of an artistic revolution, and the painters had no desire to return to conventional canons of taste. Though the museum contained magnificent paintings, as an institution it remained, as Picasso was to say, "just a lot of lies." What the School of Paris stood for was the idea that all beautiful things are equal. An African idol and an Ingres portrait could live together in a democracy of quality.

Renoir—the Impressionist who had died in 1919 and was admired and collected by Derain, Matisse, and Picasso—was a model of the avant-garde artist who was able to renew himself through a study of the past. Like the members of the generation of 1910, Renoir had participated in a revolution;

but as it turned out his greatest work was done after he'd left behind the flickering images of Impressionism and revived the lushly sculptural forms of the Venetian Renaissance. Among the beautiful late Renoirs in the Guillaume Collection is a small portrait—worthy of Titian, what with its melting golds and reds—of the artist's final model, the blonde Dédée, a rose in her hair. Dédée, who was an actress, married Jean Renoir, the artist's filmmaker son, and in 1923 Derain painted her portrait, in exchange for which he received a quartet of small paintings by the grand old man.

The discovery of late Renoir must have had the same urgency in 1920 that the discovery of African art had had fifteen years earlier. Back in the first years of the century Derain, Matisse, Picasso, and Vlaminck had made the rounds of the curio shops of Paris in search of exotic objects. To the high art traditions of Greece and Rome and Europe, and to the *Japonisme* of the nineteenth century, they'd held up Africa and the South Seas. Now, after the war, it was time to rediscover French painting. The artists, all quite prosperous, began buying pictures. Collecting was important—it was a way of realigning the relationships, of overturning the hierarchies of the museum. "The desire to collect is the necessity to reestablish the lost primordial contacts and the need to arrest eternal motion and to contemplate." This from the eccentric painter John Graham, in his splendid *System and Dialectics of Art*, published in 1936. Roland Penrose visited Picasso in his apartment on the rue La Boëtie and noticed a large Renoir hanging crooked over the fireplace. "It's better like that," Picasso said. "If you want to kill a picture all you have to do is hang it beautifully on a nail and soon you will see nothing of it but the frame. When it's out of place you see it better."

Matisse and Picasso want to modernize the art of the museums. They obviously believe certain aspects of the art of the past are closed to them. They can't do much with the old chiaroscuro or with the way the old masters gave every element its separate integrity. And there are emotions they won't attempt—the kind that, as in a Rembrandt, seem to come not from the artist but from his subject. When Giacometti, a friend of Derain's in the early fifties, joked with the American writer James Lord about how lucky Rubens

had been to have someone to paint the backgrounds and the draperies, he was voicing the regret that Derain and most every other French artist since Cézanne and Renoir had felt at their inability to bring off a painting that included everything. The methods the old masters used for getting the figures and the landscape and the little bits of still life to hold together were no longer available. On the return from the Louvre, from Venice, from Pompeii, the modern artist always ended up with a fragment: Matisse's single odalisque, Picasso's rough-hewn young men, Giacometti's head surrounded by untouched canvas. Of the major figures of his period, only Derain believed completeness was still possible. He wanted to paint pictures in which "Everything follows through; every detail is relevant to the whole." (This from a beautiful essay by the American painter Leland Bell, "The Case for Derain as an Immortal.") Derain is often accused of inauthenticity, of egotism, because he wanted to reject the fractured space of post-Cézanne art; but perhaps naïveté is more like it. Derain doesn't worry about the "relevance" of the art of the museums—he just barrels back into the past.

It's my impression that Derain expresses himself best, during the twenties and thirties, in his still lifes and landscapes. *The Kitchen Table* has dark, nut-brown depths, and bright passages of silvery gray and tan and white. Here Derain's brushwork is clear, expansive. He takes us on a fascinating meandering journey through the twist of a cloth, over a spoon, around a baguette, back across a frying pan to a basket, and so on and on. It's a great kitchen composition. The combinations of forms are quite unique, more casual than the Dutch, less geometric than Chardin. The subliminal violence of knife, fork, scissors is intriguing—and yet the drama is perhaps excessively obscure, overshadowed by the dark atmosphere, which gives us the sense of falling back into the deep space of the old-time art. One doesn't quite know where Derain is in it all. One is tempted to ask what his relation is to this kitchen—just as one wonders where he is in the beautiful Provençal landscapes of the twenties, all pale blue and pink and coffee-colored and fragrant with the memory of Corot. The perfection of tones in the landscapes is a trifle disembodied; the artist hasn't asserted himself enough as an actor in the painting, as a visitor to Provence.

Of course it was one of the triumphs of the old art—the art of the museums—that the artist knew how to keep himself out of it. Where is Piero della Francesca in a Piero della Francesca, Breughel in a Breughel? Everywhere and nowhere. Yes, they seemed to have been able to believe in the coherence and the autonomy of the world and its experiences. But this modesty the old artists achieved before "life"—the modesty of the craftsman who didn't wish to stamp everything with himself, his mark—this doesn't sit well with the modern imagination. And then there's the question of whether Derain is recapturing that modesty, or merely reminding us of it. The eclecticism of his art—with its allusions to Pompeiian wall paintings, Faiyum portraits, Byzantine madonnas, Mannerist figure compositions, Dutch still lifes, nineteenth-century landscapes—is daring but also perhaps self-indulgent.

A key to Derain's relation to the past is the large, detailed copy of Breughel's *Massacre of the Innocents* that he worked on during the second half of the forties, two decades after Guillaume had assembled his collection. The choice of this particular Breughel painting is in itself a surprise, for Derain, with his passionate involvement in landscape, might have been expected to choose to copy one of the sixteenth-century Flemish master's marvelous panoramas, which are always painted from an elevated viewpoint and seem to contain half the world. Instead, he's attracted to this harsh and tragic frozen landscape: a village, made up of a deep circle of thatched houses, in the midst of which the mounted troops slaughter the children as the parents fall to their knees, pleading for mercy. Breughel's scene, played out beneath the clear, snow-dazzling light of day, is a catalogue of precisely logged little details; there are more than a hundred figures. The horror is underlined by the elegance of Breughel's draftsmanship, by the insistence on turning the terrible incidents into perfect small interactions of form. Breughel's *Massacre of the Innocents* has none of the rhetorical, classicizing approach to experience we find in the work of Poussin, one of whose frenzied bacchic scenes Picasso had been copying in the last hours of the German occupation of Paris. The Breughel is the exact opposite of Poussin: in Breughel the mood of tragedy is ordinary, everyday. The flat modernity of the picture recalls

Auden's famous lines (on another Breughel, *The Fall of Icarus*) about how the old masters understood that suffering "takes place/While someone else is eating or opening a window or just walking dully along."

Derain's copy, done in little swoops and touches of paint, stays very close to the Breughel. Derain is feeling his way deep into the *Massacre*, forcing himself to negotiate each square inch of earth, each figure falling in supplication at the feet of a mounted soldier. There's something moving, almost shocking, about the way Derain, in his sixties at the time, bends himself to the awful yet elegant image. There's no trace of sentimentality in the view Derain takes of Breughel. Yet his very loyalty expresses a kind of regret that can't be entirely separated from sentimentality. One wonders if Derain believes the modern artist's methods could ever be equal to such horror—to, perhaps, the horror of the world war that had just passed.

"No one who ever met him was but impressed by the prodigious force of his character and his capacity for standing alone." This, from Clive Bell, presents the Derain of the twenties. Bell speaks of the "problem" that "tortures" Derain; and of a "first-rate intellect" that "can afford to mistrust reason." "He wants to create art which shall be perfectly uncompromising and at the same time human, and he would like it none the worse, I dare say, were it to turn out popular as well." Derain's ambition is all-embracing, fanatical. One imagines the Englishman as awed by the gigantic French figure he's met in cafés, whose studio he has no doubt visited. Derain "reminds one oddly of Johnson. He, too, is a dictator." But does Clive Bell like Derain? The strange, recalcitrant personality appears in the accounts of many observers. Jean Cassou, in 1926: "The artist's appearance confirms the impression produced by his paintings: on wide, slow shoulders is set a head that is clearly sculptured, with something sudden and fixed. His smile instantly reveals bitterness." Derain's personality is always invoked in the writing about his work. His nonconformism, his rejection of the light, up-front color of Impressionism are seen psychologically—as a resistance to the present. It's difficult to keep this psychological interpretation out of one's mind. It seems to explain Derain's work; or is this just a way of rationalizing our discomfort with the orig-

inality of the man? His long look backward—if that's what it is—is a reproach to everything we like to call original.

Derain's life zigzags back and forth across the landscape of modern France. His conservatism becomes, in 1931, the subject of a special issue of *Les Chroniques du Jour*—"Pour ou contre Derain." And though the individual contributions aren't especially incisive, the very existence of the issue suggests the importance of the subject, a major controversy in the midst of Parisian art. Most interesting is Rouault's statement: "He is an artist of perfect detachment and with a care for pictorial justice that is far from theories of anti-modernism or modernism." Derain's "position" is a landmark in the politics of style. And after World War II his artistic conservatism begins to get mixed up with the politics of the occupation, for Derain had taken a trip to Germany during the war, to attend the opening of an exhibition by the Nazi sculptor Arno Breker. In 1944 Picasso gave a rather lurid account of this to an American newspaper man, John Groth. Alfred Barr used Groth's notes as the basis for an article in a 1945 *Museum of Modern Art Bulletin*. Picasso, Groth says, "grew very excited in telling of Derain's visit to Weimar to shake the hand of Hitler." Picasso "hoped that Derain would be punished—shot." The visit to Germany was made by a group of artistically conservative Frenchmen, which included, in addition to Derain, Despiau, Friesz, de Segonzac, Van Dongen, Vlaminck; but Derain is the only "collaborationist" Picasso mentions among the artists, and it isn't true that Derain shook Hitler's hand.

Derain's visit was apparently made under duress, part of a deal to liberate some French prisoners of war. Around the same time Derain had moved into the studio of a Jewish painter, Léopold Lévy, to protect it from the Nazis. His own house and studio at Chambourcy were requisitioned by the Germans, and one of his important paintings, *The Return of Ulysses*, was vandalized. James Lord, in his recent biography of Giacometti, which is by no means sympathetic to Derain, says Derain wasn't a collaborator, but only someone who "allowed contemptible opportunists to puff up his reputation for their own ends." And yet the horrible history of Nazism is tracked across Derain's career. It's mentioned whenever Derain is mentioned. The crimes

of the century become mingled with the crime of not being a modern art-
ist—or the right kind of modern artist. Meanwhile, Picasso opened his stu-
dio to the GIs, got photographed for *Life* magazine, and was immune to ac-
cusations of having entertained Germans in uniform and done so little to
help his friend Max Jacob, who died in a German camp. One wonders if Pi-
casso's vehemence—his mentioning only Derain among the "collabora-
tors"—wasn't inspired by a nasty wish to be done once and for all with De-
rain, a grand old man of the School of Paris, whose art was out of step with
the times.

Derain wasn't, after all, a nobody. Those rising stars of postwar Paris, Bal-
thus and Giacometti, who often visited with Picasso in the cafés, also visited
with Derain. Both Giacometti and Balthus adopted something of Derain's
passion for the dark-toned world of the museum and some of his nostalgia.
There were lunches at Chambourcy, Derain's country estate, on Sundays.
And when Derain died, in 1954, after being struck by a car while crossing the
road, Giacometti was among the mourners at his funeral.

To see Derain's art today one must travel from Paris to the provincial town
of Troyes, once a capital of Champagne. Here Pierre Lévy, an industrialist,
put together the great collection of Derains, which has now been given to the
state, and is housed in the Museum of Modern Art of Troyes. One is grateful
for the museum, and yet the town and the museum heighten one's sense of
Derain's isolation, of Derain as the odd man out—large but eccentric, sitting
at the edge. Troyes, according to the guidebooks, is a city with a past of in-
vasions and counterinvasions. There are a great many churches, one with a
lovely cycle of thirteenth-century windows of the life of the Virgin, another
with amusing baroque decor. The whole town is a kind of antique, now
being carefully restored. The Museum of Modern Art is in the old Bishop's
Palace, next to the main cathedral. The Derains—dozens and dozens of
them—are stuffed into two rooms, with the little paintings jammed to-
gether on panels, like merchandise in an auction house. The windows are
covered with yellowish cloth shades; the atmosphere is lugubrious. You feel
as if these paintings have been buried alive. It takes a great effort to overcome

the setting, which seems to send the message, "This stuff is dated junk." (The museum brochure practically ignores the Derain collection, which is the museum's finest asset.) The paintings themselves aren't easy to enter. The darkness of so many of them lends a shadowy, interior-of-the-forest air of forboding, almost of dread. The color is winey, or tawny brown. The light in the pictures is most always that of candles, or of forty-watt bulbs. We love this darkness in older paintings—in Rembrandt and Chardin—but it can be off-putting here, because we feel we're being denied the brightness of modern art, the sparkling primaries we associate with openness of spirit. Though Derain's brushstroke has some of the largeness of Manet's, he's also pulling us into the kind of space—deep inside the picture—which Manet had begun to flatten out.

Though Derain could sustain the design of a painting of large dimensions, the most beautiful of his later works tend to be very small—no more than a foot or two in either direction. With these restricted dimensions Derain suggests an experience that's fragmented or telescoped, and perhaps also acknowledges how incomplete his grasp of the world really is. The *Portrait of Isabel Delmer*—a figure in the Paris and London of the thirties and forties who was close to Giacometti as well as to Derain—has a wonderful magnetic force. She sits in a low armchair in the deep green light of the studio, surrounded by the artist's attractive clutter—a guitar, crockery, old furniture. The brush accents the light on her ankle, a bowl on a table, her pretty face. You feel the intelligence of the artist circling around, emphasizing this or that with jots and pulls of the paint. Derain seems to be saying, "Now go here, now go there, now around," and the back and forth of the strokes carries lyric conviction. Some of the little paintings of haymaking, of a beach, or of a table with a plate of fish or a few pieces of fruit, have a similar poetry. And then there are some strange compositions, a mix of ancient Pompeii and the eighteenth-century painter Magnasco, in which figures drawn in dashes of white paint dance across a deep black space. These pictures of Derain's are a little flat, a bit underdeveloped; and yet what else in the history of art has quite their quality of frenetic activity carried on at the edge of an abyss?

In the notes Derain left for a treatise on painting, one of the most finished sections, called "In Regard to Angles," indicates the kind of thinking that lay behind the nervous exploratory strokes of his brush.

> Any plastic statement which does not respect angles is destined to destruction.
> Angles are the fate of a form.
> They are the movement toward sublime life or toward death; that is, toward another life, another rhythm. It is through them that the object is linked to the universe.

Derain's words here have a modern flavor. I can't imagine the old masters consciously placing so much value on pure painting, or insisting that feeling resides in form itself. One senses the completion of a long, unwinding journey, and the adventuresome spirit of an artist who had, half a century before, bought African masks and painted in pure hues.

DUFY

La Belle France

For a quarter century after his death in 1953 the painter Raoul Dufy was out of fashion. His washes of brilliant color and his sketchy Parisian scenes had gone the way of musical comedies, jazz clubs, and black tie and tails. His quiet funny elegance was as anachronistic as Fred Astaire or Maurice Chevalier would be in a movie costarring Robert de Niro or Gérard Depardieu. While there have always been artists who admire Dufy's work, his recent return to widespread critical favor reflects a shift in the standards by which aesthetic integrity is measured. This revival is one of those cracks in the facade of sophisticated postwar taste that seem to be appearing here, there, everywhere, all at once.

In the fall of 1984 the Holly Solomon Gallery in New York City, which was one of the first galleries to open in SoHo and mostly shows contemporary art, mounted an exhibition of paintings, drawings, fabric designs, and ceramics by Dufy. In the acknowledgments to the lovely little catalogue of the show, Holly Solomon said that it was contemporary artists who "have made me reassess the career and work of Raoul Dufy." The English painter

David Hockney, who'd done some take-offs on Dufy ideas, contributed a note to the Solomon catalogue. The year before the New York show there was a major Dufy retrospective organized by the Arts Council of Great Britain at the Hayward Gallery in London. And the London exhibit was covered by *Art in America*, a magazine that doesn't take up a forgotten name unless it's on the rise.

For the English, who've always been amused by the bubbly, decorative side of Continental art, the Dufy revival carries echoes of the Omega Workshop days, when the Bloomsbury crowd turned Fauvism and Primitivism into something that would look comfortable with the tea things near the cottage hearth. In New York, Dufyisme is one sign of the fading of the austere style that dominated the fashionable galleries in the late sixties and early seventies. Dufy is supposed to epitomize the whole larkish side of postmodern art. And though it isn't a point that's particularly emphasized in the Holly Solomon catalogue, the New York show was obviously meant to suggest a connection between Dufy and the painting with which the gallery has been closely associated, called Pattern and Decoration. Several Pattern-and-Decoration painters, among them Robert Kushner and Kim MacConnel, contributed brief essays to the Solomon catalogue. These contemporary artists do what I'd call feel-good art. They're slopping around with motifs borrowed from kitschy mass design; they want to jazz up the flatness of modernist pictorial space; but they don't give the old-modern space any new beauty or poetry or meaning. They're like happy-go-lucky kids, throwing over the severity and evangelical purism that's an aspect of twentieth-century art—and they sense, rightly, something like their anti-purism in the infinitely greater talent of Dufy.

Dufy came to modern art in 1905, when he was twenty-eight, in front of Matisse's *Luxe, calme et volupté* at the Salon des Indépendants. He made a place for himself among the advanced artists of the pre–World War I period by combining a natural instinct for the handling of paint with a close study of the lessons of Cézanne, Matisse, and Braque. In the teens and twenties a good deal of his energy went into commercial work as a fabric designer (he got into this because he needed money); and he only arrived at his personal

style, with its washes of clear color and its darting, descriptive lines, at the beginning of the thirties, when he was middle-aged. Dufy's bright, quivering world is a bouillabaisse of Fauvist color and Cubist construction. Adding spice are some lessons learned from the Images d'Epinal, those nineteenth-century French prints in which the slightly off-register colors overlap in a sort of accidental proto-Cubism. (Léger is another artist who was interested in Images d'Epinal.) In Dufy's paintings everything is blurred, a bit run-together, and he's able to encompass the whole of La Belle France: the meals of sea urchins eaten in the Old Port of Marseille; the wealthy foreigners gambling in the Casino at Monte Carlo; the charming balconies adorned with rococo curls; the farmlands and vineyards and forests hallowed by the Brothers Limbourg; and the glories of Paris, Capital of the Nineteenth Century, with its statues and chamber music and Opera House and theaters and ateliers.

Drawing gives Dufy's paintings their backbone—and what a draftsman he is! The sketches, typically in pen and ink, recall Constantin Guys's curiosity about modern life but embrace more of society. The market, that supremely democratic institution, is a favorite subject of Dufy's—he likes the plethora of activities and personalities gathered in an open-air pavilion or around some central monument in a city square. The crates, barrels, scales, and laden tables are deftly transcribed, and he distinguishes the saleswomen with their aprons and patient looks from the ladies who are shopping. There are ambling middle-aged men and young sailors and children and dogs. Dufy's drawings are sometimes all outline; in others the contours are enriched with cross-hatching. In the large sheets devoted to symphony orchestras the darkening mesh of lines suggests deep sonorities, the regal chords of Beethoven.

The paintings are expanded, exploded drawings—drawings in which the color implicit in the black-and-whites is brought out, fulfilled. Some canvases are saturated with a single tone from edge to edge. In others a couple of hues or a couple of families of hues are flung against one another: blue against yellow, blue-gray against orange and salmon. Dufy's color bursts out

of the canvas and floats toward the viewer in great, washy banners that are just held in check by the quick movements of his black and colored lines.

Within its admittedly small dimensions, the Holly Solomon show gave a good sense of the range of Dufy's themes, which included, during the forties, orchestras, harvests, harbors, pianos, studios, and a Louis XIV console. The familiarity of Dufy's motifs seems to free him—it lets him fly. In each work within a series he keeps the same basic elements, but tinkers to his heart's content, changing the colors around, emphasizing this or that particular edge or angle or plane. In the series of paintings of a piano set in the corner of a room decorated with floral wallpaper the composition is fixed, and Dufy uses color to achieve a range of moods. He paints an *Homage to Mozart*, in tender violet-blue; one to Bach, redder, deeper toned; and another to Debussy, which is greenish, dreamy, like an ocean.

Dufy can get a painting to vibrate with activity—he can whip up the surface with lots of tiny figures. That's the pleasure of his pictures of regattas and diplomatic receptions and horse races, most of which date from the thirties and forties. But he's also capable of a certain austerity. In the paintings of the last dozen years there aren't so many rococo curls. David Hockney observes that

> Nothing is covered up, or if it is, it's still visible underneath. This helps us to see more as his brush stroke does not just tell us about the thing depicted, but his body and the difficulty of his movements because of arthritis.

Dufy spent much of the later part of his life in a long search for a cure for this terrible arthritis, and one feels the lightness of his work was something achieved at a price. As with Cocteau (who admired and wrote about Dufy) there's a switching back and forth from elaborate fancies and frivolity to a plain, undecorated manner. In a tiny composition of five walnuts that was in the Solomon show, each little form—some cracked open, some whole—is described with clear, unambiguous strokes of brown paint against a light gray-blue ground. This work of pure, unaffected description recalls van

33

Gogh's paintings of shoes. The ship in the second version of *Le Cargo Noir*—just a few lines scratched into the wet surface of the canvas with the back of the brush—is as concise as a child's drawing.

I was particularly glad that the Holly Solomon show included a painting from the late series of interiors of the studio at Perpignan in the south of France. It's in these paintings—each showing a corner of the studio, and, through the window, a slice of exterior view—that Dufy pares his art down to essentials and achieves some of his most intensely felt effects. Easels, portfolios, pictures, sculptures, a model reclining on a divan: the elements are arranged and rearranged from painting to painting so as to push and pull the space into surprising configurations. In some of the canvases the swirling arabesque of a sculpture of a standing nude creates a whirlpool-like effect; in others a selection of colored portfolios builds a rhythm that carries your eye across the room. The painting that was at Holly Solomon, *Studio with Three Easels*, is one of the simplest in the series: three easels—one holding a small painting—are shoved against the back wall, and there's a cast of a torso on a table to the left. The space—open and unemphatic—is all a matter of loose, insouciant color washes (yellows, salmons, pinks) running across the walls, in opposition to the gray-blue of the torso and the Indian and Venetian reds (Dufy was addicted to these colors) of certain outlines and edges. Some of the paintings in this studio series hint, in a rather casual way, at an allegory of painting: you may see a still life and, on an easel, a painting of a still life and think, "The Art of Painting." But the pictures never have the declamatory tone one expects of allegory. *Studio with Three Easels* is, even within the rather subdued mood of this series as a whole, an especially unemphatic painting. It's like a piece of music in which nothing much happens and you're just carried along by gentle waves of sound.

Part of the interest Dufy holds for certain painters today has to do with his involvement in the French luxury textile industry. Holly Solomon's artists, many of whom in their own work like to blur the distinction between art and decoration, are fascinated by Dufy's collaborations with that suave wheeler-dealer of high fashion, Paul Poiret, and with the hundreds of fabric designs

Dufy did for the firm of Bianchini-Férier. They admire the way Dufy, during the teens and the twenties, helped the decorative arts catch up with the beautiful ease and breakaway color and design of Fauvist and Cubist art. Sonia Delaunay, the pioneering abstract painter who took up fabric and fashion design in the early twenties, said in a lecture on "The Influence of Painting on Fashion Design," given at the Sorbonne in 1926, that "some time before the war, couture began to free itself from academicism," and she assigned a high place in this development to Dufy.

> From the Matisse group, Dufy emerged with an assertive personality. He brought together the influence of Persian *faïence* and wood engravings of the fifteenth century with the teaching of Cézanne. More than in his paintings or woodcuts, Dufy expressed his personality in a series of textile designs characterized by large fruit and flower motifs organized in a fashion similar to that of his pictures. These compositions possessed a pictorial quality, and although they were enhanced with decorative freshness, they were only copies or more or less conventional interpretations of patterns derived from earlier times. The fabrics of Dufy came like a ray of sunshine clearing an overcast day. They were taken up by fashion to which they imparted a note of gaiety and the unpredictable, which had not been seen before.

Dufy's fabrics range from jazzily modern to delicately nostalgic. He devised a whole universe of designs, including parodies of eighteenth-century and Victorian models, as well as some based on the popular characters of his own day. In a blue-black-and-white Charlie Chaplin design he gets a rhythm going between the figure of the Little Tramp, the undulating strips of celluloid, and a glimpse of city lights. He did smashing florals, takeoffs on classic plaids, and scenes from exotic places—China, the jungle. All these designs reflect the fashionable tastes of the period. They articulate a rising mood, and can be separated neither from the figure who sponsored them (Paul Poiret) nor from the art they influenced (the set designs of the Ballets Russes). Sonia Delaunay, working in a pure abstract style a few years later, is, I believe, a far greater textile designer. We don't, today, see her fabric designs as faded fashions—they're authoritative, like her paintings. The smaller

pleasure of Dufy's textile work lies in its skillful echoing and expansion of haute couture tradition. The scale of his designs—which is often rather constricted, at least from the modern point of view—doesn't expand in the imagination. In addition, Dufy's taste for veils of echoing and overlapping color doesn't always translate well into the relatively opaque surface of a printed textile.

Dufy only really took off as a decorator when he began to accept commissions to design tapestries in the thirties. His soft-edged, freewheeling planes of color translate beautifully into the overlapping threads of traditional tapestry, a medium that had already accommodated the color planes of Rubens, Boucher, and Fragonard. Dufy presents tapestries as nothing more or less than ornaments for a wall. His designs "take" to tapestry the way Rouault's "take" to stained glass. In *The Three Graces (The Oise, the Seine and the Marne)*, with its big bosomy heroines, and *Amphitrite*, another watery fantasy (he loved transparent things), Dufy revels in the idea of high decoration, decoration fit for a king, that's at the heart of the tapestry aesthetic. He has the blessed good sense not to worry about what the relevance of tapestry might be for our time. By accepting the art on its tried-and-true medieval and Renaissance terms, he avoids the pitfalls of most modern tapestry artists who, in attempting to justify the form—to give it a new importance—end up with things that look like little more than glorified area rugs.

As a twentieth-century designer, Dufy marks the polar opposite of the machine-tooled taste that flourished at the Bauhaus in the twenties. To the hard he opposes the soft, to the industrial, the handmade. (His tapestries were fiendishly expensive to produce.) Dufy created for the Beauvais tapestry works a series of designs for chair upholstery based on views of Paris. His designs are flights of fancy rather like the scenic escapades of eighteenth- and early nineteenth-century decorative art, only in Dufy's tapestries Paris is a modern city complete with Eiffel Tower. There's an especially happy feeling in the way Dufy has, without missing a beat, infused a contemporary scene with all the beguiling charm of a rococo garden. He presents the modern world through the softening glaze of the past. It's like Renoir's viewing the new century through a fluff of eighteenth-century brushstrokes.

Decorative ideas just trip off Dufy's imagination. In a series of ceramic planters designed like miniature gardens, with steps and paths and retaining walls and pools, he adopts the style of the calligraphic, blue-and-white Delft pottery of Holland. The planter that was in the Holly Solomon show takes the form of a swimming pool, with little sea maidens cavorting around the sides. Dufy wants to get into the mind-set of those wonderful Delft painters. He wields the brush every bit as well as they did (very well indeed), and you don't feel that he's trying to outdo them or burlesque them. This is an act of homage, of pure love.

Dufy doesn't fit in very easily when the history of the art of this century is described as a single, unified development. His paintings—like the dark, shimmering canvases of Derain and Rouault, and the pellucid ones of Albert Marquet—are difficult to judge within the continuum of history, and so they tend to be viewed merely as historical curiosities. Those of us who love Dufy's work want to bolster his position with the testimony of his famous friends. Colette thanks Dufy for illustrating her *Pour un Herbier*: "What would have become of my little botanical essay without Dufy?" Matisse says, on being informed of his death, that "Dufy's work will live." And Cocteau celebrates his enthusiasm.

> Fauconnet had just died. Dufy accepted the job of doing in his place the sets and costumes for the famous show *Le Boeuf sur le Toit*. Next, there were the illustrations for the *Madrigaux* of Mallarmé, which I commissioned for Editions La Sirène. He never weighed the risks or the gains, he caught fire and offered his favors like a little bouquet.

Gertrude Stein—who was, like Cocteau, an inspired critic of art—wrote a little essay in which she described her encounters with the artist and his work.

> I came back to Paris after the long sad years of the occupation. I will tell all about that, and I wandered around the streets the way I do and there in a window were a lot of etchings and there so pleasantly was one by Dufy, it was an etching of kitchen utensils, in an inspired circle

and at the bottom was a lovely roasted chicken, God bless him, wouldn't he just have a lovely etching by him in the window of a shop and of lots of kitchen utensils, the factories could not make them but he had, and the roast chicken, how often during those dark days was I homesick for the quays of Paris and a roast chicken.

The essay continues. We see furniture with coverings by Dufy at the Salon d'Automne "just at the end of the last war 1919," and Dufy himself, in Aix-Les-Bains during the occupation, "sitting on the terrace in the sunshine . . . his hair white white and his face rosy and his color like his color is when he paints other things." Then there's a lunch together, and a discussion of Dufy's copy of Renoir's *Ball at the Moulin de la Galette*. Stein repeats several times the epigram, "Dufy is pleasure," but her real theme is reflected in another phrase she repeats: "Dufy and war," "Wars and Dufy." Through the juxtaposition of casual little encounters and the catastrophes of wars and occupations, Stein zeroes in on the acidic tension, the nervous energy of Dufy's work. Even if "Dufy is pleasure," he reaches toward it in the midst of other things—wars, occupations. Dufy doesn't live in a fantasy land. His observations of glamorous race tracks and beautifully furnished apartments have just a bit of the acerbic quality one finds in Proust's descriptions of elegant receptions. Dufy is sensitive to the moral implications of class and style. Consider all the attention he pays to the plain hard work of farmers, waiters, and musicians.

Dufy was an immensely cultivated man. This doesn't necessarily prove his mettle as an artist, but it does help us put the work in context. In 1948 his old friend Pierre Courthion spent a few weeks with the artist and recorded their conversations. Dufy fights off spells of his arthritis, talks about his illustrations for another book—Gide's *Les Nourritures Terrestres*. There are meals and excursions, discussions of Proust (not surprisingly, one of Dufy's favorite authors) and also of Stendhal, Joyce, and Faulkner's *Light in August*. Courthion tries to get Dufy's opinion on Poussin's *Four Seasons*, but the painter keeps shifting to Claude Lorrain, whom he prefers. Of Delacroix, Dufy comments that the small paintings are where his genius really shines.

Dufy loved the old myths—when you see his free copies after Titian and

his sea goddesses out of Pompeii, you know he was in touch with one of the wellsprings of the Western tradition. But he was also comfortable with the modern machinery of the harvest or a Mexican mariachi band. He could see, simultaneously, the fields of Claude Lorrain and the farms of mid-twentieth century France. And he would combine them, as in the little painting of threshing included in Holly Solomon's show, where, amid the blue sky and yellow hay and busy workers, there's the figure of a little nymph, dropped in like a friendly visitor from another planet.

Dufy had an easygoing manner—that's what you feel in Stein's description of him on a terrace in 1944, and in Courthion's account of his 1948 visit. He was terrifically hardworking, but not, perhaps, neurotically so. How else can we explain how an artist so evidently serious and determined pretty much left off painting for design for years? Dufy had great equanimity; he was unfazed by large subjects—symphony orchestras, regattas. He had the unfussy, expansive temperament necessary to take on large murals and decorative commissions.

The 1937 World Fair was the last splendid party of the early twentieth-century Parisian world. In the Spanish Pavilion hung Picasso's *Guernica*, black and gray, a harbinger of things to come. Robert and Sonia Delaunay painted immense murals of bright-colored machine-age forms for the transportation pavilions, and Dufy, in a U-shaped mural for the Palace of Light, made a free association on the theme of energy and matter. Dufy included everything from the gods of Mount Olympus to the great inventors to the lights of the modern city. How typical and admirable of Dufy, the surprise of this "traditional" artist devoting his largest effort to an homage to Modern Times. To see *La Fée Électricité* today, at the Museum of Modern Art of the City of Paris, where it's permanently installed, is always a happy surprise. In reproduction it looks congested, like an overblown collage; but at full scale it's splendid as well as vast, and turns out to embrace many of the central concerns of twentieth-century art, such as the abstract value of color and the idea of a gravity-defying space. At the center of the U-shaped mural are great electrical generators surmounted by the classical gods. The generators are painted in an utterly un-Dufyish, straight-lined manner. They're

a severe, light-blue foil to the rest. The gods above catch just the right tone: light, humorous, yet dignified. Around the lower section of the mural are the great inventors and thinkers connected with electricity, each a succinct, perfectly observed, moving portrait. Above rises Dufy's panoramic vision of a planet full of laborsaving and pleasure-creating machines, many powered by electricity. The color flows and blends, like an exaggerated, technicolor version of a sky changing very quickly on one of those half-cloudy Parisian days. It's the summum of Dufy's world. Some scenes—streetlights on a blue evening, golden waving wheatfields—are as good as anything he ever did.

Dufy invents here, for a secular age, a whole, complicated world of images and ideas. In a note jotted down when he started work, he caught the flickering vastness of the thing:

Lucretius—the sea—waterfalls—storms—the rainbow—
the sun—pastoral symphony—the moon—the constellations—
the poles—the equator—volcanoes, wind, rain—calm—all atmo-
spheric phenomena—the points of the compass.

All this—and more—and put together with a beautiful sense of decorum.

Wallace Stevens wrote a little essay in appreciation of *La Fée Électricité* (which isn't all that surprising, considering the poet's own mosaic of extravagant poetic images). He says that the mural "is most definitely a union of drudge and dazzling angel. . . . Composed, episodically, day by day, over a long period of time, [it] has all the interest and meaning of a simple prose narrative." Dufy allows "history to crowd its figures upon him. . . . Here in this large work one finds the identity that we recognize as Dufy, engaged in all the delectations that make up his identity, extended and prolonged." *La Fée Électricité* is one of perhaps two dozen twentieth-century works that speak with something like the largeness of the grand old murals in the churches and the palaces of Italy. Since all the other examples are by Picasso, Matisse, Léger, the Delaunays, *Électricité* puts Dufy in pretty lofty company—up there with the gods. "Raoul Dufy's sudden death in March, 1953," Wallace Stevens wrote, "was like a rip in the rainbow."

LÉGER

■

Popular Dance Halls

The art of Fernand Léger is an unsinkable vessel, solid yet buoyant, carried forward by the great river of modern Parisian styles and ideas. Léger was an exact contemporary of Braque and Picasso, and had created, before going off to serve in World War I, an original group of paintings called "Contrasts of Forms," which, with their casually piled-up cylindrical volumes of bright yellow, blue, and red, strike many people as the best things he ever did. He doesn't, though, belong in spirit to the moment of Picasso and Braque; his Cubism has nothing of the ruminative mood of their work. Léger can't ignore the wide, wide world. He must take the measure of things and master them.

All manner of modern art seems to have a powerful effect on Léger: Robert Delaunay's Simultaneism, and also Futurism, Constructivism, neoclassicism, Surrealism (though the influence of this last he denied). Léger was propelled by each movement that came along, and yet remained independent, shooting straight to his goal. Like Robert and Sonia Delaunay (who

were both born four years after Léger, in 1885, and whose two careers were as intertwined as the circular forms in their paintings), Léger had been made big-eyed and audacious by the upheavals of the beginning of the century. These artists who came up in the wake of Cubism loved the giddy variety of modern life—the objects from the department stores; airplanes, gears, the Eiffel Tower; new forms of entertainment, such as soccer and cinema. (Léger tried his hand at movie-making, and once considered giving up painting for film.) He shared the Delaunays' interest in pow-pow-pow bright color and large-scale projects. These three artists stand at the point where the private style of the old Parisian bohemia gives way, around the time of World War I, to an avant-garde that actually believed it could change public consciousness.

When you're in a room full of Léger's paintings, these landscapes, still lifes, figure compositions, and abstractions—all done in dense blues, pale yellows, saturated reds, soft grays, and resolute blacks—have a unity of purpose that feels expansive, invigorating. The figures in Léger's paintings confront us head on, in the Byzantine manner, and their unblinking forward gaze, paralleled in the more abstract work by an overriding frontality, pulls us out of ourselves, into some happier, public place. Like Dufy, Léger is kind-spirited, only in a brasher, strictly contemporary way. Léger's paintings don't touch at any kind of deep experience—they're emotionally shallow. But they have a spectacular surface beauty, and this is so perfectly sustained that one seldom regrets the absence of either spatial or emotional depth.

Like Robert Delaunay and some of the other artists who wanted to explain Cubism and the birth of abstraction, Léger wrote a good deal, mainly manifestos addressed to artists' congresses and university audiences, and articles for magazines such as the *Bulletin de l'Effort Moderne* and the *American Abstract Artists*. In these writings Léger always has a point to make, a course to suggest; he rarely makes the sort of cryptic, personal remarks we expect from a French artist, and which Braque perfected in the *Cahiers* he published in 1948. Léger lived life as a public man. He wanted to get to know the young artists who came, as he had, to study in Paris, and so he ran a school in

the twenties and thirties and then again after World War II. To retain this teacher's role year after year, even after the war when he was in his sixties, famous and rich, bespeaks a devotion to a special kind of hopefulness—a hopefulness of a community of youth. In everything Léger says and does there's a dissent from the aestheticism of modern art, an effort to give the new painting a more popular appeal.

Léger's basic idea is that art ought to break out of the shell of the easel painting (the small-scale picture painted to be exhibited in a gallery and sold to a discriminating collector) into a fuller relationship with the rest of the world. This parallels the thought of the de Stijl group and the Russian Constructivists. The goal, for Léger as for these other modernists, is the merging of painting and sculpture and architecture. Léger had first trained as an architect because it seemed to his prosperous peasant family a more practical profession than painting, and even long after he'd become a painter the idea of working side by side with architects—with *practical* artists—remained dazzlingly attractive. Léger liked to recall his visits with Alvar Aalto, and their discussions of workers' housing. It was a disappointment of Léger's later years that few (or at least not enough) of these large-scale projects came his way.

In Françoise Gilot's book *Life with Picasso* there's some poking fun at Léger's lack of culture. He's quoted as asking the dealer Kahnweiler, "Did Caravaggio come before or after Velázquez?" And this delights Picasso, who recalls Léger's statement that "Painting is like a glass of red table wine," and—this is Picasso now—"You know as well as I do that not all painters drink *le gros rouge.*" But it may well have been Léger's lack of urbane refinement and cultural finish that enabled him, more than any other artist of the time, to sustain an interest in the life of what he called "The man of the people [who] comes into the world with a feeling for beauty," and whose "instinctive judgment passed upon manufactured objects is aesthetic in character." What other modern painter could have written the small vignettes of the lives and pleasures of the working class that brighten Léger's essays? In "Popular Dance Halls," published in 1922, he picks out details of costumes and manners—he has a curiosity worthy of Atget or Colette—and then de-

velops a theory of the individual's relation to the environment. The artist is compassionate, attentive, and writes of a way of life that is beautiful in a rather austere way:

> Most of the men one meets there are young; they have the look of well-groomed workers. A white shirt, without a stiff collar, cuts off the mask at shoulder height. That gives the effect of a medallion. Only there have I observed men's profiles; the girls, too, are accentuated because of the severity of their flattened hair and made-up eyes. When they are dancing, they are clearly outlined against the bare-white background—one sees them as a complete figure; they stand very straight, backs to the wall, or sit at a table leaning on their arms like workers who are resting their bodies.
>
> The men's dances are the most curious. Head against head, they dance stiffly, holding each other at the sides, their hands flat, their necks glued to their bodies.
>
> They prize their elegance, they care for it, they shiver in the winter, but their style is to wear neither a vest nor an overcoat. . . .
>
> Their precocity is a result of their environment; it is completely natural that they begin to "work" the suburban villas by age sixteen. They certainly go into the factories at the same age. They have been reared in an environment where nothing is hidden. Painfully, knowing the truth about everything, they are men before their time, and this explains their decisiveness and their sense of purpose. Their eyes saw everything from the minute they were born. In that school, one is not young for long.

There's a connection between Léger's interest in the young men in the dance halls and the attentiveness that went into Renoir's *Ball at the Moulin de la Galette*, or Seurat's *Invitation to the Sideshow*. From the evidence of Léger's essays all French people constantly make careful calculations of taste. "The ditchdigger who prefers a blue belt to a red one for holding up his trousers is making an aesthetic choice." Or—

> Go into the shop of a little dressmaker in the provinces. Have the patience to watch all through a fitting that a local businesswoman is having. To get the effect she wants, she will be more meticulous, more exacting than the most elegant Parisian. This stout, fifty-year-old lady,

she too wants to achieve a harmony that is appropriate for her age, her environment, and her means. She too organizes her spectacle so that it will make its effect where she thinks necessary; she hesitates between the blue belt and the red one, indicates her choice, and accordingly worries about "the Beautiful."

Léger's essays are a curious mix of the old French faith in the solidity and essential goodness of the ordinary man (which we know from Louis Le Nain and Chardin) and a Socialist's vision of the seamless harmony of the new social order. He sees in the practicality of the working man a willingness to accept the modern world. A man "will say 'the pretty bicycle,' 'the nice car,' before he knows whether or not it will function. This in itself indicates an acceptance of a fact: the new realism." And yet Léger is under no illusion that this acceptance will lead straightaway to a taste for modern art. He tells a story about his tussles with a cleaning lady that reflect—comically, cozily—on the reception of the new art.

> When I lived in the Paris suburbs, I had in my room a very large piece of antique furniture on which I arranged some ornaments. I always enjoyed placing them unsymmetrically—the most important object on the left, the others in the center and on the right. I had a maid who used to clean the room every day. When I came home in the evening she had always re-arranged the objects with the largest in the center and the others symmetrically placed on either side. It was a silent struggle between us which could have gone on indefinitely, because she considered that my ornaments were "in disorder."

When Léger said, after World War I, that the experience had changed him, he was referring to the dramatic effect the war had on normal habits, how it had a leveling effect on consciousness and helped him to give full expression to his sense of the unity of modern life. With wars come dislocation, changes of attitude, the rise and fall of generations; and for Léger, who believed that painting could encompass these things, World War I, or at least its aftermath, was an opportunity to be seized. The large-scale compositions he created after the war are full of the facts and tastes and manners of the age.

The City (1919) is about the Paris that Atget had memorialized in his pho-

tographs of the first years of the century, where the old crooked buildings are giving way to a new streetscape that's epitomized by the plate-glass display window. Léger shows how Atget's Paris, with its charming doorways, passageways, interiors, and parks—the city Mondrian observed forced us "to live amid the plastic expression of the past"—has been superseded. *The City* is about the exhilaration of modern urban life, with its movies and billboards. Léger gets at the broken jumpy rhythm of the coming-into-being of a new age. Léger doesn't go so far as Mondrian, who declared in 1926 that "home and street must be viewed as the city, as a unity formed by planes composed in neutralizing opposition that destroys all exclusiveness." Léger leaves some figures and billboards and stairways intact. The beauty of his *City* is in the way all the parts are edited and shaped and organized into a composition that's varied and full of surprise and yet has no loose bits. *The City* is one of the few paintings of the modern period that could be hung alongside David's *Oath of the Horatii* and Delacroix's *Liberty Leading the People* and Courbet's *Artist's Studio*—those works that combine history and allegory to achieve something totally new. Léger believes that each period in an artist's career ought to result in a few huge canvases to which his other, smaller works play a supporting role.

From Robert Delaunay's *The Cardiff Team* of 1912–13 (in which the rugby players, Ferris wheel, Eiffel Tower, advertising signs, and biplane float together) to Picasso's *Guernica* of 1937 (with its shattered images of panic and death) Parisian art is sprinkled with attempts to make modern art capacious, inclusive. The picture could be a flexible container, and the artist drops in many different things. And we now look back with a kind of awe on these paintings of modern life, because of course we can no longer imagine putting so much in—being *that* inclusive.

What's so energizing in Léger's *Le Grand Déjeuner* of 1921 (the first major composition after *The City*) isn't just the artist's beautiful way with a variety of blacks and whites, or how he sets a tan figure against a pale gray one. This brilliant structure is further enriched with dozens of little flicks and touches of working-class or petit-bourgeois individualism. Léger's three gigantic women, with their great masses of hair waving seductively down

from parts in the middle of their heads, look like three shop clerks who've had the great good luck to be set up by some sugar daddy in an apartment furnished in the latest fashion. There's something petit bourgeois about the profusion of little knickknacks on the table, the area rugs scattered over the floor, as if these young women have given a fusty, Victorian feel to the Deco style. (Maybe it often had that quality—maybe that's part of what distinguishes Deco from Bauhaus design.) The women loll about. One has pillows arranged in a great fan-shape around her head, as if she were fantasizing life as a high-style advertisement or a scene from a Hollywood movie. They're undressed, sexy—but in a slightly fussy, homebodyish way. A few years later they'll have turned into practical businesswomen in a little provincial town, and take great care with their fittings at the local dressmaker's shop.

While Léger's work is never less than first-rate, the energy level in the paintings does rise and fall, and sometime toward the end of the twenties the conviction seems to go out of his art. In the thirties and forties his subjects (*Adam and Eve*, the *Divers*) don't have the same urgency they had in earlier years. Léger spent time in America—as a visitor in the thirties, and as a refugee in the forties—and he has spoken about the things he found interesting: the flashing lights in Times Square (which gave him the idea that color can flow freely across the figure); and the profligacy of a nation that left broken farm machinery abandoned in the fields, while in Europe it would be carefully repaired, or carted away.

The Waste paintings, done while Léger was living in America in the forties, are typical of the artist who always wants to show us what he's seen— who's at moments perhaps all too eager to strike out in a new direction. With their metal fragments intertwined with vines and leaves, these paintings are an outgrowth of Léger's rambles in the farmland of upstate New York. They're the first works Léger ever did about old things dying, and they may be his attempt to come to grips with what he knew was going on in Europe. The period around World War II is, after all, one in which art moves toward dark, interior visions (it's the time of labyrinths and minotaurs). Léger's work of the late thirties and early forties, though, continues his love of crisp

form and brilliant color—these he could never give up—and he seems to have considerable difficulty expressing a sense of wartime, with its perils and distress. Léger's cheerful muse waits for a time of hope and renewal.

In the postwar years, returning to Paris from his exile in America, this great artist returns to the heights. The scenes of circuses, construction workers, and vacationers from the last five years of his life (he died in 1955) recall the brilliant anecdotal subjects of the early twenties. *La Grande Parade* (1954) brings into our own time the string of paintings of popular performers that had begun with Watteau's *Gilles* and included Seurat's *Invitation to the Sideshow*. The figures are drawn in black with just a bit of shading on an expanse of snowy white; the color is unfurled in a few great banners. *La Grande Parade* is as exhilarating, as jewel-bright as a sunny winter's day.

Léger spent part of the last few years of his life in the town of Biot, an old pottery center just inland from Antibes, where some projects were afoot to create ceramics based on his designs. His connections with the place weren't deep, but the Léger Museum there, which was the creation of his widow, Nadia, catches his bright, at times wonderfully naive sense of the modern world. The museum, located in the countryside below the beautiful little medieval town, is surrounded by scrappy villas that match the antipicturesque suburban terrain of Léger's own landscape compositions. The building is a rectangular, boxy structure, the shape designed to accommodate, ranged across the entire front facade, a mosaic and ceramic decoration originally destined for a stadium in Hanover. This facade is thus a sort of modernistic billboard, and, like the mosaic facade Léger designed for the church of Notre-Dame-de-Toute-Grâce in the French Alps, it's beautiful and brilliant and just a little crass. In the garden at Biot there are large ceramic sculptures after Léger's designs, and freestanding mosaic plaques based on some of his most famous images. Inside, the stairs are flanked by his stained glass and tapestries and upstairs, on the series of portable panels that break up the large simple space, one sees his whole career—with, of course, a much stronger representation of the later work. (Famous artists never manage to keep their best early work.)

The key to the experience of Biot is this late work—the final large version

of *The Construction Workers*, and *The Campers*, with their masklike yet kindly faces. The sleekness of the art of the twenties, which had grown out of the idealism of Russian Constructivism and de Stijl, is now somewhat dissolved. Léger's optimism is run through with question marks, possibly because World War II and its aftermath are more perplexing, more terrifying than the war and postwar period had been three decades before. Of *The Construction Workers*, Léger wrote: "Their trousers are like mountains, like tree trunks. Trousers are genuine when they have no pleats." Though there are still the same beautiful, clear primary colors, the workers are wrinkled and battered, and this may reflect the sordidness and wrecked nerves of the Communist Party, which Léger joined after the war. It's a time of hope, but also of "lesser-of-two-evils" debates, and artists and intellectuals from Western Europe gather at Communist-funded conferences and wonder how far they'll go with Stalinism. At the Congress of Intellectuals for Peace in Wroclaw, Poland, which Léger attended, "Witnesses observed the healthy skepticism of Picasso through it all." This is from *The Left Bank*, by Herbert Lottman.

> [Picasso] openly mocked Fadeiev for his attack on formalist art—modern art, in other words. When confronted with officially inspired anti-semitism in Poland, Picasso let it be known that his own painting was "Jewish," that Eluard's poetry was "Jewish," as was that of Apollinaire (whose mother was of the Polish nobility). The congress was still in session when the news came that Zhdanov had died in Moscow. Fadeiev did not hide his despair. "What will we do without him?" he said. Fadeiev committed suicide after the revelation of Stalin's crimes by Khrushchev.

Léger sometimes referred to works like *The Construction Workers* as Social Realism—they're certainly the only works that ever deserved the name. And yet the paintings, though contemporary, are also elegiac, a summary of the century so far.

Léger admired the unnaturalness of history painting, how Poussin and David had invented compositions and figures to clothe their ideas. He, too, had his idea—the socialist's belief that the individual is always bent to the

forces of the group, that there's no cure for a class society but a classless one. And so he subsumed the little anecdotes of everyday life—the woman at the dressmaker, the young men in the dance hall, the workers at the construction site, the picnic—to a composition that's flat and beautiful and severe. Léger wrote about his compositions:

> After having done *The Mechanic*, *The Three Musicians*, *Le Grand Dé-jeuner*, and *The City*, I was often worried by the problems arising from pictures of great subjects—theme paintings. This had been David's territory, and we have fled from it. I'm returning there, for he came near to a solution of it.

Léger's figure compositions refer to Byzantium, neoclassicism, and also Neoplasticism. A tradition is necessary—to give form to one's perceptions, to help put the facts straight. The artist heals all the wounds, and wraps all the troubles up in a structure of epic clarity. Léger's people have bold faces. We sense, behind their simplified features, a fundamentally sympathetic spirit. They're all self-portraits, equipped with the artist's large, rounded nose, slit-eyes, surprised eyebrows, and thin mouth. Though Léger created cardboard men and women, he didn't feel alienated from them. It's not a bad world, after all. Work and play, the construction site and the picnic, are painted back to back. The vacationers stand content in the blemished coun-tryside of modern industrial Europe, and are as deeply woven into the land-scape as the gods and goddesses in Poussin's late mythological subjects.

At the Léger Museum the dozens—hundreds—of unblinking faces add up to a benign crowd. One looks out of the huge windows at the plaques set up in the garden, and though these are a little obvious, they partake of the same bright spirit, as if Léger were saying, I will give you more and more and more. In *The Construction Workers* the steel girders climb up into the sky and mingle with the clouds—it's an Assumption for socialists. Even the gift shop, oddly placed at one end of the gallery with the paintings, becomes an aspect of the artist's generosity. It's full of mass-produced Légers: plaques and plates, postcards and other inexpensive reproductions. A postcard is a Léger for Everyman.

Léger regards the modern environment with the same tolerant air as Le Douanier Rousseau, an artist whom he, together with the Delaunays, Picasso, and Kandinsky held in the highest regard. Picasso appreciated Rousseau mostly for the psychological power of his portraits; Léger, like the Delaunays, admired his naive good spirits, the way he accepted telephone wires and airplanes as facts of life. This easy embrace of modern times also characterizes Léger's lifelong friend, the poet Blaise Cendrars. (In 1919 Léger had illustrated Cendrars's *La fin du monde filmée par l'Ange Notre Dame* with beautiful colored stencils.) When Cendrars hurls a series of product names at us and calls it poetry there's no tension, no regret.

> Bébé Cadum wishes you a good journey
> Thank you, Michelin, for when I return
> Like negro fetishes in the bush
> The petrol pumps are naked

Léger, like Cendrars and Rousseau, operates in the very midst of mass culture kitsch without getting sullied by it. His art revels in clichés. He doesn't take the elaborately distanced view of such things that Picasso does; he's not a sophisticate in a giggly mood, as Dufy can be; nor, thank goodness, does he take the modern world *seriously*, as do his Purist friends Ozenfant and Le Corbusier. By means of some sort of miracle—which has to do with the ease and immediacy of colors and surfaces—Léger gives us the popular dance halls, the construction sites, the picnic grounds without an overlay of sophisticated commentary. He watches the passage of the old Paris and he has no regrets. Nor does he escape into utopian dreams. Léger is a feet-planted-firmly-on-the-ground kind of optimist—a realist who can still hope. He's a man to come back to when the wars are done and peace has settled over the land. The Léger Museum is a celebration of modern life—an homage to the People—and we're surprised to find that we don't feel this populist vision is beneath us.

MATISSE & PICASSO

◪

At the Shores
of the Mediterranean

The Chapel of the Rosary, which Matisse designed in the late forties, after a
decade punctuated by serious illnesses, is on an unprepossessing street in the
town of Vence in the hills above Nice. One's first impression of the building
is of something tucked away; from the entrance at street level one walks
down a flight of stairs to reach the chapel. What is visible from the street are
the stucco walls, two small ceramic mosaics, a bit of the chapel's blue-and-
white tile roof, and its wrought-iron cross. Matisse's building works with the
natural and manmade beauty of the scene at a distinct but not irreverent an-
gle: the blue-and-white, zigzag-patterned roof makes a modest dissent
from the inevitable red roofs of Provence, and the cross stands out beauti-
fully against the luminous vistas beyond. As with the rest of the buildings in
this neighborhood of comfortable suburban villas where Matisse lived in
the nineteen-forties, what creates the impression here isn't architecture but
the way the architecture fits into a landscape full of spectacular plunging
views.

The woman who opens the door of the chapel and acts as a kind of informal guide speaks about Matisse's desire to make a Provençal chapel. Certainly, one feels this ambition in the flat simplicity of the space and the slightly iridescent glow of the tile that covers much of three walls. What also strikes a visitor is the extent to which Matisse has avoided many of the obvious features of the architecture of Provence. Matisse has no use for the red-tile floors, rough plaster, and stone walls that give such a regional flavor to the nearby building of the Maeght Foundation, which was designed by the Spanish architect José Luis Sert in 1959. The architectural design of the chapel, over which Matisse had total control, is startlingly plain. With its smooth plaster walls and unlovely corners and details the chapel looks as much like an example of standard prefab modern interior design as photographs lead one to expect. Matisse hasn't created a romantically appealing piece of architecture. Indeed, his unwillingness to enter into the conventions of Provençal style (those conventions out of which Sert created such a lovely building) is the key to what he's doing here. The chapel's dull architectural framework acts as a kind of assurance that Matisse isn't going to play any tricks with us. He's trying to find a way to be truthful both to his skeptical artist's spirit and to the implications of the religious imagery he's taken on.

Since the beginning of the nineteenth century, the art of the Middle Ages and early Renaissance has exerted a powerful pull on European painters. The French cathedrals of the twelfth and thirteenth centuries and the Sienese paintings of the fourteenth and early fifteenth centuries offered artists a universe in which forms were based less on nature than on an idea of the divine. The spirituality of religious art appealed to artists who were in revolt against the rationalism of the nineteenth century; and medievalism, by the latter part of the century, had made an unexpected alliance with art for art's sake. Matisse had studied with Gustave Moreau, who represented the end of the line of medieval-revival aesthetes, and Matisse knew Georges Rouault, also a Moreau student, who'd managed to reshape their teacher's dark, glittering imagery into a vehicle of original religious expression.

But Matisse, like so many artists of his generation, had to circumvent the

sentimental medievalism of the fin de siècle in order to make his way into the twentieth century. It was half a century after he'd studied with Moreau that Matisse finally took on Christianity in the chapel at Vence. This is a Christian art without nostalgia. Matisse's stained glass wipes away the centuries of darkness that have covered the Gothic traceries. The windows, with their hundreds of leaf forms in green and blue and yellow, carry us back to the beginnings of ornament. Matisse takes his shapes directly from nature; the process is as basic as it might have been in Archaic Greece. These windows are forthright, unshaded; and in the mornings Matisse's pure-colored light splashes across the chapel onto murals made of white tile and a few black lines.

The diptych that's formed by the *Mother and Child* and the *Stations of the Cross*, on adjacent walls, is one of the very rare instances in post-Enlightenment France where a great artist has experienced Christian subject matter wholeheartedly. By working over the designs for these murals dozens of times, by studying the compositions of Mantegna and Rubens, by paring down and paring down still more, Matisse has been able, despite the atheism upon which he insisted, to inhabit the iconic forms. Like the early Christian craftsmen, he's acting almost transparently to convey the meaning of his sacred subject. After a lifetime spent distilling the essence of everything he sees in nature, Matisse finds himself in deep sympathy with the distillation that is early Christian art. Matisse is as indifferent as the Romanesque artisans were to any naturalistic detail that gets in his way. He's attuned to the narrative possibilities of line itself. In the *Stations of the Cross*, that peculiar alphabet of attenuated signs, Matisse reveals an unexpected affinity with the late style of Paul Klee. The shivering marks of the *Stations of the Cross* are set in a quiet yet decisive confrontation with the buoyant curves of the *Virgin and Child* in the greatest room that any modern artist has conceived.

The winding bus ride up through the hills from Cagnes-sur-Mer; lunch in the largish, plain square of Vence, with its shade trees and bus depots. These

are part of the experience of the chapel—just as, a few miles to the south, the ride through a drier, scrappier, sun-scorched landscape is part of the experience of Picasso's War and Peace Chapel in Vallauris; or again, in the same neighborhood, the hill town of Biot mingles with the afterglow of the Léger Museum at its feet. For the visitor looking at art, the towns of the Côte d'Azur, with their resort-area informality, are the retirement land of the School of Paris. Here's Nice, where Matisse lived for decades. Here are the hills above the coast, full of the variegated, seductive foliage that Bonnard painted at Le Cannet. And here are the beaches Picasso sat on in the forties and fifties.

How strange it is that Matisse, Picasso, and Braque all outlived the generation of abstract artists that rose up in their wake. Kandinsky, Klee, Malevich, and Mondrian seem to have been the victims of the press of time and change—dead in Switzerland, Russia, Paris, New York; broken by wars, immigrations, horrible ideologies, disease. Like their new, epoch-shattering art, they remained strangers in a strange land. The generation of 1905 appears, by comparison, richly blessed. Braque, Léger, Matisse, and, above all others, Picasso go on and on, weathering World War II and becoming, in the postwar years, the hoary stars of newspapers and picture books. We see them all in Alexander Liberman's beautiful book *The Artist in His Studio*: dinosaurs, remnants of an earlier age, yet comfortable and self-confident, apparently having made a difficult transition with dignity. (Braque is still as handsome as a movie star—he gets better looking as time goes on.) They die at home, in comfort and wealth, after careers that have the length and largeness of something in the Old Testament.

The later work of the School of Paris masters rarely has the dewy purity of their beginnings. There's a weight of experience—in living, in painting,—and this can pull an artist down. And yet there's also, for us, a giddy happiness to be found in the long unfolding paths of artists who've lived through, and accepted the pastness of, their pure, classical moments. Yes—we want the Fauvism of 1905 and the masterpieces of Analytical Cubism. But who would want to miss the long exploration of the south of France

55

(meltingly psychedelic in Bonnard, comic in Dufy) and of the mysterious heritage of the Mediterranean (which becomes Archaic Greek in Picasso, Asiatic in Matisse, Etruscan in Braque, Pompeiian in Derain)?

In the biographies and memoirs we read of visits and friendships. It's in the south, beginning in the twenties, that Matisse and Bonnard get to know one another. This is an easy friendship, with jokes, like the time Bonnard posed for a photographer as a Matisse odalisque. Bonnard had already, long ago, at the turn of the century, been a sensational, essentially graphic artist, close to the *Revue Blanche* circle and Misia Sert. But only in the south (where he moved in the middle of the twenties, when he was nearly sixty) did he really set out to fulfill himself as a painter. Year after year he worked at his odd little pencil drawings made of dots and dashes and scribbles, and at his cozy scenes of breakfast tables and terraces and bathrooms. The couple of dozen oils that are sublime masterpieces, fit for the ages, began to appear in the thirties, a staggering late flowering in a mode of domestic bourgeois serenity that one would have thought had been thoroughly tilled years before. The nude in the bathroom, the staircase in the studio with the yellow flowers outside: these are subjects of the greatest eccentricity and originality, carefully nourished and made to grow ever more beautiful under the ministrations of the ageing master with the face of an Oriental sage. There are moments in the thirties and forties when Bonnard, not Matisse, is the greatest colorist in the world. Great with the impetuosity of a rule-breaker who turns his purples and yellows and oranges and greens into hallucinogenic fantasies on the sunstruck south. One of his very last paintings, the small *Flowering Almond Tree*, with its snow-white frost of blossoms, might be regarded as France's final farewell to the plein air tradition that had dominated her art for more than a hundred years.

If the friendship of Matisse and Bonnard was easy, assured, that of Matisse and Picasso, renewed in the years after World War II, remained wary, ambivalent—one doesn't quite know if "friendship" is the right word. Picasso, ever the bohemian, is amused by Matisse's embarrassment at being caught playing hide-and-seek with his secretary Lydia. But when Matisse comments of Françoise Gilot, Picasso's new mistress, that if he painted her

portrait he'd make her hair green, Picasso, who's made nervous and competitive by Matisse's admiration, does just that. There are exchanges of paintings, like the peace offerings of great Indian chiefs. We see Picasso's winter landscape of Vallauris in Matisse's bedroom leaning in front of the fireplace, surrounded by designs for the chasubles of the chapel, and we note some affinities between the little explosions of foliage in paint-on-canvas and cut paper. One interesting gift-giving story relates to the New Hebrides idol, larger than life-size, "carved in arborescent fern, streaked with violent tones of blue, yellow, and red, very barbaric looking and not really old," which had been sent to Matisse by an admirer. It sits in Matisse's studio—and he tries to pawn it off on Picasso, who says (in a story told by Françoise Gilot), "we didn't have room in the car to carry it away." The gift is only delivered after Matisse dies, by his family. And then it sits in Picasso's studio. How strange—this product of some craftsman thousands of miles away presiding over those two magical studios.

Part of what engages a visitor to the south of France today is the artists' efforts to come to terms with the spirit of the place. In 1946, when Picasso was in Antibes, Romuald Dor de la Souchère, the curator of the town museum in the Château Grimaldi, a big stone structure with a twelfth-century tower on a cliff overlooking the sea, offered Picasso, who needed work space, a studio. Picasso was intrigued by the château, began to decorate it, and ultimately left to the city everything he did there—thus the Picasso Museum. The work done in Antibes looks good in reproduction. Even Clement Greenberg, a stern critic of the later Picasso, was generous about these paintings when they were reproduced in a special issue of *Verve* in 1948. But when you actually get to the museum the general effect of the work turns out to be terribly thin. You feel Picasso trying to plunge into the ancient origins of the town, into its near-mythic history as a Greek port named Antipolis. One of the big paintings is called *Joy of Life, or Antipolis*, and this is full of the mythological creatures—centaur, satyr, nymph, faun—with whom Picasso, in his imagination, must have wanted to populate the Mediterranean beaches and woods. When you're visiting the Château Grimaldi you know what Pi-

casso was up to. You understand that he came to the shores of the Mediter-
ranean and wanted to bring the spirits of the ancient port to life; but it's a se-
ance that doesn't come off. The huge monochrome triptych *Satyr, Faun, and
Centaur with a Trident* reveals Picasso working toward a minimalist decor
that presages Matisse's work five years later in the chapel. Still, Picasso's line
here is approximate, rather vague, really. He's just covering ground. Picasso
always knows what to do with a corner, how to fill the space. A few small,
greenish-gray still lifes of anemones and octopi are lovely; but basically the
museum is full of neatly put together, rather dull paintings. At the Château
Grimaldi, Picasso's combination of intellectual brilliance and workaholic
enthusiasm goes nowhere. What Picasso did here is completely swamped by
the spectacular views of the Mediterranean visible from the château terrace.
You get the impression Picasso spent most of his time at the beach—in fact
you hope he did.

Picasso at Vallauris: now this ought to be the nadir. Here was the Maestro,
in the little dying town that he won over in the late forties and early fifties
with his energy, his ingenuity, his spirit. The Maestro's *Man with Sheep* is in
the town square (a gift to Vallauris), and arriving on market day, one sees a
crate of Spanish garlic sitting casually at the statue's feet. All the olives and
the tomatoes and the breads of the market, and then the Picasso: one can't
help feeling that this has about it the air of a scenario too carefully contrived.
Picasso's involvement in the ceramics industry of Vallauris is said to have
turned the town's economy around; and the *Man with Sheep*, standing in the
square, seems designed to support a most artificial picture of Picasso as
grand seigneur. But the old guys of modern art have a way of surprising you
and getting down to serious business when you least expect it—and that's
what happens here in Vallauris. In the War and Peace Chapel, which Picasso
painted in 1952 and which in reproduction seems one of the most bombastic
of all his works, he breaks through in places, creating a haunting mural from
an odd combination of Cold War current events and classical associations.
(Did Picasso paint his unconsecrated, secular chapel only one year after Ma-
tisse's real one to prove he could do it, too?)

The War and Peace Chapel is very small—just a little vaulted room—and the paintings, which are curved, fill it, bending across the ceiling and creating one seamless piece. This cave-like space isn't more than five yards wide, so we're forced into a close proximity with the murals; their life-size and more than life-size figures seem to occupy *our* space. *Peace*, with its dancing woman, big, goofy horse, child acrobat, and picnickers, is formidable. Picasso's drawing has the twisting contortionist's energy of the best of his thirties and forties work. The color is deep, full-bodied. It's a painting that, though done over a period of months, looks to have been done very fast, in a surge of inspiration—there are splatters and drips of paint. *Peace* is an invention, a conceit, but it's a conceit in the major decorative mode of Pompeii and Venice, and it works. *War*, with its shadowy murderers, angular chariot, and big good-guy holding up a dove-decorated shield, is less of a success, though nowhere near the embarrassment it looks to be in reproduction. It's not tacky, like the *Massacre in Korea* (1951). *War* is a potboiler. You get the impression here that Picasso didn't know what war was like or didn't know how to tell what he knew; maybe it was that he'd done war before, in *Guernica* and *The Charnel House*, and wasn't much interested. Still, it's a brilliant potboiler. In the chapel an engaging dialogue develops between *War*, with its broken, ugly, slapped-together forms, and *Peace*, where all is curved and curled and humorous. One is glad for *War* if only as a complement to the deeper-running, more direct emotions of *Peace*.

Picasso's output from the end of the forties to the middle of the sixties is most uneven. For the first time his reach as often as not exceeds his grasp. Spending time with this work, you can feel as if you're drowning in mediocrity; but just when you think he's gone completely haywire, up pops something really good—something that only Picasso could have done.

The superiority of the *Peace* over the *War* panel at Vallauris is symptomatic of Picasso's inability, in these years, to bring off successfully the kind of dark vision which made for so much of his most convincing work in the thirties and forties. He's always better off in the late forties and the fifties

when the subject is pleasure. Françoise Gilot, in her *Life with Picasso*, recalls a lunch with Gide, who was accompanied by a "young man, dark and very handsome." Gide said:

> "Both of us have reached the age of serenity," adding, with a nod to his young man and then to me, "and we have also our charming Arcadian shepherds."
>
> Naturally, Pablo rejected that aesthetic interpretation of life. "There's absolutely no serenity for me," he said, "and furthermore, no face is charming."

But one rather thinks Gide had Picasso down pretty well. The work of the fifties is full of pipers and shepherds and fauns. The pastoral theme, announced at Antibes, flits through the forties, fifties, and early sixties, in the slippery, all-too-buoyant forms of the linoleum cuts, in the slightly tipsy lines that wind their way through the illustrations for books such as Jean Tardieu's collection of poems, *L'éspace et la flûte*. ("It was in the happy time. . . .") Among the charming works of the period are a series of frosted glass figurines—matters of the twisting of a form, which make a modern response to an eighteenth-century Venetian glassmaker's dreams. Even Picasso's large-scale sculpture of the fifties, which is some of the most substantial work he did then, fits into this mood. The *Baboon with Young*, the *She-Goat*, the gravity-defying *Girl Jumping Rope*, the *Woman with Baby Carriage* are confected out of a collage of found elements—a truck for a face, a wicker basket for a skirt. They suggest a pastoral of the junkyard.

In the pottery works at Vallauris, Picasso developed his bucolic motifs on forms that could be multiplied by the potters—and thus he was able to send out his new style in a long series of replicas and reproductions. This proliferation, together with the explosion of his graphic work, was at least in part a response to the new audience for modern art that Picasso had no doubt sensed when the GIs beat a path to the door of his rue des Grands-Augustins studio in Paris immediately after the war. Seen in profusion, the pottery, with its repetitions of shapes and forms, feels megalomaniacal, but also rather touching, for these pots and platters and pitchers reflect a reach into the liv-

ing soul of Provence, with its rich deposits of clay and its markets where fishermen will offer ancient amphora tips pulled up with the morning's catch. Hélène Parmelin, a novelist married to the painter Edouard Pignon, who often visited with Picasso at Vallauris, recalled the primitive beauty of life there. "Sometimes, Picasso walked up to his house on foot, through the Vallauris night which smelt of rotten flowers (scents were distilled there) and wood smoke from the potters' furnaces. It was very dark and very warm." Especially in these years he spent in Vallauris, Picasso is in touch with the ancient myths of metamorphosis. He turns a jug into a bird or a woman, a plate into an arena with crowds at its edges and a bullfight going on in the center. While many of the ceramics have a knotted-up quality that relates to some of the weakest oils of this period, Picasso's painting on ceramic can achieve a winning fluency and directness. The idea of transformation—so essential to Cubism and collage—produces now a comic tabletop game.

Where Picasso may be at his most natural in the years after the war is in the series of paintings of the interiors of La Californie and the surrounding landscape, done in the middle of the fifties, after he bought the turn-of-the-century villa in the hills above Cannes. These canvases reveal Picasso in an unexpectedly naturalistic mood. The subjects are traditional—a landscape, an interior with the accoutrements of the studio—and Picasso, surprisingly, seems to want to respect the conventions of the genre. Picasso was at this time much preoccupied with the old masters, and a remark he made to Rosamund Bernier in 1955 holds a key to what the paintings are about.

> I've been copying Altdorfer. It's really fine work! There's everything there—a little leaf on the ground, one cracked brick different from the others. There's a picture with a sort of little closed balcony—the closet, I call it. All the details are integrated. It's beautiful. We lost all that, later on . . . These things ought to be copied, as they were in the past, but I know no one would understand.

This comment tells us more about Picasso's involvement with the masters in the fifties than do the many pretentious series of copies after Courbet, Delacroix, El Greco, Velazquez. In the best of the La Californie interiors—and

the very highly articulated ones are some of the best ones—Picasso is trying to get all the little pieces of the scene to fit together. There's a yearning for closure—for the wholeness of a traditional image. You feel Picasso galvanizing, pulling together the various elements that he sees before him.

In one of these interiors the great upward sweep of the rococo-revival windows dominates the crammed, chaotic studio. Picasso revels in the curving moldings of his florid, turn-of-the-century salon. He uncovers the pattern of tightening and loosening curves that unites the architecture with the brush-and-palette-laden table, the various statues, chairs. He moves us around the room and out the window into the verdant garden with its exploding fronds of palm. The painting, predominantly gray, is dotted and dabbed with touches of red and blue and brown. It's densely worked yet spacious, and has a subdued naturalistic force reminiscent of certain works Picasso had done back in 1909 when he was on the verge of inventing Cubism.

Often after the war, and especially after Matisse's death in 1954, Picasso made a great show of appropriating the older man's subjects and styles. The palm tree outside the studio window at La Californie is a motif borrowed from Matisse, who used it most memorably in the *Egyptian Curtain* of 1948; and in spirit many of the portraits of Françoise and Jacqueline are Matissean, as are, of course, Picasso's copies after Delacroix's *Women of Algiers*. But when Picasso took Matisse up in the fifties it was in an effort to reestablish his grip on easel painting, whereas everything Matisse had been doing since the thirties had grown out of a desire to free himself from the self-enclosed world of the canvas hanging on the museum or gallery wall. By the forties Matisse had been living in the south, away from the centers of art, for a generation. This self-imposed isolation from artistic fashion, together with a series of brushes with death not uncommon in an infirm old age, had brought him to a state of almost beatific creative freedom.

Painting had become increasingly difficult for one in Matisse's invalid state. His illustrated books of the forties—so much more satisfying than Picasso's, so much more of a giving-over to the experience of the page, with its convergence of image and text—are a classic case of a minor genre receiving

major attention. Matisse's *Florilège des Amours de Ronsard*, published by Albert Skira in 1948, consists of dozens of sketchlike lithographs scattered around the lines of beautiful old Caslon type. The lithographs are printed in a soft brown, the text is in black. Matisse wants us to feel that he's scribbling in the margins, and it's an old man's scribbling, full of the breasts and bellies and faces of a whole gallery of beautiful, shimmering-eyed women. Matisse knows how to tilt and tip his images so as to pull the double-page spreads into all sorts of fascinating curving arabesques. He feels the page as a whole and he composes across it and through it. And he finds a way here, amid the rhyming verses of a sixteenth-century poet, to give his art a mythic depth. Along with the coupling figures there are cupids, pipers, a mermaid, a rape of Europa, a birth of Venus, and a general sense of metamorphosis, with fruits and blossoms that look like breasts, faces that look like flowers, a woman whose torso is embroidered with flowers, and a tree in the shape of a woman. As Matisse's lines move across the page they become harder or softer, thinner or thicker—like magical unfurling ribbons. Most of the pages are spare, with a good deal of empty space. But occasionally Matisse will fill a page with an image—a bouquet of flowers, each with a center that's a star; or a woman whose blouse is a mass of ruffles—and then there's a surge of energy, a flood of passion. Matisse is working at the heights of sophistication and culture, spinning out of the whole French tradition an art of perfect ecstatic modern beauty that is meant to be studied amid the old bound volumes of a gentleman's private library.

For Picasso the decoration of a plate remained a separate activity, not to be confused with the painting of a canvas. But for Matisse, who'd been thrusting decorative patterns into the center of easel painting since 1908, the distinction between painting and illustration and decoration became less and less significant. The paper cutouts of the last decade of his life, with the forms cut from sheets of paper that had been painted to Matisse's specifications in brilliant gouache, are carefree, blithely hedonistic. Color is no longer something the artist works through in the painting process. Now, Matisse begins with color as a sculptor begins with stone. In some of the paper murals Matisse floats beyond all the distinctions that had for centuries separated

painting from drawing from decor. When you're in front of the thirty-two-foot-long *Large Decoration with Masks*, with its brilliant flowers on a dazzling white ground, you don't quite know what it is, but you want to stay and bask in it.

The photographs of Matisse's studio taken in the last decade of his life tell us a great deal about the genesis of these collages. In Matisse's apartment the pieces of cutout paper are tacked up, here and there, and one takes them in along with everything else in the room—with the chairs, pitchers, tables, oil paintings. In some photographs a wall is covered with dozens of seaweed forms; it's like the crazy proliferation of things a kid puts up in his bedroom. (A number of the galleries that exhibited the cutouts in the fifties made an attempt to match this crowded effect.) Other compositions creep across Matisse's walls, as if in imitation of the self-propelled growth of forms in nature. In a 1952 photograph *The Negress* is "taking a walk" around the studio; her feet are literally resting on the floor. *The Negress* is a joke of a picture, inspired by Josephine Baker and her banana skirt, a memento of the Roaring Twenties. Matisse is going effortlessly now, cutting into the clearest tones of blue and yellow and red and green. But so often, blue and white, the colors of much modern neoclassicism: of certain Mondrians and Picassos, and of the lighting in George Balanchine's Stravinsky ballets.

One of the most fascinating of the studio photographs, from 1944, includes a cut-paper composition of pure geometric design—all rectangles, except for one circle and one diamond. Though Matisse later dismantled the composition, we treasure its survival in photographic form because it's one of those rare moments when a member of the pioneering generation of the School of Paris made an overt bow to the nonobjectivity of the next generation. This could be a painting done by a member of the Abstraction-Création group in Paris in the thirties; it's as if the cut paper, which makes such a clear separation from the conventions of easel painting, has freed Matisse to try things he would never have done in paint.

By the forties, Matisse had separated himself definitively from the nineteenth-century naturalistic tradition into which he'd been born. Dominique Fourcade has written that the light in the paper cutouts isn't the light

of Nice; he calls it an American light—whatever that is! Perhaps for a Frenchman this is only to say it's a new, exotic kind of light. In the paper cutouts Matisse, the man who stayed longest with nature, turns out to go furthest beyond the framed moment of traditional Western art. No other figure of the heroic age of modern art (not Picasso, not Mondrian) transcended easel painting. (Pollock and Newman remained easel painters as well.) Matisse is the exception. In the last paper cutouts he crosses barriers: from painting into decoration, from the fixed moment of the canvas to the floating movements of an eye roaming across a wall. Like the ancient Chinese landscape painter Tsung Ping, who in his old age painted landscapes on the walls of his room so as to do "my roaming from my bed," Matisse is creating a world that he can wander through without stepping outside his door. Pierre Schneider, in his great book on Matisse, quotes some lines from Goethe:

> I have built my home on nothing
> And so the whole world belongs to me.

And Matisse, in the text for *Jazz*, his album of paper cutout images, speaks of happiness:

> An artist must never be a prisoner even of himself, a prisoner of a style, a prisoner of a reputation, a prisoner of good fortune. Did not the Goncourt brothers tell us that Japanese artists of the great period changed their names several times in their lifetime? This pleases me: they wanted to safeguard their liberties.

When we look at the paper cutouts, we have the special pleasure of knowing that Matisse's late style, unlike that of almost every other major figure of the School of Paris, was immediately accepted, and granted a place of honor in the art of our time. Picasso in his last years believed himself to be another Rembrandt, an artist acclaimed early and forgotten later on. Matisse passed his last years hailed as a master who remained in step with two or three succeeding generations. The clear light of the paper cutouts is the gift of an octogenerian who can still walk into a morning world where all is wonderful to behold. To have that at past eighty. Bravo.

BRAQUE

The Anticlassicist

Braque's late paintings are mysterious, seductive. The surfaces have been worked, reworked, and worked again. Some paintings are extraordinarily rich, almost overfull of complication; others are pared down, dramatically simple. Braque's canvases draw you in with their grave lyricism. He's the only School of Paris master who stayed away from the sunny south. In his interiors, landscapes, figures, and still lifes each stroke of the brush reflects a northerner's deliberate kind of intelligence.

In 1949 when Braque began his Studio paintings—a cycle of symphonic meditations on the artist's trade—he was sixty-seven years old, and had recently recovered from a serious illness. The beauty of the work of the last fourteen years (Braque died in 1963) is at least in part due to a kind of double perspective: even as the artist is pressing into the future, he's reminiscing about his own past. The brilliantly colored bouquets and landscapes of the fifties recall the Braque of 1906, who entered the avant-garde when he took up the raucous color that had earned for Matisse, Derain, and Vlaminck the nickname of Fauves—Wild Beasts. The flicker of short, staccato, silver-

gray brushstrokes in the two heroic female figures of the early fifties (*Reclining Woman* and *Night*) recapitulate the Cubism of 1910 and 1911. These late paintings seem to carry an awesome weight of memory, both of Braque's own earlier personae and of those artists who'd obsessed him his whole life long.

The man we know from the photographs of these years is white-haired and extremely handsome—hardly an invalid. His features are large and clear, and yet with something delicate and refined about the set of the deep, dark eyes and the wide, beautiful mouth. Braque is obviously conscious of his good looks as he poses for the camera in his soft, casual artist's clothes. One is a bit surprised to hear about his Bentley limousine and chauffeur, because there's something modest, unprepossessing about the figure of the artist, and about his country home, with its robust antique wooden furniture, its bits of old wrought-iron hung on walls that are daringly painted in varying hues of orange. His life fits no pattern, is luxurious and severe by turns.

Cubism—Braque's and Picasso's great gift to the century—had long before been absorbed into history, a point on the road from Impressionism to abstraction, a "movement" with its historical logic. But for the founding fathers of Cubism this art that courted disorder and chaos in order to create a new order remained wonderfully enigmatic. Until near the ends of their lives Braque and Picasso enjoyed building grand pictorial structures out of the bits and pieces of nature. Cubism was by definition impure, hybrid: it existed halfway between the known world and other, alternative realities. And even as it "yearned" toward something purely abstract, it was entrenched in the emotionalism of the nineteenth century. Though Braque painted many of the most homogeneous and serene of Cubist paintings, the Cubist tension between the real and the unreal was always there in his work, and his need to choose between various levels of illusion, various ways of representing things, created an anarchic undertow. Beginning in the thirties the irrational, improvisational side of Cubism became increasingly pronounced in Braque's work. He was no longer the classicist of Cubism. By the time he began the Studio series in 1949, he'd become a fervently anticlassical artist.

In the paintings of these later years Braque holds nothing in reserve. The

canvas becomes heterogeneous, a clash of diffuse elements. You can't predict where he'll go next. He has no preconceptions about what a painting ought to be or ought to contain. At times he's pushing over the border of emotionalism, almost into sentimentality; at others, he's drugged on pure painting, and floats off into an Elysium where all that matters is that the grays echo harmoniously. Braque's insistent juxtapositions of closely related yet strikingly distinct bits of color, form, and brushwork yield an exaggerated, intensely self-conscious version of the cuisine side of French painting. To many, these paintings look elegant, decorative. They *are* immensely stylish; but Braque insists on their stylishness with a particularly modern ferocity. In the late paintings, style is picked apart, anatomized. Color effects, fragments of drawing are isolated, held up for inspection. Braque goes all the way through style—all styles: classical, rococo, and so forth—to achieve here a kind of detachment that approaches stylelessness.

"Georges Braque: The Late Paintings 1940–1963" was organized in 1982 by the Phillips Collection in Washington, D.C., as a celebration of the centennial of Braque's birth. Rather than memorializing the Braque everybody knows, the Phillips challenged us to push deeper into his work, to go all the way. It was a logical show for the Phillips, which has a great collection of nineteenth- and twentieth-century French paintings, and it was also a great show for the eighties, a proclamation that by now we ought to be ready for the late Braque. This was the first time an American museum had dealt exclusively with the period from World War II to the artist's death, and the show was that rarest of birds—a museum retrospective inspired by love. Containing fifty paintings, "Georges Braque: The Late Paintings" gave many of us our first opportunity to take a close look at this work, so much of which is in European museums and private collections.

At the Phillips Collection, *Studio IX*, with its welter of insubstantial forms, hung next to a window that framed a backyard full of sun-splashed leaves and branches. Turning back and forth between the window and *Studio IX*, I was struck by Braque's odd, half-mystical realism, by how desperately he wanted to invoke the flickering lights and darks of the world.

Whoever placed the pots of flowers and plants with dark green leaves in a few of the Phillips galleries must have sensed this, too. In the Studio paintings sunlight and shadow, effects of time and weather, sift through Braque's art as never before.

Braque's *Cahiers 1917–1947*, a book of reflections on art that combines images and texts, forms a kind of prolegomenon and key to the vision of the Studios and the other late works. The decorations in the *Cahiers* are a free-flowing rush of images: heads, leaves, vases, and coffeepots; palettes, brushes, and easels; figures of goddesses and hunters that recall the Etruscan-style designs Braque did for an edition of Hesiod's poetry in the thirties. The image on a page doesn't, in general, illustrate the text. Braque himself comments in the *Cahiers* that "form and color do not blend. There is simultaneity." Here are some of his subtle, oracular pronouncements:

> I am far more concerned about being in tune with nature than copying it.

> In art there is no effect without twisting the truth.

> There is only one thing in art that has value: that which one cannot explain.

> Impregnation—Obsession—Hallucination.

> The painting is finished when it has blotted out the idea.

> Emotion is neither added nor imitated. It is the bud, the work is the blossoming.

Surrounded by Braque's sensuous, calligraphic leaf-forms, these aphorisms argue that art must be "in tune with nature." But the truth must be twisted. Painting involves the loss of self and consciousness. The idea must be "blotted out;" the emotion is merely "the bud." To paint, one must begin with an idea—"impregnation"—and go through a process of search and struggle—"obsession." But one will arrive somewhere else—at "hallucination." Painting is an act of transcendence, dissolving thought and emotion into it-

self: the Studio series works these fragmentary meditations into grand easel-painting ideas.

The artist's studio first came into painting with Velazquez and Vermeer in the seventeenth century. The subject reflected a new self-consciousness on the part of the artist, a sense of how difficult and exciting it was to work in the gap between reality and illusion. Watteau's *Gersaint's Shopsign* (1721) and Courbet's *Artist's Studio* (1854–55) took up related themes; but since Courbet the subject had rather devolved, from allegory to something closer to anecdote. Braque's Studios may be an attempt to reclaim the allegorical potential of the picture-about-pictures idea.

Braque begins modestly enough, in *Studio I*, with a little dialogue between two painted pitchers, black and white. The objects are fixed in space, firmly related to one another. After that, all clear demarcations evaporate. The Studio paintings contain palettes, easels, bits of sculpture—they're generally referred to as still lifes—but these objects are so dissolved, so shattered, as to render the pictures hardly still lifes at all. Maybe they're anti–still lifes—the annihilation of a genre. Though *Studio VIII*, completed in 1955, is bright and almost exuberant, the prevailing mood in the series is of a velvety-dark forest interior with shafts of sunlight coming through. The studio is a fairyland, romantic in its jumbled profusion. The paintings are deep, slippery, difficult to navigate.

The magnificent *Studio VI* (at sixty-four inches, very large for a Braque) is small-scale, almost intimate in mood. More than anything else, it's about a conversation—a kind of duet—between a bird, perched atop an easel, and the bust of a woman. They seem to address one another in a song that's as attenuated, as insubstantial as the pulled-out strands of paint that run through so much of the painting. Out of the darkness surrounding this surreal pair loom a lamp, a palette, jars, and brushes. Things emerge, flicker for a moment, and then disappear. Braque always admired the work of Paul Klee—he visited Klee when Klee was near death in 1939—and he may have had in mind Klee's last, tragic still life, in which the vases and pitchers wave their spouts and handles in a gesture of farewell.

Studio IX, completed in 1953 as *Studio VII* and then completely repainted in 1956, is dense, impacted, grayish green. Here the bird—symbol

of all that's gentle, of peace and hope, is exploded by the gridlike matrix in which it's caught and bursts forth in a series of spiky projections. You feel the claustrophobic horror of a bird flying into a room, caught, unable to escape. In the *Cahiers* Braque observed that "the poet may say: a swallow is stabbing the sky, and makes a dagger of a swallow." In *Studio IX* he produces exactly this metaphor. This broken bird, as well as the light bulbs and strange heads that inhabit some of the other Studio paintings, recall the imagery of Picasso's *Guernica*, the greatest of modern public outcries in paint. There's a connection in the way the artists use the shattered glass of Cubism to suggest the darker side of the human condition, but of course there's also the difference that the Studios are private dramas, chamber dramas.

Further glimpses of the terrain mapped out in the Studio paintings are provided by enigmatic canvases such as *The Cauldron* (1949) and *The Checkered Bird* (1952–53). Braque's sublime brush, his control of tone draw one into a labyrinth of possibilities. Why is the bird trapped in a grid of red lines? What is the meaning of the smoky gray patches in *The Cauldron*? Smoke? But they're not smoke shapes. The questions seem almost impertinent, and the paintings, more often than not, convince us. In two of the last large figure paintings, *Night* and *Reclining Woman*, Braque reclaims the dappled brushstroke and silver-gray palette of Analytic Cubism as the vehicle of a sort of mythic figuration. Out of a welter of short brushstrokes emerge women whose weird visages are calculated to inspire unease—a modern version of archaic awe.

In 1957, when Braque spoke with the English critic John Richardson, he rejected logic, moderation, and measure in art. The process of working his way into a painting was "rather like a fortune teller 'reading' tea-leaves." Art should disturb—"the whole Renaissance tradition is antipathetic to me." Renaissance perspective, especially, seemed "a ghastly mistake," for it tended to create a distance between the spectator and the object, when what art ought to do was bring them closer together and offer a "full experience of space."

After the Studio paintings Braque seems to have wanted to move on from Cubism. In the fifties nature offered war-shattered nerves the promise of re-

lease from the man-made and man-ruined world, and landscape painting, which had been of only secondary interest to Braque for many years, moved to the center of his art. He became a painter of primal nature images.

Coming at the midpoint of the century, this upsurge in landscape work by Braque and other artists is a bit of a shock. Although landscape painting had once upon a time been the site of many daring modern inventions, the School of Paris had ultimately become ambivalent about its plein air youth. Braque painted no landscapes between 1911 and 1928. To return to landscape was to rethink Poussin, Claude Lorrain, Corot, and Courbet, but also Monet, Cézanne, Fauvism, and early Cubism. André Masson, the Surrealist who spent the thirties and forties painting dark, labyrinthine visions, found himself, when he took up residence in Provence on his return from wartime exile in America, attracted to the light of the Impressionists. He wrote about "boundlessness," made a book of lithographs based on a voyage to Venice, and painted paled-out, brushy canvases in a style that flickered with memories of Turner, Monet, and Cézanne. Balthus left Paris for the countryside, where he embarked on his great series of powder pink and lime green farm-scenes, with their echoes of Gide's *The Immoralist*. Nicholas de Staël, who was born in 1914, who'd been a friend of Braque's since 1944, and whose finest paintings would always be the impacted abstractions of the late forties, also turned to nature. De Staël's thick planes of earth and air, produced with a palette-knife, recall Courbet, but there's also, in his boats and harbors, a suggestion of the continuation of that plein air tradition in the magnificent seascapes of Marquet.

Braque's landscapes are emotionally deeper than any others of the fifties. Braque's small-size pictures, often done in the traditional elongated "marine" formats of nineteenth-century art, do away with the entire language of Cubism, and make an essence of a long history of nature poetry in paint. In many of Braque's landscapes there's almost nothing going on, just a vibration of earth, water, air. Braque's artistic memory circles back to the first grand years of the modern movement, when post-impressionism had begun to cut the cord that tied art to nature. The sensuousness of paint is allowed, almost, to float free, or is pinned down to nature in new, surprising ways. Braque's brushstrokes register as sand, earth, clay, sun, rather than as

gray, brown, red, yellow. The pieces of pigment are metaphors—or, as the French would say, signs.

The artist who comes to haunt the work of Braque's last fifteen years is van Gogh. Both Matisse and Picasso owed an almost incalculable debt to van Gogh, and one is hardly surprised, in photographs of Braque's engraving studio, to find a reproduction of one of van Gogh's *Sunflowers* pinned to the wall—Braque's own *Sunflowers* is a salute to the Dutchman. Braque's fascination with van Gogh irradiates many aspects of the late work. The more high-keyed, sunny side of Braque's palette mirrors van Gogh's desperately optimistic, throbbing blues, yellows, and golds; the vehemently horizontal, bluntly composed landscapes recall the earlier artist's double squares; the ears of wheat in Braque's *Wheatfield* are a quotation from van Gogh's *Ears of Wheat*; and the birds that fly through so many of Braque's late fields evoke, inevitably, van Gogh's final *Crows over the Wheatfield*.

Why van Gogh? No doubt because he provided Braque (and Picasso as well) with an expressionism that was independent of subject matter or narrative. Within the most ordinary aspects of our world, van Gogh uncovered forms, colors, and rhythms whose pure, elevated force could convey the deepest kinds of emotions. Van Gogh, in his letters, writes of nature in terms of color effects: he describes deep violet ground and foliage against a yellow sky, and red earth against a background of delicate mauve hills. The color statements in Braque's late landscapes (and still lifes) are equally direct and quite as unusual. There are yellow skies, red tracks of field, and a piquant harmony of yellow and lavender that recalls one of van Gogh's favorite combinations. It's in large measure through this expressionism of color that Braque conveys his final, intense feelings about the world around him.

Also new in some of the last works is a reverence for the particularity of an object—a plough, a garden chair. Braque seems less willing than ever before to abstract from nature. In his close-up views of garden chairs, Braque homes in on an ordinary object in much the same way van Gogh did. Van Gogh had always pushed his chairs, shoes, flowers, and fields right up against the picture surface, so that we can almost touch them. Braque doesn't have van Gogh's concern for precisely how the parts of the chair fit together—there's something tenuous, almost insubstantial about the Fau-

vishly colored *Mauve Garden Chair*—but Braque does, with van Gogh, seem to be exclaiming, "This chair matters!" No classicist could care so much about a piece of garden furniture.

Though Braque's last decades were marked by illness, he remained extraordinarily adventuresome. Some of the late motifs don't always produce convincing paintings, but Braque's open-ended, experimental method encourages us to follow him wherever he goes. The Studios, landscapes, and seascapes aren't a summing up. They're too offbeat for that, too full of new ideas, new directions, and unexpected resolutions. The dense, mannered surfaces of the Studio paintings and the abbreviated ones of the landscapes still surprise us. And the birds—those most static of all Braque's works, those hieroglyphic creatures poised on a canvas, or a piece of paper, or the ceiling of the Etruscan Gallery of the Louvre—what of them? They're hardly compositions at all, more like heraldic devices, stamped on the close of the career.

During Braque's last eight or ten years the compositions become simpler and simpler. The paintings are talismans, emblems. So much rests on the power of the brush, on the resonance of a painted surface. The Bird paintings are about the mystery of a silhouette—how it marks off space, announces a beginning and an end. In some of the late pictures, thick globs of paint rear up like volcanic eruptions. Others are rapidly, almost breathlessly brushed. In *Seashore* we're confronted with the blinding, dense gray-black of a stormy sky so overpowering it invades the frame as well. In *The Field of Colza* the world is two rippling, narrow, horizontal planes, one of sky blue, one of harvest gold. These paintings are an avowal of the painter's craft, beyond all artifice, in its essential form. They're a painter's prayers—a last recitation of the possibilities of the brush. Though not so well known in America, they have found a most diverse group of admirers. It's not surprising that Jean Hélion, the pioneering French abstractionist who turned to representation some forty-five years ago, should have admired them, as he said in an interview a few years back. "Maybe," Hélion speculated, "Braque had not painted the pictures he should have painted and at the end of his life had the

feeling of these unpainted pictures and tried to indicate what he could have done." Clement Greenberg's comments on the late landscapes, in *Art and Culture*, come as more of a surprise:

> These broadly and emphatically treated pictures, murky yet pungent in color, adumbrate new and very un-Cubist ideas of design as well as of color, ideas that are more original and also more relevant than anything discoverable in Picasso since 1939. They demonstrate how radically independent Braque has it somewhere in himself to be.

When Braque died in 1963 he was given a state funeral in the courtyard before the east facade of the Louvre, opposite the church of Saint-Germain l'Auxerrois, where Chardin is buried. André Malraux, then Minister of Cultural Affairs, composed a beautiful funeral oration. Malraux emphasized the freedom that Braque, along with Picasso, had brought to painting, and how this new freedom had opened our eyes to the nonillusionistic art of the past, "from our Romanesque painting to the beginning of time." But it wasn't the high color of Fauvism or the brown and gray traceries of Cubism that Malraux ultimately seemed to want to evoke. As he summoned up darkness, rain, a worn peasant-woman's hand, and the farmers and sailors of the little town of Varengeville, where Braque had lived, what must have been on his mind were the landscapes and seascapes of Braque's last decade.

In his oration Malraux commented that the glorious funeral accorded Braque might, in some way, be considered a "revenge" for the pitiful ends of Modigliani and van Gogh. Speaking from the Cour Carrée of the Louvre, Malraux said that "Braque expressed France with a symbolic force so great that he is as legitimately at home in the Louvre as the angel in Rheims Cathedral." At the Phillips exhibition Braque's greatness was gloriously, abundantly clear. But it was all the more interesting for being a complex, contradictory kind of greatness. To the end, Braque remained an experimentalist, unafraid. Does Braque's work achieve that transcendent state of *"poésie"* he saw in the final phases of Rembrandt, Corot, and Cézanne? It's hard to say. It's a measure of the largeness and newness of Braque's late paintings that we can't yet place them.

PICASSO

A Grand Finale

Picasso lived in La Californie, his villa in the hills above Cannes, from 1955 to 1961, from the ages of seventy-four to eighty. Those were his buffoonish years; he was cashing in on the immense capital he'd built up as a living legend for going on half a century. The American photographer David Douglas Duncan, arriving to deliver a gift, was pressed to stay and snap the Maestro decorating ceramic plates, dressing up as a clown and a matador, and entertaining the actors Yves Montand and Simone Signoret. Out of Duncan's visit came, in 1958, *The Private World of Pablo Picasso*, a picture book meant for adults but better suited to art-infatuated ten-year-olds. Also from the fifties is Henri-Georges Clouzot's film *The Mystery of Picasso*. (In the spring of 1986 this movie made something of a hit with New York's downtown crowd—the children of the postwar boom—when it was revived at the Film Forum.) In Clouzot's movie the bare-chested Maestro sits behind sheets of clear plastic, and the camera follows the creation of Picassos blow by blow. Most of what Picasso does on screen is pretty thin—overdecorated line drawing. But who can resist the footage of the old Spaniard asking the

cameraman who's filming the emerging drawing to stop for a moment while Picasso mixes more ink? The practicality of that interval of paint-mixing brings the somewhat artsy, overheated design of Clouzot's movie, with its filming-of-a-film conceit, to life. For a moment Picasso's guard is down—he's just working at the trade—and we're there with him, the Titan of Our Time. But then he goes back to being "creative," and we get lost amid the pretentious clang-clang of the Georges Auric score. It seemed by the end of the fifties that Picasso was going to end his days as a self-consciously crazy old coot, wowing whatever part of the international art establishment still cared to watch.

John Richardson, a friend of the artist, believes that the key to Picasso's newfound concentration in the sixties and right up to his death on April 8, 1973, was the ministrations of Jacqueline Roque, whom he took up with in 1954 and married seven years later. (In Duncan's 1958 book Jacqueline is a quiet presence in the background.) In 1961 they departed the Côte d'Azur for a beautiful and isolated villa somewhat inland, near Mougins. Richardson proposes (in a 1984 essay in the *New York Review of Books*) that the name of the house—Nôtre-Dame-de-Vie, after a neighboring pilgrimage chapel—ought really to be bestowed on Jacqueline, who managed to keep at bay the old man's terror of death and focus him back onto his art. The beauty of Richardson's homage to Jacqueline—to her "solicitude and patience that sustained the artist in the face of declining health and death," and to "her vulnerability"—is now, a few years after Richardson wrote these lines, overlaid with the tragedy of her own suicide, at Mougins, in the fall of 1986. And what can one say about that, an addition to the gallery of badly scarred lives that Picasso left in his wake? . . . This is all very recent history, as are the paintings, drawings, and prints of Picasso's last five years. It's a question whether we ought to regard late Picasso as the end of something that belongs to another world—to the lost early modern world of Vollard and Apollinaire and Gertrude Stein—or as a part of our own, ongoing history. Personally, I'd rather keep the late Picasso with us for a while—as an occasion for fresh impressions, criticisms, appreciations. There's something gross, crass, cartoonish about the gaping-faced figure paintings; and one

doesn't know how to reconcile this with the still-elegant, almost nineteenth-century turnings of the lines in the prints and drawings.

It's difficult to judge the quality of the sentiment that went into the work of Picasso's last few years. In Picasso's case late style may have something to do with a desire to make sublime visions out of the closed-down horizons of an old man's retreat from the world. Picasso is obviously determined to convince us that he's creating from the edge of the abyss. The slob-genius execution of the paintings—the scrabbled brushstrokes, the stretches of bare canvas—suggest an artist who wants us to see him as a wrecked-out romantic hero. His themes—death, hope, love, fear—are the big ones. He's laying all the chips he has left on the table. The manner of the paintings is large-gestured, childishly rhetorical. Each face, with its wide-open eyes, seems to say: "Don't judge me—accept me." Take it or leave it—that's the challenge thrown up by Picasso's cast of characters. This is hoax or epiphany; either/or. No compromise is possible.

These are paintings that you may be able to seize through some sort of revelation or illumination; but I'm not sure you can ever get very close to them. In 1957 Clement Greenberg said that Picasso

> has for years now shown a distrust of his facility and its promptings, and he seems to try to avoid anything that might suggest its presence. But the real consequence of this distrust is perverseness: he too deliberately makes things crabbed and clumsy, as a matter of effect rather than of cause, of choice rather than necessity.

There is, as Greenberg seems to suggest, something queer about the crudeness of much of the later work. Greenberg wrote this in the fifties, but the "crabbed and clumsy" quality is present to the end. These canvases aren't painting in the classic French sense of the well-made structure. They're something else—a dazzling figurative Abstract Expressionism, with roots sunk deep in the Old World. De Kooning's women are, by comparison, the tamest embroideries. These late paintings are nuts, off-the-wall: Picasso's figures are caught in the very act of jumping out of their own skins.

In the last few years of his life Picasso became an artistic alchemist turn-

ing the base metal of sex jokes, stock characters, and silliness into knock-out, apocalyptic images. Half the time the transformations don't come off—he's a failed wizard; and when the transformation does take place it's a mystery why or how. A guide is needed, and, as if by magic, it appeared, in 1974, in the form of André Malraux's beautiful book *Picasso's Mask*. (It was originally published in France as *La Tête d'obsidienne*.) This brilliant synthesis of reminiscence, criticism, and aesthetics opens when Malraux, who's in the process of "bringing up to date" his notes about the Spanish Civil War, receives a call from Jacqueline, whom he has never actually met. She would like Malraux's help in fulfilling Picasso's wish to have his collection of paintings by Matisse, Cézanne, Renoir, Corot, Le Douanier Rousseau, and others placed in the Louvre as a distinct collection. (They're now in the Musée Picasso in Paris.)

Malraux flies south to see Jacqueline. She meets him at the airport and takes him off on a tour through Picasso's collection of paintings by other artists. The book's eight sections form a series of interlaced meditations—on the rooms full of Picasso's sculpture at Nôtre-Dame-de-Vie; on Malraux's visits and conversations with Picasso, mostly, it seems, in the forties; on the great exhibition of Picasso's work from 1969 and 1970 held at the Palais des Papes in Avignon in the summer of 1970; on Malraux's own idea of the Museum without Walls. It's all presented in the stream-of-consciousness nonfiction prose style Malraux perfected in his later years. You get happily lost in the juxtapositions of the forties and the seventies, of ancient and modern art. In the final section, Malraux goes with Jacqueline to visit Picasso's grave on the grounds of another one of the artist's homes, the Château de Vauvenargues, and his thoughts return to Picasso's sculptures. He recalls Jacqueline saying to them, sadly, "All of you—you'll never become sculptures, never again." The magician is dead.

Malraux can, I suppose, be criticized for using Picasso to confirm his theory of the Museum without Walls—Picasso's vision is seen, posthumously, as supporting Malraux's own. It's scarcely credible that Malraux (even with notes) remembered so many conversations so accurately; but even if what Malraux has Picasso say isn't quite what Picasso said, it's still poetically right,

it illuminates the paintings. Malraux is almost as much of a cultural legend as Picasso, and so he can confront the artist on his own level. In *Picasso's Mask*, as in the Braque funeral oration, Malraux becomes the Homeric bard of School of Paris art. There's nothing picturesque about his portrait of the great Spaniard. Picasso is regarded with seriousness, openness, no trace of sentimentality, and the sketch of the widow, Jacqueline, is clear, light, remarkable—one feels the strength and the vulnerability to which Richardson refers.

If a simple thesis can be ascribed to this complicated book, it's that there are two Picassos—Cubist and Demonic—and that the Demonic takes over in the end. Picasso is both Architect, Builder of Pictures, and Magus, Master of the Other.

> It was clear from the heaps of paintings I was examining [at Nôtre-Dame-de-Vie] that Picasso had only two manners. The first is the collection of canvases that made up the Picasso Museum: the Blue period, the Rose period, stage sets, and Cubism; the second, all the others and most of the sculptures. *Les Demoiselles d'Avignon* and *Guernica* belong to both. In those, the division between Cubism and the convulsive works corresponded to the break between what Picasso had inherited from Cézanne and what he had inherited from Van Gogh. "Pity us," wrote Apollinaire, "we who are enduring this endless quarrel between Order and Adventure. . ."

Malraux recalls visiting Picasso's rue des Grands-Augustins studio years earlier, at the end of World War II.

> Picasso had gathered together a throng of arbitrary figures that had been peripheral to his art for twenty years without conquering it. Here, one after another, were the rediscovered heirs to *Les Demoiselles d'Avignon* and his Negro period, with eyes where the ears ought to be, breasts where the knees ought to be—the Martian children of his *Figures at the Seaside*, his *Lovers* of 1920, his *Woman Asleep* (that bristling sign, all hooks, which Kahnweiler had kept for thirty-seven years), his extraordinary *Crucifixion*, with its strings of shoulder blades and thighbones, his *Weeping Woman*, and all the forms that anticipated those which his genius-in-chains was later so lavishly to produce; also

recent figures akin to them—*The Blue Hat*, his portraits of Dora Maar, the *Child with a Lobster*, the *Woman with Artichoke*—all of which the newspapers had already labeled "Monsters." Assembled in one place, those paintings, which, at first described as "humbug" or "moronic," and then called "provocative" and "gratuitous," in fact revealed what his tangled profiles within full-view faces had—within the category of distortion—in common with his splintered *Crucifixion*. All of them were works carried to an extreme. If anyone had asked him yet again, "What are those?" he would have replied, "Paintings." Before that day I had seen only three or four of them, and knew a few others from photographs.

That particular group had no connection with any other of his works that had been exhibited. Since the beginning of the war—even since the Spanish Civil War—I had seen very few paintings. At Picasso's, only still lifes. Hardly any of his sculptures were known at the time, and they were not to be exhibited until twenty years later, at the Petit Palais. As far as I was concerned, and those of my friends who hadn't visited either his studio or Boisgeloup, the last and most masterful expression of his genius was *Guernica*. At first I got the impression that those eighty canvases pointed to a new manner; yet they had been painted with long intervals between each one since 1919. By assembling them all in one place Picasso had isolated the virus of his art—the virus, not the leavening agent, for certain of his major works (and above all *Guernica*) belonged to another world, if not to another style of painting altogether. No one could have known that those fragments of meteorites would become the heralds of his tarots.

Tarots are what Malraux calls the paintings of the last five years. It's a brilliant term: the paintings are flat, almost heraldic in their frontality, and, like the cards of the tarot deck, they're fates, figures of fortune.

Malraux doesn't make the mistake that recent art historians have, of looking for the key to late Picasso in the artist's quotations from Rembrandt, van Gogh, whomever. The late tarots are an outgrowth of the horror-portraits of the thirties and forties; the compression of overscaled images within tight frames, so typical of the World War II years, is carried over in the last years into a style of blown-up icons. In the marvelous back and forth of their conversations, Picasso and Malraux keep circling around the mys-

tery of religious art. They agree that when the Mesopotamian, Romanesque, and Hindu sculptors carved a face what they were carving was the image not of man but of God. What gives the Romanesque face its power, they argue, is its connection to God. It's not a face, it's a mask—the mask of God—and the phrase that runs through Malraux's book is a phrase of Picasso's: "I must absolutely find the Mask."

Since the sixties Picasso's late work has had a following in America among some art historians, who've emphasized the artist's pyrotechnical feats of historical reference. The Museum of Modern Art's 1980 Picasso retrospective included an excellent selection of late work, and the Pace Gallery mounted a good show in 1981. Nothing Picasso ever did is quite overlooked, but it's significant that the only museum in the United States to plan a show of Picasso's final phase, the Grey Art Gallery at New York University, is small, adventuresome, and rather underfunded. The catalogue for "Picasso: The Last Years, 1963–1973," an exhibition slated to open in the winter of 1983–84, was already off the presses, when, late in 1983, the Grey Art Gallery ran into funding problems, was forced to cancel, and the Guggenheim, with its far greater resources, stepped in to save the day. By the time "The Last Years" opened at the Guggenheim in the spring of 1984, trend-spotters in the painting world, thinking of neoexpressionism, were inclined to call Picasso's late style prophetic; but what an odd compliment this was, implying as it did that Picasso in his eighties was paving the way for Julian Schnabel or Sandro Chia.

The Grey/Guggenheim exhibit focused on a period of ten years (decades have a nice, round feel) but really emphasized the last five. Gert Schiff, the curator of the New York show and a professor at New York University, began his catalogue essay with an account of an evening in 1962 when Picasso and some friends looked at slides of Poussin's *Massacre of the Innocents* and David's *Sabines*. The picture of Picasso sitting in his villa in the middle of the night studying the old masters appeals to Schiff, and Schiff thinks the resulting paintings remarkable. But the 1962–63 Rape of the Sabines series is really very bad Picasso. Here Picasso succeeds only in turning classical figure

composition into a lumpish, quasi-Cubist hash in which flattened forms are stuck unpleasantly into a fairly traditional landscape space. Though the early and mid-sixties contain wonderful things and are suggestive of the glories to come, it's more logical to place the beginning of Picasso's final phase in 1968, as Malraux does, with the creation of *Suite 347*. The late period is very short—maybe no more than three years.

In 1963 the master printmakers Piero and Aldo Crommelynck set up an etching studio in an old bakery in Mougins, and their proximity and friendship allowed Picasso, in 1968, to unleash an extraordinary final burst of graphic art. While in earlier years Picasso often liked to work at one graphic technique at a time—doing a series of pure line etchings; or focusing on the lush grays of aquatint—his work on *Suite 347* is a celebration of everything you can do on a copper plate. Here thin neoclassical lines and heavy hatching and aquatinted grays come one upon the heels of the other as Picasso moves rapidly from plate to plate. The etchings of *Suite 347* are often crowd scenes—there can be four, five, and more figures to a plate. It's party time, time for a masquerade that keeps veering off into sex and self-exposure. There are sensual, big-eyed young men and women whose firmly rounded faces, arms, and legs are bursting with the first inklings of maturity felt in Greek sculpture of the very early fifth century B.C. And there are thin, tense figures of men (some, apparently, with the face of Aldo Crommelynck) and women of the seventeenth and eighteenth and nineteenth centuries, who seem suffocated by costumes and mannerisms, aged by the burdens of their own cultivation. Picasso reacts to the etching plate as a very shallow space: his figures line up, straggle along its bottom perimeter. *Suite 347* recalls Giotto's Arena Chapel in its range of feeling and in the almost cinematic way the scenes, viewed consecutively, compose in the mind a larger vision. *Suite 347* is an Arena Chapel for the twentieth century: secularized, miniaturized, the great expanse of frescoed wall reduced to the dimensions of the etcher's plate.

Writing about the late style of Titian, Erwin Panofsky said that, like all late styles, it was composed of "a coincidence of opposites: intense emotion and outward stillness, color and non-color, the broadest and apparently al-

most chaotic technique of execution and the most rigid order and density of composition." The painting of Picasso's final phase suggests, especially in its formal dimension, a similar conjunction of opposites. Picasso is taking on the members of his fictional entourage one by one. The figures fill the picture space. They command it, as do the characters of the tarot deck to which Malraux compares them. These last canvases are an odd mixture of Cubist and pre-Cubist ideas. The artist insists on the edge of the picture as framing a fictive space not unlike that of the old masters. There's a sense of moving air, of a three-dimensional atmosphere (and this makes the pictures appear to some viewers fussy, old-fashioned). But Picasso reinstates the old space only to confound it. While the tightness with which Picasso's men and women fit into the frame of the canvas gives the paintings a playing-card stillness, the thrashing brushstrokes inject a scary exuberance into the bodies of his peculiar characters. Picasso wants to combine the dynamism of Baroque composition and the tricky, now-you-see-it-now-you-don't forms of Cubism into one giddy balancing act of a style.

Picasso builds his figures out of lines that loop into elaborate rope tricks, with knots appearing and disappearing before our eyes. Malraux has compared these screwball arabesques to the mysterious bronze plaques of animals created sometime between the third century B.C. and the third century A.D. in the wide ranges of the steppes where Europe meets the East. "Just as the people of the Steppes contributed claws and talons to the definitive thrust of their convulsive ideograms, Picasso invented propeller-shaped nostrils, networks and swords, and knotted strips which are unknotted or confuted by the lines that surround them." The designs are abstract—but out of them emerge magic figurations.

In the *Cavalier with Pipe* (1970) the color is a hot-and-cold mix of orange, black, and blue. The figure, knocked together out of flat angular planes and scribble-scrabble hands and features, glowers out at us, a sword in one hand, while his pipe sends forth a stream of whitish, wrought-iron-curlicue smoke. He's demented, nasty, dumb. In other paintings, also black and blue and orange, this same soldier is a member of a family, shown with wife and child. And then there are other groups of paintings, often with their own

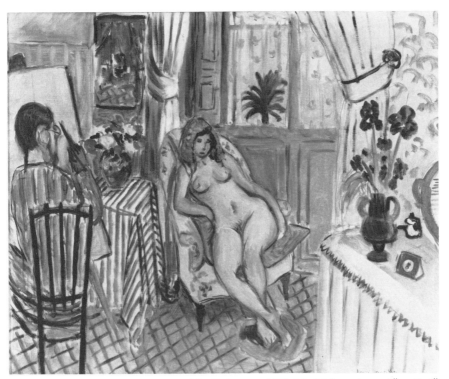

1. HENRI MATISSE, *The Painter and His Model* (1919), 23⅝″ × 28¾″

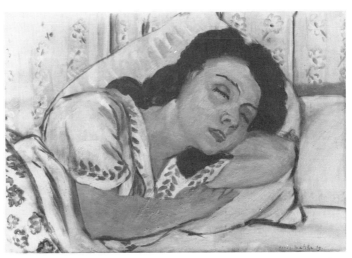

2. HENRI MATISSE, *Portrait of Marguerite Asleep*
(1920), 18⅛″ × 25⅝″

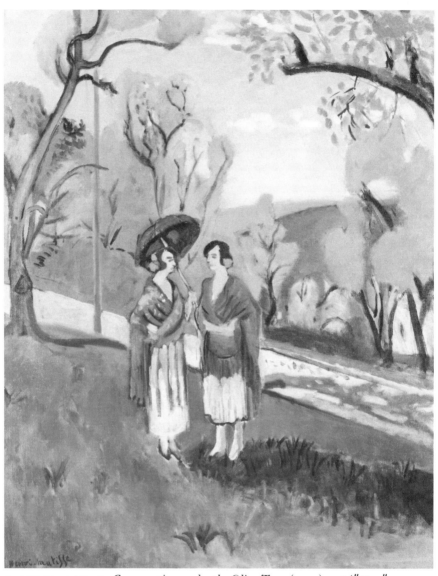

3. HENRI MATISSE, *Conversation under the Olive Trees* (1921), 39⅜″ × 33″

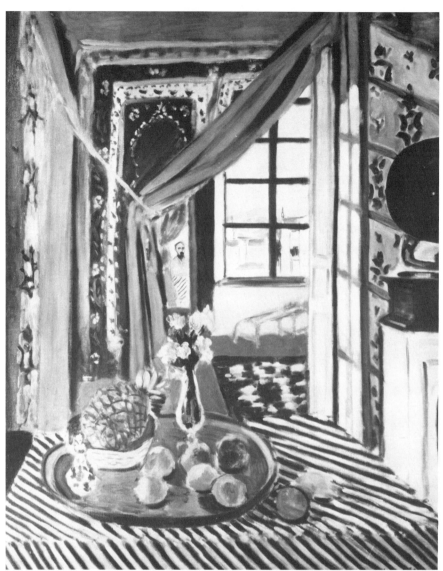

4. HENRI MATISSE, *Interior with Phonograph* (1924), $39\frac{5}{8}'' \times 31\frac{1}{2}''$

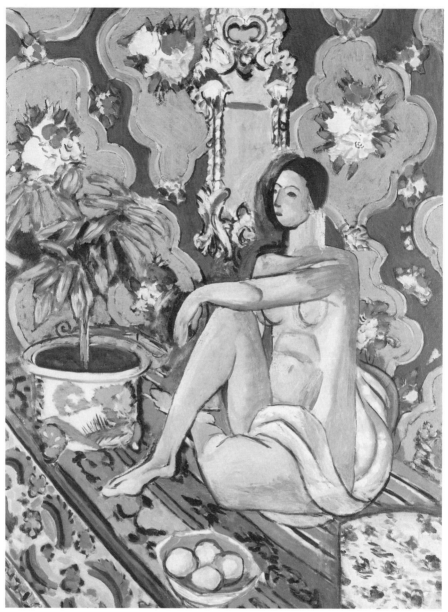

5. HENRI MATISSE, *Decorative Figure on an Ornamental Ground* (1925–1926), 51⅛″ × 38⅝″

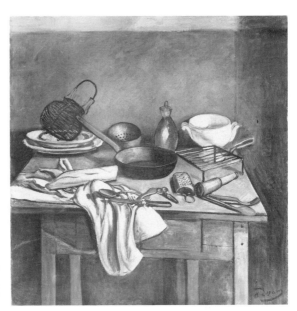

6. ANDRÉ DERAIN,
The Kitchen Table (1924),
47¼″ × 47¼″

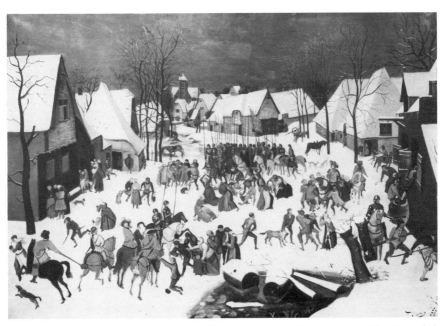

7. ANDRÉ DERAIN, *The Massacre of the Innocents, After Breughel*
(1945–1950), 38¼″ × 57⅞″

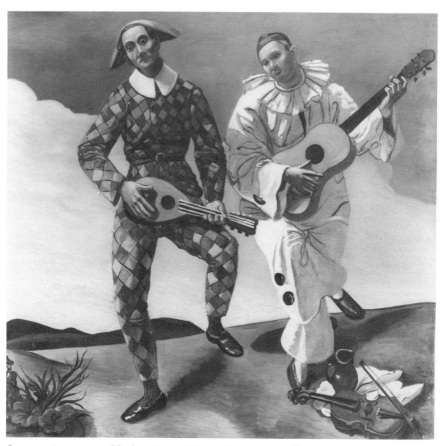

8. ANDRÉ DERAIN, *Harlequin and Pierrot* (1924), 69⁵⁄₁₆″ × 69⁵⁄₁₆″

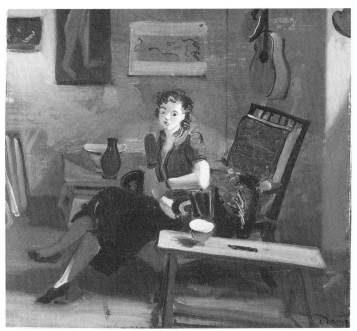

9. ANDRÉ DERAIN, *Portrait of Isabel Delmer* (1938), 18¼″ × 20⅛″

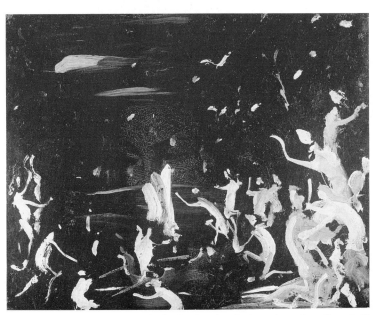

10. ANDRÉ DERAIN, *Embarkation for Cythera* (1945), 13″ × 16⅛″

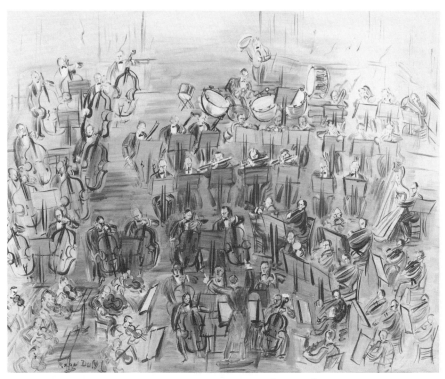

11. RAOUL DUFY, *The Gold Orchestra* (1942), 31⅞″ × 39⅜″

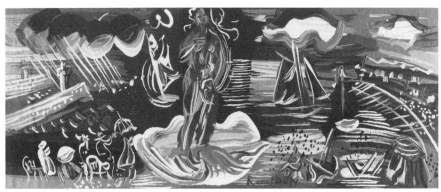

12. RAOUL DUFY, *Amphitrite* (1948), 46½″ × 109″

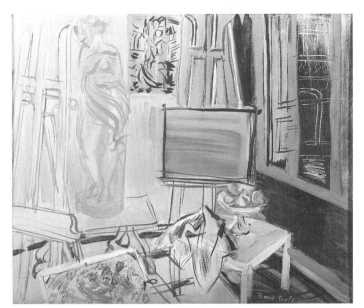

13. RAOUL DUFY, *Studio* (1942), 18⅛″ × 21⅝″

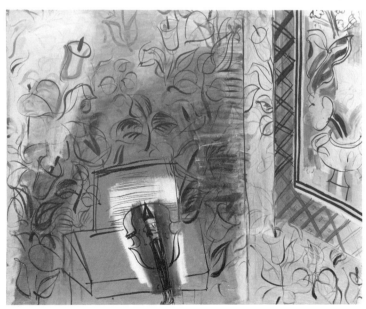

14. RAOUL DUFY, *Homage to Bach* (1952), 31¾″ × 39⅜″

15. RAOUL DUFY, *La Fée Électricité* detail (1937)

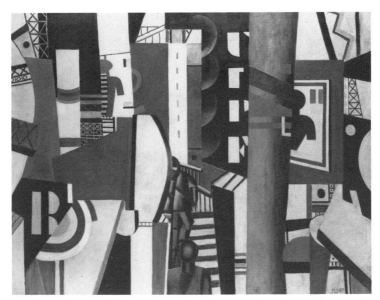

16. FERNAND LÉGER, *The City* (1919), 90¾″ × 117¼″

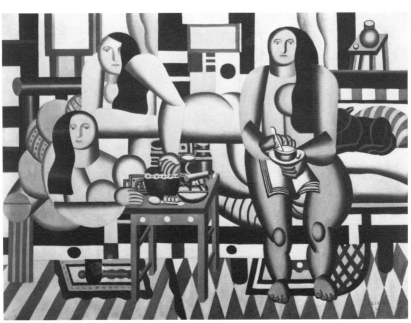

17. FERNAND LÉGER, *Le Grand Déjeuner* (1921), 72¼″ × 99″

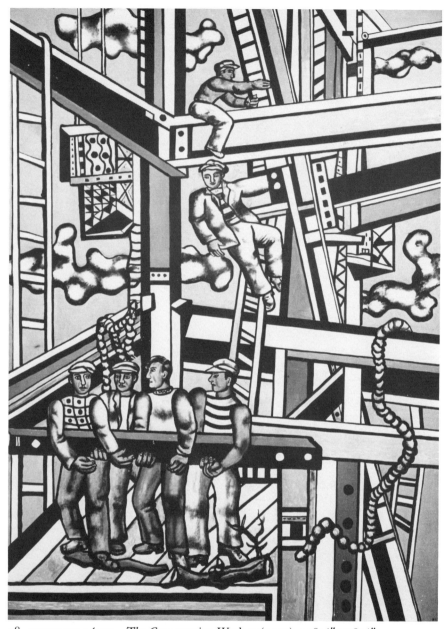

18. FERNAND LÉGER, *The Construction Workers* (1950), 118⅛" × 78⅝"

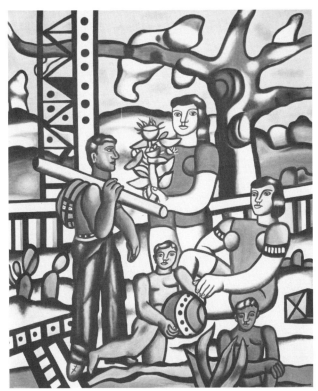

19. FERNAND LÉGER, *The Campers* (1954), 118⅛″×96½″

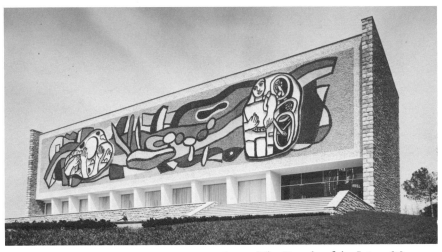

20. FERNAND LÉGER, The Facade of the Léger Museum
(executed posthumously, 1957–1960)

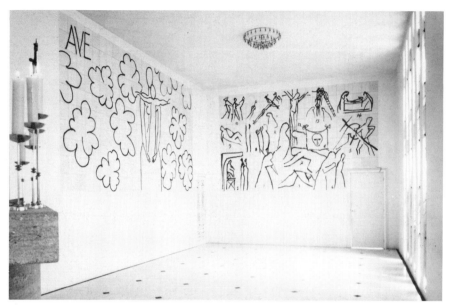

21. HENRI MATISSE, The Chapel of the Rosary (1951)

23a. PABLO PICASSO, *Bird Held by Two Hands*
(1950), 15¼″ × 17¾″ × 7″

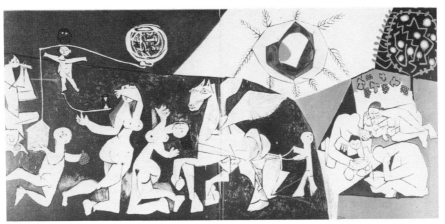

22. PABLO PICASSO, *Peace* (1952), 15′5″ × 33′7″

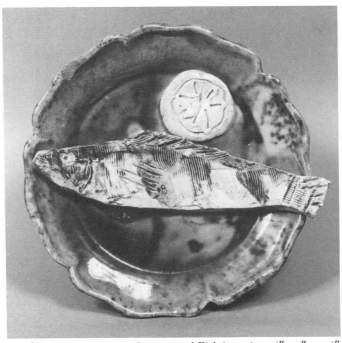

23b. PABLO PICASSO, *Lemon and Fish* (1953), 1¾″ × 9″ × 9½″

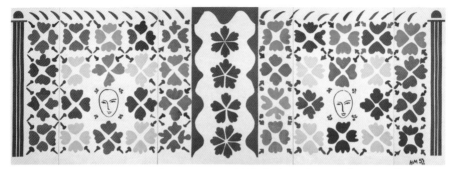

24. HENRI MATISSE, *Large Decoration with Masks* (1953), 139¾″ × 394¾″

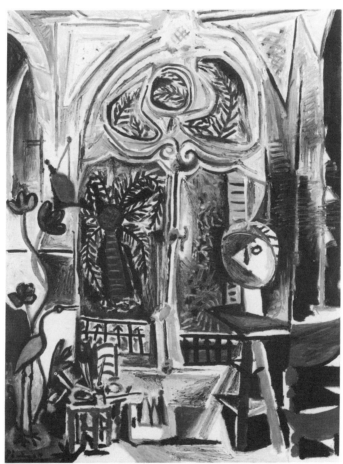

25. PABLO PICASSO, *The Studio* (1955), 28¾″ × 21⅝″

color combinations. There's a cycle of raucous, bright figures; and another cycle, more relaxed, even melancholy, painted in pale green-gray-tan-white colors. Most of the late paintings are of people, and the occasional landscape or spiky still life is especially interesting because it seems so rare, so much the exception to the rule.

The late Picassos are packed with references to Giotto, Titian, Rembrandt, Velazquez, Goya, Degas, van Gogh, as well as to Picasso's own earlier paintings, especially those of the Negro period and the period of Marie-Thérèse and Dora Maar. These late paintings comprise a Borgesian library of quotations. But Picasso isn't interested in plumbing the depths of Western art; he treats figures like the musketeers of Rembrandt as if they were little more than jocular cardboard puppets. Picasso's soldiers and lovers are the opposite of those of Velazquez and Rembrandt; they have no psychological subtlety, they're one-dimensional. Picasso is reaching for the muted emotions of certain summing-up works—of Poussin's *Four Seasons*, Titian's *Nymph and Shepherd*. He's trying to merge sadness and happiness, fear and ecstasy into a great late style. Picasso wants to take his place among the Masters; he identifies with the old Titian's and the old Rembrandt's unwillingness any longer to bother about the details. Picasso is just indicating things now; he's indicating things so abruptly that he sometimes seems to be carrying on like a graffiti artist. Picasso is too obsessed ever to slow down; he gives us the bare bones, the flashing outlines of ideas.

In the late cycle of kissing lovers Picasso proves that cartoonishness can be poetic. No one before Picasso had injected sex so directly into the high-art tradition. Rubens's *Garden of Love* reveals a ribaldry more commonly associated with genre painting; Picasso, an octogenarian in the Age of Porn, goes further and further. The erect penises and gaping vaginas of his lovers, both in the paintings and the etchings, are straight out of sex manuals and pornographic magazines. Picasso renders his thrusts, penetrations, and entanglements with a formal conviction we understand as sincerity. His compositions may derive from the trashy images of popular culture, but what interests him is the true feeling of which trash is sometimes an indirect, communal expression.

The late paintings, knocked off fast, cloning themselves in the studio in Picasso's final hyperkinetic fit of creativity, are a shorthand expressionism, an attempt to make fire out of a few sticks and a lot of friction. They're easily dampened by a bad setting; they seem to rise or fall on the way they're presented. Hung edge to edge against the worn stone walls of the Palais des Papes in Avignon in 1970, they formed Picasso's private cathedral. At the Pace Gallery's "Late Picasso" show in 1981 they were a hot wind blowing onto the chic of New York's Fifty-seventh Street. In "Picasso: The Last Years, 1963–1973" at the Guggenheim in 1984, they didn't quite come off. The Guggenheim's wide-open space was the worst place on earth for these products of an ancient villa with its thick-walled, foursquare rooms. Picasso's octogenarian machismo kept diffusing in the cool spiral of Frank Lloyd Wright's modern museum.

The 1971 *Mother and Child*, which hung at the very end of the Museum of Modern Art's 1980 retrospective, and is now in the Musée Picasso in Paris, is the late style at its very best. The child, looking out at us through big, scared eyes, sits in his mother's great, enfolding lap. The painting is a loose bundle of curves and arcs done in sea-green, underwater color. The faces—the masks—are Catalan, thirteenth century, an essence of all the Mother and Child figures that Picasso had known. Picasso isn't borrowing from the Romanesque; he's inhabiting the same creepy-naive world. Picasso's last figures, like the wall-scale images of the Middle Ages, are stylized in ways that make them feel otherworldly, remote. At the 1980 retrospective the *Mother and Child* appealed to spectators almost as powerfully as the Madonna and Child does on the tympanum of the Royal Portal at Chartres. This wasn't an image you walked up to and communed with; it was an image you stood back from, in stunned silence, along with the rest of the crowd. When I think of the *Mother and Child*, I think of the friends with whom I first saw it at the Museum of Modern Art. We were three zonked Picassomaniacs going through the museum on a warm May afternoon, and the panicked looks on the faces of that mother and that child seemed to summarize everything we'd seen in that great retrospective—the whole distorting-mirror

world that Picasso had invented over three-quarters of a century of nonstop work.

Malraux's superb description of the 1970 show at the Palais des Papes is as much about the experience of looking at Picasso with other people as it is about the work itself. Inside the Palais des Papes, Malraux hears "ageless cries and shouts, which echoed in from the courtyard, where the Théâtre National Populaire[,] rehearsing a Cretan tragedy, seemed to be acclaiming the Minotaur." He listens in on "some hippies discussing the *Couples*. They had understood the sense of rebellion that had motivated the paintings; they had also understood that it wasn't the same as their own. The hippies were dreaming of India, of Buddhism, and of early Christianity, communal and musical." And Malraux then goes on to record, at length, another conversation that he hears, between a group of young radicals. They're arguing heatedly: Is Picasso a revolutionary artist or a bourgeois entertainer? Can art have any relevance at all to revolutionary politics? Malraux, of course, had been completely out of sympathy with the students who closed down the schools and took to the streets in 1968, and his rendering of these conversations is rather ironic. But he's too much of a literary artist to engage in mere ridicule. If the radicals at the Palais des Papes have framed the questions wrong, it's because they don't know how large the stakes really are. For Malraux the hippies seem closer than the radicals to the truth. Malraux believes Picasso's tarots aren't a radical analysis of bourgeois experiences, but of experience, with a capital *E*.

In bringing into his portrait of Picasso's last works the hippies and radicals and mystical and political ideas of the late sixties, Malraux shatters the old-masterish glaze some want to superimpose on the paintings. Malraux's description of the Palais des Papes set me to thinking about the time in which these paintings were made: the late sixties and early seventies. These were the years of be-ins, Aquarian Age lunches on the grass. In dance halls and discos people moved wildly to a new, free-form kind of pop music. Godard made *Weekend*, his vision of hell on a modern freeway, and the Living Theater came to the United States with *Paradise Now*. In colleges, students were

introduced to classical literature through Euripides' *Bacchae*, in which bacchic madness triumphs, finally, over Apollonian reason. The titles of books popular at the time—*Love's Body*, *Madness and Civilization*—recall an effort, not necessarily to deny civilization, but to understand a life of the mind and the body for which culture couldn't always account.

It had been almost three-quarters of a century earlier that Picasso had painted *Les Demoiselles d'Avignon*, the great voodoo-witchcraft painting that began the biggest smashup in the history of Western art. For Picasso, the conflict between the Apollonian and the Dionysian, roughly framed in terms of the classical and the primitive, had been with him almost from the start. Picasso didn't need anyone to show him which way madness lay. Though the sanest of men, he'd found new ways to introduce the unconscious into the conscious world of art. For the Surrealists and so many others, he'd led the way. In the sixties the pictorial arts seemed unable to cope with the fissures that many sensed in culture; Picasso's late work may bridge the gap. The slightly dazed, van Gogh-ish young woman in a hat that Picasso painted in July 1971 is pure Picasso, but she might also be a figure sitting on the grass at a be-in in San Francisco's Golden Gate Park in the late sixties. And Picasso's frenetic lovers of 1969 are related to the hippies who were dancing in the mud as the sun came out after the first night of rain at the famous Woodstock Festival (also 1969). In the fifties Picasso looked like an old hedonist fading away into the glare of the Mediterranean sun. The work of the last few years of his life reveals a very different man: the wisest bacchant of them all.

GIACOMETTI

◪

Paris without End

In 1954 Alberto Giacometti was commissioned by the French government to design a medallion to honor Henri Matisse, and he traveled down to Nice to make a series of studies of the old man. Giacometti's drawings, with their network of lines, often have a way of making people look aged beyond their years, and these sketches, which were done a few months before Matisse's death, show a very different figure from the one we know in the photographs of the late forties and early fifties. All the vividness is gone. Matisse, reclining amid the pillows of his bed, seems more than halfway to death.

In his recent biography of Giacometti, the American writer James Lord describes the visit—actually there were two, separated by a couple of months—and how Giacometti and Matisse "talked little." "One day, though, when conversation came to the subject of drawing, Matisse suddenly grew more animated than Alberto had ever seen him and exclaimed, 'Nobody knows how to draw!' After a silence, turning to Giacometti, he added, 'You don't know, either. You'll never know how to draw.' It was a judgement," Lord observes, "in which the younger man wholeheartedly

concurred." One feels a bit bad for Giacometti, a great draftsman being chided by one of the greatest who ever lived, and yet what else could be expected from Matisse, after having acknowledged the mastery of the younger man so far as to submit to his pencil? In Giacometti's drawings of Matisse the Paris of the present is saluting the Paris of the past—and it's an old-fashioned salute. Giacometti's pencil scratches away on the paper as if the instantaneous magic of the camera had never been invented.

To have Matisse as a model was a great opportunity that Giacometti had made for himself by pursuing the art of portraiture with a ferocious concentration for many years. Giacometti will always be revered as the artist who painted and sculpted men and women in isolation; he made of fragmentation a convincing poetic subject. And yet his figures and portraits are the fruits of an intimate involvement with other people, of thousands of appointments in the studio, in the café. The drawings of Matisse and Stravinsky and so many others celebrate the artist as society's eye; and the splendid sketches Giacometti did on napkins in cafés attest to an easy conviviality—no other modern artist was so open about his art. The painter Mercedes Matter, a friend of Giacometti's in his later years, has observed that "even when he had not put pen to paper, as he looked across the room or spoke with friends, he was going through the motions of drawing with his forefinger against his thumbnail."

After World War II, Giacometti's studio became a sort of sanctuary to which many authors came, notebook in hand. The artist's work, seen in quantity, could become the raw material for provocative contemporary meditations. Genet wrote a book, *The Studio of Alberto Giacometti*, an amalgam of description and conversation. "This afternoon we're in the studio. I notice two canvases—two heads—of an extraordinary intensity, they seem to be walking, coming to meet me, never stopping this progress towards me. . . ." Sartre's 1954 essay on Giacometti keeps bringing us back to the aloneness of the artist; but the essay is as much about Giacometti's desire to make contact with other people. Sartre relates how "A friend once moved in with [Giacometti]. Pleased at first, Giacometti soon found his presence disturbing. 'One morning I opened my eyes, and there were his trousers and jacket *in my vacuum.*'"

Among Giacometti's admirers there is much dispute about the relation between the Surrealist sculpture of the early 1930s and the representational work Giacometti did after World War II. Some see the Surrealist period as the high point of his career; others regard it as a preliminary stage. It's as if viewers take their stand either in the thirties or in the fifties, and look forward or backward to the great divide, which is Giacometti's return to representation in the forties. This divide in Giacometti's work is very much the product of a personal odyssey; but there's really no way to separate that odyssey from Giacometti's public life, or from the fact that he was the one artist who made himself at home among both the Surrealists of the pre-war years and the Existentialists of the post-war years. Picasso managed to remain at the center of intellectual developments in Paris from 1910 to 1945; Giacometti did the same from 1930 to 1965. These two artists who came to Paris when they were young had the outsider's insatiable curiosity about the city. They studied Paris as if it were a text, and their art catches many shifts in urban style and urban thought.

Giacometti is very much a product of the Parisian art world of the late twenties and early thirties, when Picasso and Braque were familiar faces, and some of the great figures of early abstraction were living there as exiles. The old School of Paris, of what the dealer and friend of the Cubists Daniel Henry Kahnweiler called "lyrical art," of "an Eden from which unhappiness and death were banished"—this was already long gone. It was still to Paris that the whole world came to learn the pleasures of pure color and the hedonism of surfaces and textures and forms—Giacometti had come from Switzerland in 1922 at the age of twenty; but the days, if there had ever been such days, of pure invention, were now layered with the cloudbursts of ideas that had come in the wake of Fauvism and Cubism and nourished Delaunay, Mondrian, Kandinsky, Klee. Paris had a very fertile soil, one in which the strange seeds of dispute and polemic grew as if in some ferocious yet fantastic tropical landscape. And Giacometti, who was "discovered" by Masson and taken up by Breton in 1929, is one of the most impressive of all the hybrids that leapt into life back then.

Surrealism, the sign under which Giacometti arrived at his first maturity, was a reaction against the public Paris of the late nineteenth and early twen-

tieth centuries—the Paris of the bourgeoisie who passed their lives half-buried in the bric-a-brac of capitalist culture. Like romanticism a century before, Surrealism began as a literary movement that gave expression to all the pent-up emotions that the characteristically moderate spirit of French art was unable to acknowledge. Giacometti's Surrealist sculptures are conceits, and like some of the episodes in Buñuel's movie *Un Chien Andalou* (1929), they cut so close to our shared fantasies and fears as to achieve the status of icons. Giacometti is one of the most elegant of the Surrealists; like Miró, he creates a mysterious art that's without cobwebs or congestion. Giacometti invents peculiar cages, but they aren't labyrinthine or maze-like. His greatest Surrealist work, *The Palace at 4 A.M.*, has a clarity that recalls Florentine art at the beginning of the fifteenth century. In Giacometti's Surrealist period, lasting about half a decade, one sees the artist zeroing in on the obsessional side of his personality—the side that gave a disconcerting intensity to everything else he ever did. But the Surrealist work may ultimately be too neatly finished. It rarely draws you in. A Surrealist Giacometti is a fait accompli.

A remarkable memento of the Parisian community of artists in the years before World War II is a collection of essays published in 1935 by Editions G. Brobitz et Cie, and illustrated with etchings by, among others, Arp, Calder, De Chirico, Ernst, Giacometti, Gonzalez, Hélion, Kandinsky, Léger, Lipchitz, Magnelli, Miró, Nicholson, Ozenfant, Picasso, Seligmann, Taeuber-Arp, Torrès-Garcia, and Zadkine. This list of names suggests a loose-knit but very strong network of passions, affinities, ideas. Giacometti's lovely print—in which a triangle, a circle, and a little constellation of folded planes are set into a perspective space made of a scant seven lines—is an idealist's dream troubled only by some vague memory of De Chirico. It's a small study of great sophistication, and demonstrates the artist's natural elegance, as well as a rather deep grasp of the important issues of the day.

Not long after completing the print for Brobitz's collection, Giacometti was to begin his return to representation. This intriguing decade-plus adventure, which culminated in 1948 with the first exhibit of the new figurative work at the Pierre Matisse Gallery in New York, must have required considerable courage of an artist who was already well known and even

fashionable as a Surrealist. (Breton expelled Giacometti from the movement in December 1934 when the artist resumed working from the live model.) Of course one can find hints of Giacometti's mature manner in the products of his Cézannesque youth; but there are also hints of disaffection with Surrealism to be found right in the midst of the Surrealist period. In 1932 Giacometti made two highly detailed drawings of his studio in a neoclassical outline style derived from Ingres and the Ingresque manner of Picasso. When you first glance at Giacometti's sheets, the artist's crowded studio looks like something out of the early nineteenth century, an old atelier in Rome—the farthest thing possible from Breton's Left Bank world. But look again, and you realize that this nineteenth-century fantasy is furnished with the avant-gardist's caged enigmas, his Cycladic abstractions, and, in the center of the room, his *Palace at 4 A.M.* The neoclassical past meets the Surrealist present; the future will contain elements of both.

In the catalogue of a 1986 exhibition, "Alberto Giacometti, retour à la figuration, 1933–1947" (organized by the Musée Rath in Geneva and the Pompidou Center in Paris) the background for Giacometti's change of style—a background of wartime and exile in Geneva—is most movingly described. The tiny hotel room in which Giacometti lived in Geneva, and the life of the small city, with its group of intellectual refugees gathered around the publisher Albert Skira, begins to seem the perfect microcosm in which to reinvent Parisian art. Jean Starobinski, a friend of Giacometti's in the forties, recalls in one of the catalogue essays these Geneva years:

The times. Between 1943 and 1945. The end of the afternoon, the long evening. Especially after [the poet] Jouve's return to Paris. Before, I had been expected almost every evening, on the rue du Cloitre, by Blanche and Pierre Jean Jouve. Often, Balthus had been one of their little group. Not Giacometti, too independent, and considered besides a Surrealist, which was unacceptable to Jouve. For the same reason, Jouve and Skira didn't have any contact. And Jouve demanded that his faithful share his loves and hates. But Balthus and Giacometti, linked by a very real sympathy, saw each other, argued at length (I remember an impassioned conversation about Konrad Witz and Grünewald . . . at Skira's house). . . . Geneva having become a little capital, it had its intellectual and artistic geography, with capricious interior

frontiers. Geneva a capital? My single story will furnish the proof. A Frenchwoman, spotting Alberto Giacometti on a café terrace, rushed over to him. "Jean! You here?" She had taken him for Jean Cocteau (because of the vague similarity of their hair). The denials of Alberto wouldn't convince her otherwise. She didn't hide her disappointment, convinced that her friend Cocteau didn't want to recognize her. Alberto, for his part, didn't want to bear the blame for someone else. (The woman expected to meet *le tout–Paris* in Geneva. She wasn't totally wrong.)

A number of the contributors to the "Retour à la figuration" catalogue observe that two of the most important early representational paintings, of Giacometti's mother and of a sideboard with a single apple, were done when the artist was staying at the family home in Stampa in 1937. There is a suggestion that the return to representation was also a return to roots, as if the artist had to go back into the womb before he could be reborn. And perhaps in this case the Freudian interpretation has some validity. In the forties the figure sculptures became smaller and smaller—embryonic, really—some so tiny they could be stored away in matchboxes.

Back in Paris in 1945, Giacometti was sure of his direction, and found an audience that was weary of Surrealism and ready for a new view of Man. The friendship with Balthus, whose work had never been abstract or overtly Surrealist, continued. In a photograph taken by Alexander Liberman in a Parisian bistro in the early fifties they're two giggly young men standing at a table with a third man, the enormous, much older André Derain, who looks rather like one's image of Simenon's Inspector Maigret, and has, despite his formal stance, a bit of a smile moving across his face. In the postwar years Giacometti and Balthus were among the very few who remained loyal to Derain, now out of fashion and branded a collaborator by Picasso. After Derain died in 1954, Giacometti recalled how in 1937 (only four years after completing *The Palace at 4 A.M.*) he'd looked into a gallery window and seen a painting by Derain of "three pears on a table silhouetted against a vast black background." Giacometti said that this Derain painting "arrested my attention and impressed me in a completely new way. . . . Derain excites me

more, has given me more and taught me more than any painter since Cézanne; to me he is the most audacious of them all."

Giacometti's is one of the most eccentric of great modern achievements. His odd tableaux, from the *Palace at 4 A.M.* to the *City Square*; his sculpted figures, with their belabored distortions and fragmentary limbs; his paintings left half-painted or containing in the center a tiny head surrounded by wide margins of washy gray space—all these have about them a self-consciousness, an almost adolescent cultivation of angst and sentimentality. Giacometti is all too willing to show us the agony of creation, the point where clarity breaks down and confusion reigns. But his self-pitying, expressionist side is kept in check by the force of a will that measures itself against the standards of tradition—and of the most recent developments of tradition, which are to be found in modern Parisian art.

The origins of Giacometti's later style are located somewhere between the Surrealists' famous excursions through the flea markets (Giacometti had gone with Breton), and an earlier generation's equally epoch-making confrontations with the old masters and ancients in the Louvre. Like the Surrealists, Giacometti expected to make marvelous discoveries in the most ordinary places. And with Derain, he saw the past of European art as glorious, and our distance from it as the occasion for melancholy reflections. Giacometti's art and Giacometti's life are full of perplexities and struggles. The work can never be completed, and yet the artist carries on, just as everyone carries on in life, feeling at once very much alone and very much a part of things.

Giacometti's adventuresome intelligence is captured for all time in the pages of James Lord's *A Giacometti Portrait*, the slim book that was brought out by the Museum of Modern Art at the time of the 1965 retrospective, and has become a well-thumbed treasure for many artists. This account of the sessions the American writer spent with the artist while Giacometti was painting Lord's portrait in 1964 gives one a sense of the brilliant flashes of the artist's conversation in the later decades of his life. In the book Giacometti is silent for a long time, and then all of a sudden maniacally talkative. When

he speaks it's in great volleys of sophisticated prose. Giacometti is art-obsessed in the quirky, self-involved, ironic way that many true artists seem to be. This is from Lord's account of the fifth of the eighteen painting sessions he describes in his book.

> When [Giacometti] had painted for an hour or more, we rested for a while. That is, I stretched my legs, while he immediately started working again on one of his sculptures.
> "My taste gets worse every day," he said. "I've been looking at a book in which paintings are reproduced next to photographs. There was a portrait by Fouquet next to a photo of a real person, and I preferred the photo by far. Yet I like Fouquet very much."

Giacometti is always turning everything around in his mind. He seems almost to want to shock himself, to challenge himself by saying, "A photograph is better than a great painting," and then seeing how he feels about the statement. Giacometti is tearing up his own taste and reconstructing it, just as he's tearing up paintings and sculptures and reconstructing them.

A Giacometti Portrait is a book that no one seems to dislike, and perhaps this is part of what has made the controversy over James Lord's full-scale biography of Giacometti, published in 1985, such a great surprise. Almost all those who were left of the old Surrealist and Existentialist circles were up in arms over it; a letter of protest signed by Simone de Beauvoir, Jean Hélion, Michel Leiris, and many others was published as an advertisement in the *New York Review of Books*. Lord, according to many of Giacometti's old friends, had missed the spirit of the artist and given a distorted picture of his wife, Annette. Certainly in the first half of the biography, which covers the pre–World War II years, Lord considers Giacometti too much in isolation from the large movements of Parisian art; he gives a disturbingly emptied-out picture of Paris's legendary days. Lord's *Giacometti* isn't a book that will show you where the light, Mozartean elegance of much of Giacometti's finest art has its origin. Mercedes Matter brings us closer to this aspect of the artist in her introduction to the luxurious 1987 volume of photographs of Giacometti's sculpture by her husband, the late Herbert Matter. "There was still about Giacometti, along with the Parisian sophisticate, a residue of his Swiss

mountain background, the Alberto of Stampa—something untouched, almost quaint, something extremely courteous, gentle, endearing." Still, the second half of James Lord's biography, in which the author can draw on his personal acquaintance with the artist since the fifties, makes quite an impression. Giacometti's old friends may be angry that Lord has hung all the soiled linen out in public; but there is a point to Lord's Boswellish pages—they give us a portrait of the artist as caught in the exhausting, hyperkinetic rhythms of urban life. Like Henri in Simone de Beauvoir's *The Mandarins* (which covers some of the same postwar Parisian terrain), Giacometti reels from all-night bouts of work to cafés and arguments and love affairs.

Giacometti got up at one or two in the afternoon. "After washing, shaving, and dressing, he would walk to the café at the corner of the rue d'Alésia and the rue Didot, five minutes away, drink several cups of coffee, and smoke six or eight cigarettes." Back in the studio, he worked until six or seven. Then he went over to the café again, "for a couple of hard-boiled eggs, a slice of cold ham with bread, a couple of glasses of wine, several more cups of coffee, and a lot of cigarettes." He worked in the studio through the evening, after which there were the midnight rambles among the bars and cafés of Montparnasse, where he liked to pass the time drinking with prostitutes. Returning to the studio before dawn, he worked until daylight, slept for six or seven hours, and got "out of bed, usually still tired from the work of the previous night." This, along with the outdoor plumbing and rundown rooms of the studio where he lived and worked for decades on the rue Hippolyte-Maindron was the setting for a life that got stranger and stranger as the years went by.

In the beginning there had been the two brothers, Alberto and his trusty sidekick, Diego, who made the armatures, did the casting, and generally kept things going around the studio. After World War II came the addition of Annette, whom Giacometti had met in Geneva, and with whom he was locked in a difficult, stormy alliance. If Lord can be believed, Giacometti gloried in the mess of relations—the wife who hated his way of life, and then his impotence, and his friendships with prostitutes. And he complicated it all by pushing the Japanese philosopher Isaku Yanaihara, who had become one

of his prime models, into an affair with Annette (Yanaihara signed the letter of protest); and then by bringing in Caroline, the prostitute he called "La Grisaille" and painted and sculpted over and over again. Caroline was a remarkable person who engaged Giacometti for many reasons, not the least of which was her lawless way of life. Giacometti got her out of jail once, gave her considerable sums of money, and was finally allowing her pimps to extort money from him almost at will.

> One day, when a young artist had come to call on Alberto, suddenly the studio door flew open and Caroline came in. Behind her were two nasty-looking men, who stood together scowling in the doorway. "I need money," she said. "Give me all you have."
> Giacometti had to dig about in his hiding places to fetch the bundles of bank notes he had on hand, while the caricatures in the doorway glowered and the young artist was unable either to leave or to pretend not to notice. Caroline surveyed the scene with composure, giving no sign of embarrassment.

Lord's attitude toward all this is rather peculiar. He says that "Though Alberto endeavored to be equitable, the pith of his ethics lay in what he made as well as in what he did, and the making required a manner of being in which the maker had no choice but to do or die." Lord may be overawed by the artist; he may be too eager to transform every eccentricity into an example of goodness. He may want to make Giacometti into a sinner so he can then exonerate him, turn him into a saint. Still, after all the years he has spent in Paris, James Lord understands that some of the richness of Parisian art comes from the artist's obsessive pursuit of experience—of all kinds of experience. Giacometti is fascinated by Caroline and her sleazy underworld because for him this chaotic bohemia of postwar Paris is an extraordinary subject as well as an ordinary way of life.

Giacometti's struggles with his little lines, and his little bits of plaster—adding and subtracting in a never-ending attempt to articulate a sense of the space between the artist and the subject and between the subject and its environment—these tend to be seen as struggles carried on in private. Yet Gia-

cometti's back-to-basics attitude is also very much in tune with the art scene of the fifties. What Giacometti did is related to Bernard Buffet's first Parisian cityscapes, with their intaglio-sharp black lines and cool planes of gray and blue and green; to the scratched and scraped forms of *l'art informel* and Jean Dubuffet; and to the broken modelled surfaces of the sculptors Germaine Richier (who worked in the studio of Bourdelle, where Giacometti had also studied) and George Spaventa (an American who studied with Zadkine in Paris). Of course Giacometti goes further than the others. He has such a clear methodology. He knows how to keep postwar angst under control. Giacometti's idea is to work from nature at the same time that he looks to older art for structures through which to organize what he sees with his eyes. And this double perspective spells a return to the practices of some of the greatest masters of the nineteenth century. This was the method of Delacroix, who studied the colors of the objects around him but then structured his pictures à la Rubens; of Cézanne, who fused Poussin with nature; and of Seurat, who adapted Piero della Francesca's sense of design. For Giacometti, art is an inconclusive struggle between the past and the present, between his love for the impersonal power of Egyptian and Assyrian art, and the yoke of personal style that weighs him down no matter which way he turns.

Giacometti uses the rigidity of the Egyptian style, born of a hierarchical society where a man's fate was fixed at the moment of his birth, as a metaphor for the very different trap of the twentieth-century man. Giacometti's Parisians can no longer claim the freedom of movement that naturalism had invented to express the optimism of the rising classes during four centuries of European life. The *Figure between Two Houses*, in the striding pose of an Egyptian princess, can move in only one direction, in a world where depth doesn't exist. This Egyptian manner could have been affected, too much a backward glance, except that Giacometti uses nature to release and reinvigorate the old forms, to refill them with expressive possibilities.

The lumpiness of the sculpted surfaces tells us what Giacometti has been through; the surfaces have been worn down by the passage of time. When Giacometti's sculptures don't succeed, it's because there's too much confusion in the working-out of the bodies, too much ambivalence left in. The

greatest sculptures, such as the *Walking Man* of 1960, are simple, direct. Here the realization of the forms is clarity itself, as in the back, where the spine, running so resolutely downward and so deep inward, brings to life the whole bundle of coursing nerves.

In the sculpture, direct observation from nature ignites the archaic configurations; the idols turn out to be modern men and women as well. In the most personal and immediate and moving of the painted portraits the process is reversed, and the memory traces of those rigid, unempathetic heads of Gudeas and pharaohs and Romanesque madonnas hold the bursting sentiment in check. Certain of the heads of Annette, especially, reach a purity of human feeling that's present only very rarely in twentieth-century art. Tradition organizes sensation. The rigorous painting process clears away everything extraneous. The strokes of paint become thinner and thinner, glance around the features as in a Watteau. In a couple of dozen portraits Giacometti finds his way into the rarified atmosphere of the late heads of Cézanne and Rembrandt. And you can't go further than that.

The typical Giacometti image is a figure under stress. These men and women stand razor-straight; or, when they're seated, their backs are rigidly upright, their hands folded in their laps. Giacometti's figures are flattened out by the pressure of their coming-into-being; yet the expressionist intensity of their personalities is the fulcrum, the nearly still center of a world with many delightful, odd trajectories. Giacometti isn't unconscious of or uninterested in the picturesque. Though his cityscapes and landscapes are relatively rare, they excite us with a happy sense of his having overcome obsession and burst beyond his foursquare rooms toward deeper perspectives, a more various sense of the world. The streetscapes are passionate and rapt and alive. The drawing that supports these painted vistas—the lines running this way and that—reflect the amorousness of a roving eye.

Toward the end of his life, when Giacometti turned to lithography (and a process by which a drawing done on paper could be transferred to a lithographic stone) he was letting loose with drawing, catching everything in his net of lines. When he called his collection of a hundred and fifty lithographs of Paris *Paris sans fin*, it was no doubt to suggest the marvelous variety of ur-

ban experience. In this beautiful deluxe edition Giacometti escapes from the studio into the endless possibilities that meet the walker through the city.

Giacometti's decision to do a limited edition book was a way of paying his respects to the tradition of the deluxe edition that had at one time or another occupied every Parisian artist of the century. Since Vollard had set out his grandiose, impossible projects with Picasso, Rouault, and others—projects that often took decades and sometimes didn't reach fruition—the elegant illustrated book or album had been a hallmark of the artist's cultivation, his familiarity with the worlds of literature and ideas. Special watermarked paper, old typefaces, consultations with printers and binders—how much time was spent on these! There were certain oddities: Picasso's *Buffon*, for which he never read the eighteenth-century naturalist; Matisse's illustrations for Joyce's *Ulysses*, based on episodes in Homer's *Odyssey*. But how many triumphs came out of it all: Matisse's *Love Letters of a Portuguese Nun*, with its soft, blossoming lithographs; Dufy's *La Belle Enfant*, its etchings of French life spilling across the pages and around the blocks of text; de Segonzac's lovely plates for Virgil's *Georgics*—so much better than his paintings; Derain's Rabelais, in the manner of a medieval woodblock book, with colors intentionally misregistered over the designs. It was characteristic of Giacometti that he would have wanted to be involved in this tradition; also that in its modesty of scale and in the simplicity of its black and white lithographs, his *Paris sans fin* should have offered a kind of a reproach to the glamour of so many of the *livres d'artiste*. *Paris sans fin* is one of the most extraordinary things Giacometti ever did, and one of the most satisfying of all the books done by twentieth-century artists. Like Matisse's *Jazz*, it isn't, strictly speaking, an illustrated book. There's no text that has occasioned it; it's more of an album. Giacometti had been working, at the time of his death, on a short text to accompany the full-page lithographs; but this is a kind of lyrical-enigmatic gloss on the illustrations, which, with their depictions of the artist's daily peregrinations, are really self-explanatory.

In *Paris sans fin* interior and exterior views, closeups and deep perspectives are grouped and juxtaposed on successive pages to create a cinematic effect. The odd croppings and tilting forms sometimes recall the style of Eu-

ropean photography, especially in Germany, in the thirties and forties; but the casual immediacy of the individual views also makes a connection to the methods and sensibilities of Manet, Monet, and Degas. The Impressionist idea of catching an ordinary moment *sur le vif* had never really recovered from the tightening-up of the surface in Cézanne and the other post-Impressionists. But somehow, at the end of Giacometti's life, after the years in the studio cursing at the model and tearing the sculptures apart and putting them up again, this great artist found a way to get back to the spontaneity that Impressionism had revered. Now, however, the medium isn't color patches but monochromatic angles and lines and overlapping forms.

Giacometti's lithographs were executed as drawings on the spot. The artist doesn't invent anything. He has, apparently, no overriding idea (as in one-point perspective), no method of working the figures up from bones and muscles. It's all taken in through the eye. But there is, after the years in the studio, an unprecedented synthesizing intelligence, a genius that finds the underlying rhythm that connects the buildings and the parked cars in the street, or the figures and the chairs and the zinc counters in the café.

The book begins, in the frontispiece, with a plunging nude woman, drawn in a staccato, calligraphic manner that only reappears in the last fifteen or so plates (which depict nudes again, as well as walking figures made of looping lines). In between there's the round of apartments, studio, printshop, streets, museum, laden tables, heaps of books, bridges over the Seine. A bunch of pages will focus on an interior, or a vista, or a face. Caroline in the café; Annette at home, nude. Tying it all together is the regular pattern of Giacometti's days—the back and forth from café to studio and studio to café that one knows of from James Lord's biography.

The café scenes are among the high points of the art of this century: pile-ups of tables, figures, plate-glass windows, beyond which are streets with parked cars. There's no perspective to speak of; few diagonals run through the space; just a delicate counterpoint of bits—the sign of the Café Sélect, a man's back, a curving bar, some chairs. The subjects are anecdotal, picturesque—the comfortable friendships and familiar faces of the local place, returned to over and over again. But the emotion, without ever losing sight of

the amusing anecdote, is rather cool. The only precedent is Watteau's *Shop-sign*, and like the *Shopsign*, *Paris sans fin* is a last testament that takes as its subject the experiences that are closest to home. *Paris sans fin* hints at Giacometti's profound longing for the normative—for good friendships, passionate attachments, the common geography of life. The artist's manic side is related to his desire to take it all in. The setting—full of manners, precedents, implications—is Paris. "An astonishing welter of activities, of mechanisms, and thoughts," Balzac called it, "the town of a hundred thousand romances, the head of the world."

HÉLION

◪

The Last Judgment of Things

Jean Hélion is the only artist since Léger who has made poetry out of that most shadowy of presences in modern art, the common man. This artist who was born in Normandy in 1904 and died in Paris in 1987 invented types who are much more than the statistics of social realism; characteristic types, with the mysterious aura of Le Nain's peasants and the housekeepers of Chardin. Hélion and Léger, born a generation apart, are connected by friendship, by Hélion's many borrowings from the older artist, and above all else by the liberality of spirit with which they've approached the bewildering spectacle of Modern Times. In his passionate curiosity about the look and feel of a man-made world, Hélion also recalls such seventeenth-century Dutchmen as Jan Steen and Gerard Ter Borch. Indeed, Hélion ultimately goes much further than Léger in the direction of naturalistic representation—and I sometimes wonder if Léger's rumpled workmen of the beginning of the fifties weren't inspired at least in part by the equally rumpled men that Hélion had started painting a little earlier.

Everything in Hélion comes in quantity: cycles of paintings, accompa-

nied, ever since his first brilliant abstractions of the thirties, by an outpouring of preparatory drawings. After World War II, when he became fully himself, there were the series of female nudes—almost Courbetesque, with their weary, beautiful flesh; of men reading newspapers on park benches—the papers unfurled like floating banners; and of bedraggled poets reclining in the gutter before mannequin-filled shop windows. The forms are bold, simply modelled, and there are often clear, heavy outlines running all around the shapes. With Hélion it's the artist's feeling for pure form—for the punch of a red or a blue, for the twisting route of a black contour—that propels so many anonymous figures into throbbing life.

Hélion himself came through the packed decades as one of the wisest and most generous-hearted of all the adventurers of modern art. Even as I write these pages, the testimonies of his gift for friendship and of his infectious enthusiasm multiply at every turn. The catalogue of a recent exhibit at the Albemarle Gallery in London contains an open letter to Hélion from Myfanwy (Evans) Piper, a figure in the English avant-garde. She recalls how more than fifty years ago she'd first come to Hélion's studio in Paris. "It was August: the life of the city was suspended in heat and emptiness, everyone had gone away except you and other artists who couldn't afford to—Mondrian, Brancusi, Kandinsky, Domela, Giacometti among them, all of whom I subsequently, through your introduction, visited." She continues: "Jean—your eloquence and sparkle both in French and in English (luckily for me) left me spellbound. So we got on. I remember staying, that first day, an unconscionable time . . . and walking back through the unfamiliar dark streets in a state of high exhilaration."

As it happened, the catalogue containing this letter was brought to me from Paris by a painter friend who'd just, on her first trip to Paris, visited Hélion. (She must have been among his last American visitors.) And my friend's story of her visit with Hélion and his wife Jacqueline seemed to have an open-sesame dimension much like that of Myfanwy Piper's visit all those years ago. Of course Hélion could no longer offer a young artist introductions to that list of artists—he'd outlived them all; but the shining enthusiasm that put everything in the realm of the possible, this was present to the

very end, in the blue eyes, the rapid speech, the art-filled atelier. My friend described the call to Hélion's apartment, and Jacqueline answering, "Come over today at five." Then the apartment building near the Luxembourg Gardens; the uncertain climb up the odd little flight of stairs to the penthouse; then the terrace with its magnificent gray and white and coffee-colored vista of Parisian rooftops. And one's immediate exclamation, "But that's the roofscape Hélion has painted!" The beautiful rooms with their oddly sloping ceilings. The exclamation over a white tureen on a sideboard that one knows from the paintings, and this starting off the presentation by Hélion and his wife of a parade of paintings, a cascade of half a century's work. My friend's answering, "Brooklyn," to Hélion's question, "Where do you live?" elicits the story of Mondrian's funeral in a Brooklyn cemetery. And on and on. And after a few hours and the good-byes, my friend is, like Myfanwy Piper all those years ago, "walking back through the unfamiliar dark streets in a state of high exhilaration."

Jean Hélion himself came to Paris to apprentice to an architect in 1921, when he was seventeen. Six years later he met the great Uruguayan painter Joaquin Torrès-Garcia, whose work made a personal synthesis of neoplasticism and folk art motifs. It was through Torrès-Garcia that Hélion first came into contact with the avant-garde and got to know Mondrian, van Doesburg, Kandinsky, and the other abstract artists who were in Paris at the time. He embraced the cause of abstract art, which was then almost twenty years old, and became involved in the groups and magazines that were proselytizing for abstraction. From the start Hélion had an ability to put himself right in the middle of the fray, and this characterized his entire career and made for a life dazzling in its connections and rich in its friendships. In 1930, along with van Doesburg, he founded the Abstraction-Creátion group, which published a magazine, organized exhibits, and included among its members Arp and Robert Delaunay. The many interviews Hélion gave in recent years provide an invaluable view of the Paris of the early thirties. Hélion's generosity of spirit casts a beautiful glow over all the immortal names—he recaptures a sense of a shared experience that's rarely found in the history books.

Kandinsky used to invite everybody to sumptuous tea parties, which were presided over by Nina Kandinsky. Mondrian always sat at one end of the table, and at the other sat the youngest and most unknown of the group, myself. On my right was Arp, on my left Magnelli, and so on. One day Mme Kandinsky said to Mondrian, "What's the matter, Mondrian, are you not well?" He replied, "No, not particularly. I perceive a tree, right behind Hélion. It would have been better if you had let me sit beside him." Mondrian was such a puritan, at least verbally, that he simply couldn't bear the liberty of a tree. I had a great respect for him and liked him very much, but I must say that he was incapable of including a tree in his field of comprehension. Kandinsky, by contrast, was already liberated enough to do trees. Not that he talked about depicting them, but when he showed his paintings he would remark very proudly, "There are the colors of nature." After a trip along the Jordan River he told us that he had "captured the colors of those beautiful landscapes, those beautiful deserts." In sum, we all formed a perfect microcosm, with some advocating the most absolute rigor and others the greatest possible freedom. Though we apparently went in different directions, actually, as befits artists, we tried to grasp every aspect of the truth, from one extreme to the other.

Like Giacometti, Hélion went to school with the Parisian avant-garde of the early thirties, created his first mature work with a vocabulary borrowed from older artists, and only later, at the end of the decade, embarked on a return to reality—his "different direction."

There is to Hélion's art and career in the the thirties an international cast. Abstraction-Creátion, though formed in Paris, reflected the idealism of nonfigurative art as it had evolved in Holland, Germany, Russia; and Hélion's travels during the period—to Russia, where he met Tatlin, and to Berlin, where he met Naum Gabo—reflected a transnational brotherhood of abstract art. Hélion also visited America, for the first time in 1932, long before World War II brought many Parisian artists to the States. Unlike so many Frenchmen, he learned English perfectly. He assisted Albert Gallatin in putting together his great collection of abstract art (which became the Gallery of Living Art at New York University), befriended the young American painters, and encouraged the formation of the American Ab-

stract Artists group. Much of this long-submerged history of abstract art in the thirties has floated to the surface in recent years, and Hélion's name now has a certain currency in America among those who read scholarly articles and exhibition catalogues. Indeed, his abstract period has by now been gone over so often that it comes as something of a shock to realize that he painted abstractly for little more than a decade. But however Hélion chose to paint in later years, he always bore the stamp of the thirties, with its fervent hopes and hard realities.

Hélion's compositions of the mid-thirties, in which the geometry of the Abstraction-Création group engages with a Surrealism that "breaks down barriers and causes unexpected constellations of images to flower," are an essential landmark of the art of the time. It's the convergence of abstract idealism and Surrealist fluidity that makes for the haunted period flavor of these works. They're impersonal, muffled, expectant, somberly beautiful. Hélion's cylinder-, helmet-, and bullet-shapes, modelled in rich, pearly tones (Clement Greenberg once called the color Vermeerish), look to have been surprised into space. In the beautiful 1935 abstraction in the Albright-Knox Gallery in Buffalo, *Standing Figure*, the colored planes wrap around one another into a torso and head with the powerful heroic anonymity of a Cycladic idol. This is a silver-toned, porcelain-hard version of Léger's brash style of the disks of 1918. The smooth surfaces keep being disturbed by queer conflicting forces.

The writer Pierre Brugière, who met Hélion at Arp's house, recalls seeing hanging above Hélion's worktable in 1934 reproductions of Poussin and Fouquet—and that bow to the tradition of French art, amid the idealism of abstraction, suggests Hélion's reservations about the self-sufficiency of abstract art. When Hélion, in 1934, resigned from Abstraction-Création, it was "Because of Vantongerloo's austerity—he was a real purist—and also because of Herbin. They were both very much anti-Surrealist. As far as I was concerned, Surrealism was also a brand of freedom, so abstraction could not be opposed to it." In 1933, on a page of a notebook that contains a line drawing of a hand, he had written: "The superiority of nature is that it offers the maximum of complex relationships." In 1934, in *Cahiers d'Art*, he was ex-

plaining that abstraction and representation are in some way commensurate, equally real.

Still, it wasn't until 1939 that Hélion was painting representational paintings—a series of men's heads topped off with fedoras. Given how figural Hélion's abstractions had recently become, this return to reality wasn't exactly a surprise; and yet I don't think one can offer any simple explanation for Hélion's divorce from abstraction. Dissatisfactions and anomalies build up—but what ultimately tips the balance is really impossible to say. This is how Hélion recently described his development in the later thirties:

> I had gone to America in 1936, partly because of the American relations I had through my wife, partly to get away from the environment in which I had come to abstraction. I settled in New York to regain my freedom, but it so happened that my reputation as an abstract painter began to attract those very artists to me who, after years of representational painting, felt tempted by abstraction and the freedom it implied. So I withdrew to Virginia, to go my own way. I turned to nature, which they were escaping from; we met going in opposite directions.

Surely it's significant that the first figures aren't so much portraits of individuals as portraits of social types. The men are defined more by their headgear than by their faces—they're symbols of a new lower-middle-class man who prefers ready-to-wear suits (in which he can pass as a character from a Hollywood movie) to the traditional getup of the tradesman or craftsman or laborer. The hard clarity of the men in their hats is mixed with the fullness of form we know from the abstractions. The heads are blocky, angular; they have no softness, no flesh.

In 1939, Hélion wrote to his friend the poet Raymond Queneau from his home in Rockbridge Baths, Virginia, of a new series of watercolors. "The most beautiful," he said, "represents a street of Paris, always of Paris, native city, a characteristic place, typically atypical, for which I nourish a growing passion." The one large painting from 1939 is of the street: a severe gray facade, a cyclist, a man with an umbrella, a woman at a window. The figures don't really fill the space; it's a bit depopulated in feeling, not quite the image of the love of the street Hélion would later give us. But certainly it represents

everything for which international abstraction couldn't account. Geometry was an idea that had, in any event, begun to dissolve in the astringent waters of Surrealism, automatism, and the first stirrings of what was shortly to emerge as Abstract Expressionism. Though Hélion came to reality in America, it was a coming home to France as well—to the streets of Paris, and to the Poussin and Fouquet on the studio wall.

The Cyclist was the last large painting Hélion did before he was drafted in 1940 and went back to fight with the French. The war interrupted his work for four years. Hélion was taken prisoner in June of 1940, spent two years as a prisoner in German hands, escaped, and made his way back to the United States. All this would be neither here nor there in regard to the paintings if it weren't that Hélion published, after his return to America in 1943, a memoir called *They Shall Not Have Me*, which is, in its concreteness of naturalistic detail and immediacy of image, not what one would expect from a polemicist for abstraction, a star of the international avant-garde of the previous decade. It's a book about life among the people, the product of the same sensibility that was turning toward the life of the street in 1939. *They Shall Not Have Me* details the day-to-day struggle to exist.

In the early thirties, at the suggestion of his friend Georges Simenon, Hélion had written risqué stories in order to make some money (they're now lost). In *They Shall Not Have Me* he reveals a considerable literary gift. He doesn't write as *the artist*—his life among the intelligentsia is cast aside—we scarcely know anything about the narrator except that he's a soldier, left directionless and leaderless in June 1941. "I was not sent to war," he begins.

> It came to me in Mézières en Drouais, a charming village west of Paris, where, for months, I had crawled upon the hills, ducked under blank shots, dug model trenches, and absorbed soporific chapters from the infantry sergeant handbooks very peacefully. . . . We expected to leave for the front, and were eager to fight; but our train never came. . . . On the eve of the thirteenth, a lieutenant of my platoon, of whom I was very fond, took me aside and told me that the Germans

were hardly twenty miles away, advancing rapidly after breaking the main line of resistance. The order had come at last that all troops should evacuate.

On the very same day, June 13, Alberto Giacometti and his brother, Diego, were setting out from Paris by bicycle, to try to make it to Bordeaux, and a boat for America. For the Giacomettis, who were Swiss citizens, the days of flight ended with a return to Paris. Alberto ended up spending the war years in Geneva. But for Hélion and his fellow troops the days of rout ended in capture, and a week-long forced march during which many men fell by the wayside of wounds or starvation. After this, *They Shall Not Have Me* turns to an extended series of scenes from the two years of Hélion's life in prison.

After spending several months in a prison camp in France, Hélion is sent to work on a Pomeranian farm on the Polish border. The couple of chapters about this experience has the focused intensity of a classic of prison literature. Along with a small group of workers, he spends a brutal fall and winter—painting outhouses, digging for potatoes, working at a threshing machine. At first, the accommodations don't look so bad.

> To have a room for eight, with a few square inches of shelf for each was a forgotten delicacy [after the months in prison]. There was a window with a view of a large field and a forest beyond. As a playground, we had a ten yards' stretch between the tool shelter and the privy. The latter looked like a sentry box, and from each of the three holes inside, one could view the farm and the castle through the cracks.

Everything is a struggle. "We spent much time fitting our footwear, stuffing openings with crumpled newspaper and patches of burlap, and tying string all around. When the shoes were large enough, a layer of straw inside gave fine protection." The garbage is studied meticulously. "We found our greatest treasure in a garbage can: a map of all Germany and the northern part of Switzerland, a Shell road map."

It's hard to say whose lot is worse—that of the prisoners or that of the peasants, who've been there forever. These Pomeranian chapters are inter-

esting not only as an account of the war years, but also as a picture of life forty years ago in the backwoods of Europe. The farm is owned by a baroness, who runs a sort of ancient feudal establishment.

> When the weather was clear, the Baroness and her younger daughter came after lunch, in a coach driven by an old crow: he was assistant *Wachmann*, carried a pistol; and showed it to us, once in a while. He jumped to the ground, lowered the collapsible steps, and the Baroness descended. Wearing high riding boots, she went around, said a few words to *Tapageur*, who bowed to her from the top of his horse; to The Ox, who blushed and stammered; and, here and there, to the peasants. The daughter, seventeen or eighteen, her long hair flying handsomely in the wind, borrowed somebody's hoe, and dug a few potatoes, neatly, as if she knew how. She just stooped, of course, and lifted the potatoes one by one, with the hoe, built a little heap, handed back the tool and said with a smile: "Here you are."
>
> The peasant answered respectfully, *"Danke schön, Gnädiges Fräulein,"* as if she did not mind hurrying to make up for the ten minutes lost.

Hélion plots an escape; but before he has a chance, he's transferred to a banana boat, in the harbor of Stettin-on-Oder, where seven hundred and fifty men are kept, most of whom work at jobs in the town during the days. Here, due to his skill at languages and his general ability to take charge (an ability that had already stood him in good stead back in the Abstraction-Création days), Hélion becomes an assistant in the Commandant's Office, a sort of middleman between the prisoners and their captors. This part of the book is perhaps less gripping—life begins to take on a slower, more orderly day-by-day pace. But there are many marvelous vignettes, and Hélion's affection for people—his sense of how liveliness bursts forth in all sorts of circumstances—shines through. He describes getting together entertainment for the inmates.

> There was a tall boy who once had a bay window. He was a cabinet maker, specializing in luxurious coffins. It had borne little influence on

his mentality. He was good humored and full of indomitable vitality. Gifted for clowning, he imitated the best music hall singers, and made everyone of us laugh heartily. In addition, he inspired the others, and organized them. With all the unavoidable quarrelling, jealousies, and troubles, that such affairs involve, we composed a theatrical unit of ten actors; a singing one, of fifteen. From one harmonica in March, the orchestra grew to twenty-four instruments by December. With the complicity of a sentry particularly anxious to make ten or twenty per cent profit, we found and bought all sorts of old instruments, in the city: horns, violins, banjos, accordions, bugles, drums, with money collected from the spectators.

All during his time on the ship, Hélion is planning his escape. He leaves one afternoon, and after many near misses and the kindness of strangers along the way, makes his way back to Paris, an occupied city.

Now I wished I had avoided Paris. the beloved city was there to meet me, outside the station door, but in what a state! It had become pale and thin, like the few civilians on the sidewalks. . . .

Uneasy, I entered a café, and from the booth called several of my friends, without success. Either their telephone had been disconnected, or they were away. At last I reached one, and when I told him my name he said:

"It is impossible!" and I asked if I could come and explain to him why it wasn't.

"Immediately," he said, and I took the subway.

Finally there's the escape from occupied France, and so to America. Hélion spent a year writing his book in English (it's never appeared in France), and one feels, closing it, that Hélion might say of himself, with Léger, "The war changed me." Léger was, according to Hélion, the first to write to him when the book came out, with the exclamation, "Quelle belle aventure!"

Hélion's postwar work—all forty-odd years of it—is a long hymn to the strange and marvelous variety of daily life. In Hélion's art a powerful ordering imagination confronts a world that the artist himself described, shortly

before his death, as "a mixture of everything, good and bad, small and big, petty and grand."

La Grande Mannequinerie (1951) is one of a series of paintings that has its origins in the iconography of Surrealism, in the idea of the artist as an urban explorer, traveling the streets where the flatness of shop facades provides the backdrop for a drama of role reversals. The two mannequins in a tailor's window, with their gesturing hands, seem quite alive; while the barefoot dreamer, lying in the gutter, looks as frozen as a Hellenistic river god (he's a gutter god). *La Grande Mannequinerie*—painted in harsh, disagreeable blues and browns and greens—has a lurid, pulpy energy. The heavy, equal emphasis that Hélion gives to each banal element makes us feel that we're being forced to take things in whether we want to or not. The two dress-maker's mannequins, packed into their tight fancy French suit jackets, have wide-open eyes. The dreamer, whom Hélion identified as a poet, a sort of dropout from society, is oblivious, resigned. The painting might be read as a social statement, a protest against urban dislocation, and yet the dreamer and the mannequins are regarded with such a rapt attentiveness that what strikes us is the artist's sympathy and amazement more than anything like a tragic note.

In Hélion's studio still lifes of the postwar decade everything is given equal emphasis. Half-open pumpkins, vases of flowers, electrical outlets, cracks in the wall—they're all magnified, in much the same manner as the wrinkled clothing of the man lying in the street in *La Grande Mannequinerie*. Around 1953 Hélion goes all the way into pure representation and paints a crowded table in a strained, gray-brown scheme. *High Tea* is a bit loathsome in its rejection of ease. It's as close to academic realism as any major modern artist has ever come. The American painter Leland Bell has described this as "a picture without charm, its surface shut tight and hard. Every texture and object seems equally dense. Everything in the picture resists and repels—as if Hélion himself dared not relax. But it is not a question of failure or success—what counts is the admirable gesture of the knife in the bread, say, so clearly and precisely stated." Hélion's work of the early fif-

ties is a brilliant attempt to find the unknown within the all-too-familiar. Could anyone have predicted the jumble of *High Tea* on the basis of the flat white grounds and elegant abstract forms of twenty-eight years before?

In the later fifties Hélion was reaching for a relaxed, flexible form language to encompass everything he saw when he looked around at the world. The paintings of the early sixties—figures, still lifes, groups in the fields and harbors and markets—are drawn in curved slaps of paint. The extremist personality that was drawn first to abstraction and later to sharp-focus realism is nowhere in evidence. These canvases are a little too even in tone; your eye wanders across them, without quite getting engaged. The atmosphere is airier, more informal than anywhere else in Hélion's work. There's an almost vulgar lust for pure vision that we know from Vlaminck or the later Vuillard (maybe that's another side of Hélion's extremism); missing is the wonderful hum of ideas that generally gives a deeper dimension to Hélion's work. He moves, in 1962, to the town of Bigeonette, near Chartres; but he can't really convince us of a modern pastoral, as Balthus does in the Chassy landscapes, or Braque does in the late paintings of fields. He's an artist waiting for inspiration to strike. And when it does, in the late sixties and seventies, Hélion returns to urban themes in a series of triptychs of street life that are to his oeuvre what *Paris sans fin* is to Giacometti's and *Le Passage du Commerce Saint-André* is to Balthus's. The love affair with Paris goes on.

All through his career Hélion kept copious notebooks in which he made sketches and jotted down interpretations of his own work and reflections on the course of his career. In 1964, on the threshold of his great series of triptychs, he wrote a beautiful call-to-arms for a new heroic representational painting. (The translation, by John Ashbery, was published in the important, short-lived magazine *Art and Literature*.)

We would like, of course, to paint *complete* works, in the style of Carpaccio, Masaccio, Velazquez, Géricault. Technically, it is not utterly impossible. Spiritually, it is refused to us.

Something fundamental has gone wrong. Each time a painting moves in this direction we must rub it out, return to plans that are both

simpler and more complex; to firmer notions of space, to a tenser and less explicit degree of representation, the only one our senses can bear today.

Finally we must break off all relations with nostalgia. The canvas is not an open window giving onto the room in which the still-life sits. It is a bare wall, or a public square in which the image will be built like a monument.

Keep your distance from the inspiring object, that distance which allows liberty without depriving it of its force.

To yearn for Carpaccio, Masaccio, Velazquez and at the same time to "break off all relations with nostalgia": this became Hélion's extraordinary program. The work he did from the mid-fifties to the mid-sixties (which remains his least known both here and in Europe) was a long preparation for this final conquest, a search for "that distance which allows liberty without depriving it of its force."

The two great triptychs of 1967–1969—*Triptyque du Dragon* and *The Events of May*, each something like ten by thirty feet—are monumental and reflect an encyclopedic view of the world. Hélion obviously wants to invent complete figure compositions, compositions in which the various effects of glass and flesh and fabric and metal are given their individual weight. And in a sense this urge is antimodern, a return to the ideals of the Renaissance. Hélion is indicating what he might have done had he been born closer in time to Delacroix or Rubens. But of course he wasn't born then, so this turns out to be a contemporary grand manner—sketchlike, impromptu. The faces and limbs of dozens of figures are just suggested with bunches of strokes. Hélion's let's-try-it spirit recalls Manet and his premier modern style, with its rapid-fire jotting down of impressions.

The blue-green *Triptyque du Dragon* (1967) is a hymn to the streets—and when you're in Paris, where so many streets still compose into views as artful as Hélion's painting, you know why he was drawn to the subject. This enormous painting was actually designed to be exhibited at the Galerie du Dragon on the rue du Dragon in the Seventh Arrondissement, and in photographs of the original installation one can see that Hélion's panorama of

26. GEORGES BRAQUE, *Studio VI* (1950–1951), 51³/₁₆″ × 64″

27. GEORGES BRAQUE, *Studio IX*
(1952–1953/56), 57½″ × 57½″

28. GEORGES BRAQUE, *Seashore* (1958), 12³⁄₁₆″ × 25⅝″

29. GEORGES BRAQUE,
The Mauve Garden Chair
(1947–1960), 26″ × 20¹⁄₁₆″

30. GEORGES BRAQUE, *On the Wing* (1956–1961), 44⅞″ × 66¾″

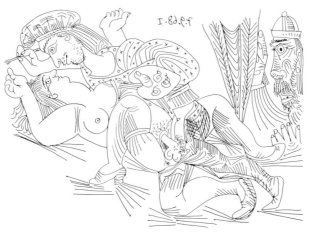

31. PABLO PICASSO, Plate from *Suite 347* (1968), 6″ × 8″

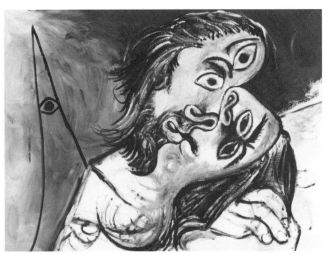

32. PABLO PICASSO, *The Kiss* (1969), 38¾" × 52"

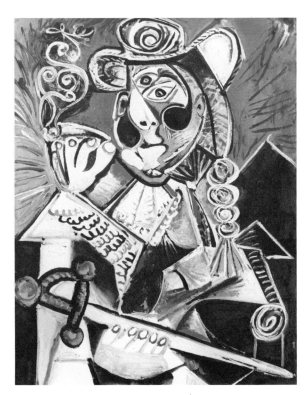

33. PABLO PICASSO,
Cavalier with Pipe
(1970), 57⅛" × 44⅞"

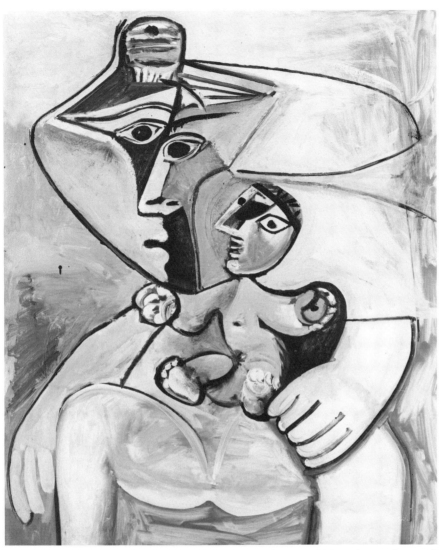

34. PABLO PICASSO, *Mother and Child* (1971), 63¾″ × 51¼″

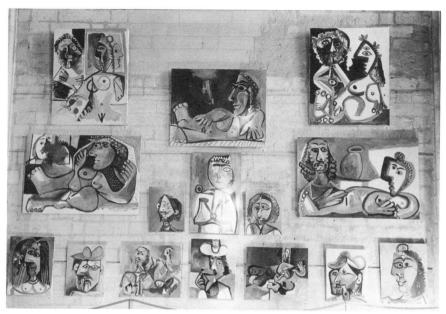

35. Installation View of the Picasso Exhibition
at the Palais des Papes in Avignon (1970)

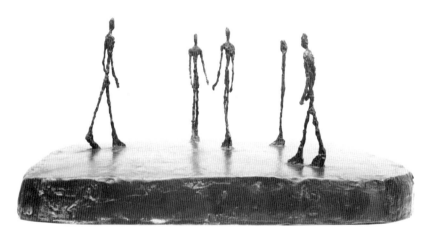

36. ALBERTO GIACOMETTI, *City Square* (1948), 8½″ × 25⅜″ × 17¼″

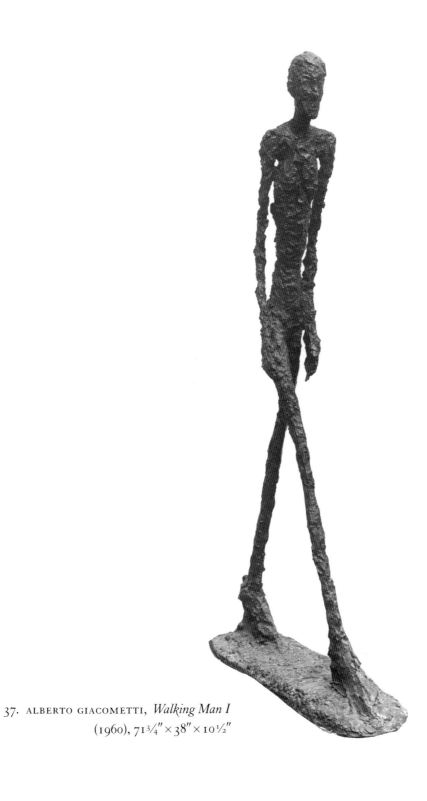

37. ALBERTO GIACOMETTI, *Walking Man I*
(1960), 71¾″ × 38″ × 10½″

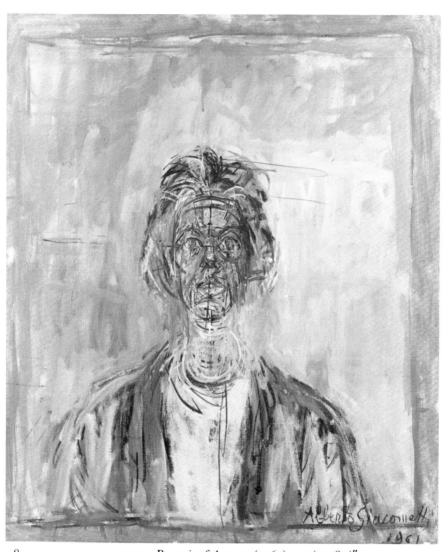

38. ALBERTO GIACOMETTI, *Portrait of Annette* (1961), 21⅝ × 18⅛"

39. ALBERTO GIACOMETTI,
Plate #17 from *Paris sans fin*
(published posthumously by
Tériade, 1969), 16¾″ × 12¾″

40. ALBERTO GIACOMETTI,
Plate #123 from *Paris sans fin*
(published posthumously by
Tériade, 1969), 16¾″ × 12¾″

41. JEAN HÉLION, *Standing Figure* (1935), 51¼″ × 35¹⁄₁₆″

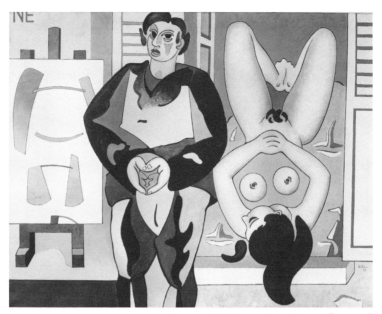

42. JEAN HÉLION, *A Rebours* (1947), 44⅞″ × 57½″

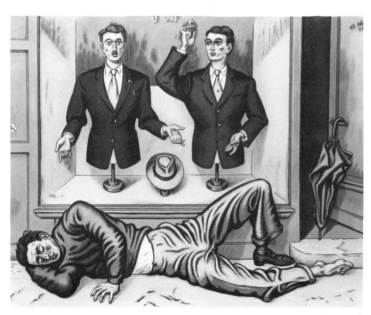

43. JEAN HÉLION, *La Grande Mannequinerie* (1951), 50⅞″ × 63½″

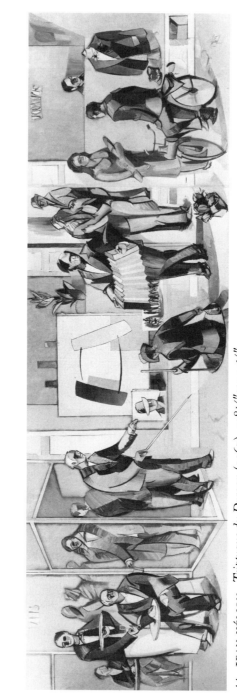

44. JEAN HÉLION, *Triptyque du Dragon* (1967), 108¼″ × 344½″

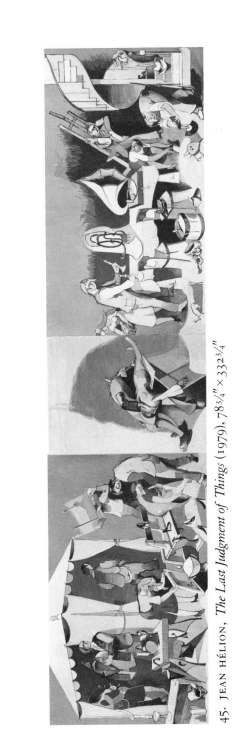

45 · JEAN HÉLION, *The Last Judgment of Things* (1979), 78³/₄″ × 332³/₄″

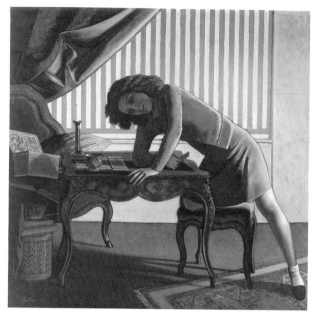

46. BALTHUS, *The Game of Patience* (1943), 63″ × 65″

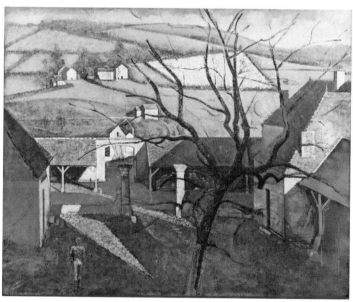

47. BALTHUS, *Landscape with a Tree* (1960), 51¼″ × 63¾″

48. BALTHUS, *Le Passage du Commerce Saint-André*
(1952–1954), 115″ × 130″

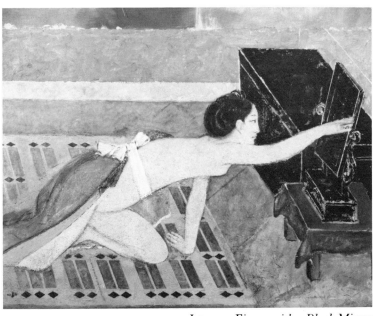

49. BALTHUS, *Japanese Figure with a Black Mirror*
(1967–1976), 59″ × 77″

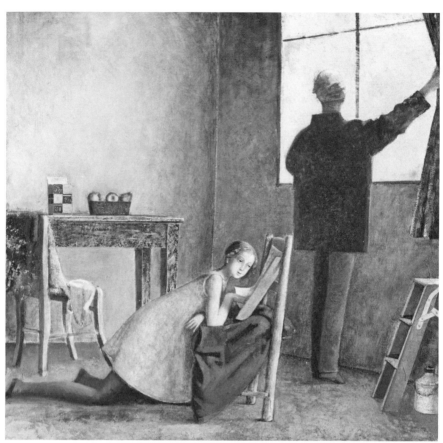

50. BALTHUS, *The Painter and His Model* (1980–1981), 89″ × 91″

street life was visible from the street, through the gallery's windows. Art and life intermingle. Along the rue du Dragon, full of interesting shops and galleries and publishing houses, Hélion found a cross section of the population of the city (a cyclist, a lady with a baguette, a waiter, a pair of lovers, a worker descending into a manhole), and this became the raw material for the exposition of two themes. One theme is Hélion's affection for the simplest acts—the drinking of a cup of coffee in a café, the carrying home of a loaf of bread—and his belief that these are the only rituals that we have left to perform. A second theme is the now-this-way-now-that-way course of the artist's own career, which is documented in the shop windows in the painting. At the center of the composition, in a gallery display, are two of Hélion's canvases—an abstraction of the thirties, and a head with a fedora from 1939. The shop to the right of the gallery, with its mannequin's torso, is straight out of the Hélions of the fifties. . . . And then of course the *Triptyque du Dragon* is being exhibited on the real rue du Dragon. Surely, this is Hélion's version of Watteau's *Shopsign*: a work of art whose subject is commerce in general and the buying and selling of art in particular, as well as the range of human interactions that all this commerce occasions.

If *Dragon* gives us the normal life of the Parisian streets, *The Events of May*, completed in 1969, represents the cityscape in eruption—the street as a site of revolution, of the barricades that rise in Paris every few generations. Hélion has pointed out that he's the only painter who took up the events of May as a subject, and also that he did it with no specific political program— his attitude toward the radicals was sympathetic but a bit distanced. Hélion said, "It is good to upset things once in a while and see what's underneath." He sympathized with the worldwide eruptions of the late sixties as an old-fashioned liberal spirit who had always valued freedom and never been taken in by Communism or by Stalin or Mao. *The Events of May*, with its reminiscences of Delacroix's *Liberty Leading the People* and its expanses of brilliant revolutionary red broken up with passages of black, rises to exhilarating heights. The central panel, where the girl rides piggyback surrounded by flags (the figures are nearly life-size), has a dizzying beauty. The figures blossom forth from the canvas, and the spiral movements of legs and

arms and flags carry us aloft. Along with Godard's movie *La Chinoise*, *The Events of May* is one of the rare works of art that really capitalized on the imagery of those years of protest, with their barricades and banners and slogans, their vigor and informality and youthful hopes.

The big paintings of the seventies, such as *The Last Judgment of Things* and *The City is a Dream*, go even further in the direction of a shorthand monumentality. Here Hélion breaks loose with his sketch-style and flings off paintings on brightly tinted grounds in slaps and slashes of color. There's no attempt at making figures that are self-contained; these men and women are built out of freewheeling planes. *The Last Judgment of Things* (Hélion's last triptych, as it happens) takes its inspiration from the flea market, a great French subject. A big cast of characters is rummaging around among the assortment of junk, and you feel here the pile-up of the ages—you see civilization *en déshabillé*. This is Hélion's version of the great Last Judgments that were carved above the doorways of Romanesque churches, and it has a related comic-apocalyptic beauty. One woman is trying on pairs of shoes; a man is inspecting a candlestick; another is holding together two parts of a broken record (Hélion always loved to break and remake forms). In the central panel the story becomes surreal: one dressmaker's dummy is making love to another one. All the way to the right there's a winding staircase, leading we know not where. The figures and objects are painted against a gray and orange ground, in quick sharp curves and angles accented here and there with planes of high-keyed, candyish greens and yellows and reds and blues. The color is abstract, a bit irrational. It's a fascinating, frenetic vision, an essence of all the little flea markets that hang onto the ends of the weekday markets in French towns.

The figures in *The Last Judgment of Things* examine objects very closely. This sifting through old things had apparently been on Hélion's mind for years. Back in *They Shall Not Have Me*, he'd described the trading in the prisons and camps.

> In the latrines, and at given spots where one stayed only a few seconds, the black market went on, feverishly. I have seen an ounce and a half of French Army tobacco, worth one franc, offered for one hundred, and overbid three times up to eight hundred francs, namely eighteen

dollars. A single ounce has been sold for as much as twenty-five dollars. Shirts, socks were bought by men attached to a unit working for the moment in Hammerstein. They slept in a special barrack, and were not constantly searched. They would smuggle the goods out of the camp and sell them to certain German workers for good civilian money, or for loaves of rye bread. But spies were rumored to exist in the camp, and special patrols were on the look-out. The transactions were nervous, merciless, and ugly.

In *The Last Judgment of Things* the transactions are sweeter, almost funny; but the painting is illuminated by the same interest in human interactions and psychology, and the peculiar value we place on *things*.

In the first half of this century artistic values were established in Paris; since 1950 they've been set in New York. This transatlantic shift has left many European reputations shining as brightly as ever before; but on certain European artists, especially ones whose careers weren't entirely formed before World War II, the rise of New York has had a disastrous effect. Since the fifties Hélion, who spent so much time in America both before and during the war, has become a figure only dimly apprehended in New York. Old timers recall his shows here in the forties, and his famous conversion from geometric abstraction to representation. There are supporters—the painter Leland Bell, the poet John Ashbery; and young artists, arriving in France, have been greeted by Hélion with the same openness that Mondrian and Kandinsky offered *him* half a century ago. The decades have been dotted with exhibitions and the abstract work has recently achieved a certain chic; but the U.S. shows, which tend to bring only fragmentary information about Hélion's various phases, often cause only more confusion.

In Paris, in the summer of 1980, the Flinker Gallery had a beautiful show of Hélion's paintings from the fifties: freely brushed views of Paris rooftops; interiors with tables and plants and flowers and baguettes painted sharp and clear. The show was intense, difficult, unyielding, full. A year later, when the Robert Miller Gallery in New York mounted an Hélion show that covered some of the same ground, only the least interesting paintings one had seen in Paris were included. The Miller show missed all the artist's high points.

And so it has gone with Hélion in New York—the disappointment of shows that leave his supporters saying, "But you haven't really seen his best work." I wonder if America will ever catch up with Hélion. Because even if a retrospective were to be mounted, seeing this extraordinary career in one swallow would probably prove to be too much. Hélion's is one of those complex careers that one must grow into, find one's way through.

When I was in Paris in the summer of 1986 there was no Hélion on view, either at the Pompidou Center, or at the old Museum of Modern Art of the City of Paris. The Museum of Modern Art in New York, so far as I can remember, has never shown one (he wasn't even in their important "Contrasts of Form" show of geometric abstraction in 1985); and the Metropolitan, which has recently acquired several Hélions, rarely shows them. In the summer of 1987 the Pompidou put up a room full of Hélions—and one hopes it will stay in place. (After writing this, I had word that it was down—another defeat!) The Pompidou installation included several abstractions, *The Cyclist* of 1939, two magnificent large charcoal drawings of male figures, a beautiful still life of herring, and one of Hélion's most important paintings, *A Rebours*. Painted after World War II, *A Rebours* is, like the *Triptyque du Dragon* of two decades later, a reflection on Hélion's past and future as a painter. It's a work of bright, smoothly painted forms surrounded by black lines; everything is given the crisp definition of the forms on Romanesque enamels. At the center of the horizontal canvas is the artist, looking a bit perplexed, locked between one of his abstractions standing on an easel at left, and, at right, an open window through which we see a female nude, upended on a bed. It's a painting of transformations taking place before our eyes. The woman's hands and feet fuse into abstract, Arpish forms. It's a painting about the potential of abstract forms to break into reality, and of reality to break into abstraction. The artist's perplexity is our perplexity, the perplexity of the modern viewer who always sees the two possibilities—the representational along with the abstract.

In the seventies Hélion did a series of Fauvishly colored still lifes representing hats and musical instruments. In 1986 I saw one of these in Hélion's studio—four hats and a sculpted head sitting on the steps of a metal lad-

der—and it's held in my mind's eye ever since. An image of a few oddly jux-taposed but unexceptional objects, painted in full color, cut so clearly out of the flat plane of the canvas as to achieve the effect of bas-relief. Here is a union of geometry, Surrealism, reality . . . an image sharp, full, clear, un-equivocal. Jean Hélion is one of the great artists of our time.

BALTHUS

◪

Artist and Model

In the paintings of Balthus, who was born in 1908, the aestheticism of the
School of Paris reaches its culmination. For Balthus, who knew Bonnard as
a family friend while still a boy, and whose mother, Baladine Klossowski,
was one of the poet Rilke's last lovers, Parisian art must have signified from
the very start of his career the perfection of sensibility, the ultimate transfor-
mation of feeling into paint. Balthus's themes were always closely tied to the
preoccupations of fashionable artistic Paris. Both Piero della Francesca and
Gustave Courbet, the two masters of the past who mean the most to him,
were popular in the twenties, and the Biedermeier furnishing in Balthus's
paintings of the thirties reflect the passion for overlooked or undervalued
styles that characterized Paris between the wars. When, after World War II,
Balthus became interested in the poetic possibilities of the painting surface
itself, it was a return to the delectation of materials we know in Bonnard,
Braque, Matisse, and Picasso. (Among the events Balthus organized during
his tenure as Director of the French Academy in Rome in the sixties and sev-
enties were exhibitions of Braque and Bonnard.) Though Balthus's family

left his native Paris when he was six, and Balthus spent most of his childhood in Germany and Switzerland, he's a completely Parisian artist—perhaps the most Parisian of them all.

Balthus's girls—the figures who sleep and loll and stretch through half a century of his art—might well be the daughters of the contemplative women that Matisse, Bonnard, and Picasso painted in the twenties. Certainly Balthus's very young women are the most recent chapter in the story of the artist and his model that has wound through four centuries of European art, since Raphael and Titian. Now all the luxuriant curves are gone; Balthus's girls have stick arms, and prominent knees and shins and collar bones. And you may not believe they'll ever grow womanish—they may end up like the women Giacometti painted after the war—nervous and thin. It's as if Balthus is trying both to go back behind the Titianesque tradition, to the slender ladies of medieval tapestries, and forward, to a new view of romance.

Balthus's paintings are the product of a period in the twenties and the thirties when the young broke with the old-fashioned manners of their parents' generation and went into revolt. André Gide's novel *The Counterfeiters*, published in 1926, offers an interesting literary parallel to the kind of voyeuristic scenarios Balthus sets up time and again. Like Gide's largely autobiographical narrator Edouard, Balthus approached his young subjects with a curiosity that's both promiscuous and detached. *The Counterfeiters* opens when the adolescent Bernard discovers his mother's love letters and the secret of his illegitimacy in the drawer of a sidetable. This itself is rather Balthusian—the discovery of secrets in the old furniture, the bourgeois drawing room as a setting for subterfuge and scandal. Gide follows Bernard and his friend Olivier as they move between the good and evil spirits of their mentors, Edouard and the Comte de Passavant. Passavant is Gide's notorious sendup of Cocteau; Edouard is his self-portrait. In the novel Edouard is a friend of Bernard's family and the boy's gentle seducer as well as the author of a journal (of which we're offered some excerpts) and a work-in-progress called *The Counterfeiters*.

Though Balthus doesn't appear in a painting with any of his girls until

1980 to 1981, in *The Painter and His Model*, he's really, like Edouard, always there as the impresario and voyeur in one of his meditations on childhood's end. Balthus's girls are locked in their salacious poses, exposing underwear and crotch, as they're locked in their moody, claustrophobic, stage set-like Victorian interiors—which, in the paintings of later years, turn Roman or Japanese. Balthus once did a copy of Caravaggio's peerless masterpiece of erotic confrontation, *Amor Vincit Omnia*, and he may at times be after the shock value we know from Caravaggio, where the boy with the wings leers out at us, dominates the painting, invites us in. Balthus, however, remains absolutely in control. As in Gide's *Counterfeiters*, in the Balthus paintings the artist and his young subject are pitted in a sort of game where the genius-creator faces off against the beginner's luck of youth, which is finally no match for experience and art.

There have been many beautiful photographs of artists taken in the twentieth century, but probably none more glamourous than those of the young Balthus in the Paris of the thirties. With his dark hair and eyes and sensually angular features set off by well-cut clothes, he's the ultimate example of the artist as society dandy. He carries his elegance easily; he's perfectly self-contained.

Even in the very earliest of his paintings Balthus holds us at a distance. His first show, at the Galerie Pierre in Paris in 1934, was described by his friend Antonin Artaud as casting the experience of the modern world in the classical language of David. But there's also a cool, haughty humor that gives this classicism an edge. In Balthus's 1935 self-portrait, *The King of Cats*, the legs are elongated, as in a fashionable nineteenth-century illustration, and a portfolio is inscribed with the picture's title, another old-style idea. In the 1934 portrait of the wife of the owner of the Galerie Pierre, the oversized head, like a head in a primitive painting, balances on the slim body in a manner recalling the human flowers in certain comic illustrations. All this suggests an escapade in nineteenth-century imagery just barely vindicated by the here-and-nowness of Balthus's subjects. These two portraits, along with those of the Vicomtesse de Noailles and of the artists Miró and Derain (the

last two owned by the Museum of Modern Art and for years the Balthuses most familiar in New York) constitute an extraordinary achievement for an artist still in his twenties. In these plain, brown interiors a few pieces of furniture stand out hard and clear, like the details of ordinary life in a trecento fresco.

The canvases of young girls that Balthus painted in the thirties are ominously nostalgic. These girls—half Biedermeier daughters, half women of the world—aren't people who have come to sit for a portrait but models who are extensions of the artist's erotic imaginings. Balthus is a dreamer painting other dreamers; his young women are sleepily distracted, sunk in reverie, caressing themselves with their fingers. What carries the paintings out of the realm of period curiosities is Balthus's superb craftsmanship. Even if the forms never have the completeness, the ultimate simplicity that we feel (and we know Balthus feels) in Corot and Courbet and Caravaggio, the figures do have the gravity, the weighty calm of pieces of sculpture. The girls are touched as well with the melancholy of Picasso's Rose Period. They're as isolated as classical antiquities, these dreamy Thérèses. They look toward us from a great, unnavigable distance.

In paintings such as *The Living Room* the situation of the Thérèses is further elaborated, becomes a little narrative, a type of modern genre painting. In *The Game of Patience* the standing figure, moodily playing cards at a little table, is an audacious construction, a sort of boomerang shape that springs upward from the floor, off its one small foot and plunges, head first, into the space above the table. At first what seems to anchor her powerful form in place is the insistent, downward thrust of the striped wallpaper, and that's a part of it, a small part of it. The clue to *The Game of Patience* is the back right leg of the card table, which isn't there. Or rather, is there, but hidden from view. Balthus has arranged things so that this leg is completely covered by a chair leg and the girl's leg; even the shadow that the table leg would cast is absorbed in the shadow cast by the back leg of the chair. Thus, the table is three-legged—almost two-legged, since the other back leg is also barely visible. By refusing to let the table become totally three-dimensional, Balthus forces us to consider the piece of furniture in two-dimensional terms—as an

element in a surface design. This is the essential image-idea in *The Game of Patience*. Every form implies a three-dimensional space but must be completed in two-dimensional space. It's Courbet redone after Juan Gris. In the context of a composition that appears, the more one looks at it, like a labyrinth of parallelograms, the girl's head has a special poetic magic: it's the intelligence at the center of the maze.

For the first stop of the great Balthus retrospective of 1983–84 at the Pompidou Center in Paris (it later came to New York's Metropolitan Museum of Art), the French produced an enormous catalogue. Along with the usual color reproductions, it contains reprints of almost every major text on the artist; some elaborate, well-illustrated essays; a reprint of Balthus's only illustrated book, *Mitsou*, published with an introduction by Rilke when the artist was thirteen years old; and black-and-white reproductions of all the paintings, including lost works. This great catalogue reveals how many barriers—aesthetic, iconographic, literary—Balthus has set between his art and reality, between himself and the world *out there*. The interiors and cityscapes of Balthus stand at an intellectual crossroads—somewhere between Surrealism and Existentialism—and give an artist's-eye view onto some of the big ideas of the day. Like all the major modern artists, Balthus knows that the final collapse of normative perception in Cubism has rendered the unmediated, direct experience of nature well-nigh impossible. In Balthus's paintings, the iconography and literature of eroticism, the visions of Baudelaire, Proust, and Rilke, the structures of older art, become conceptual frameworks through which the world can be experienced and made into art. Balthus's is the attitude of the aesthete: it's his feeling for art that enables him to turn the experience of life into art.

There are no deep vistas in Balthus; he folds everything back into a tightly circumscribed illusion. Balthus's street scenes are closed off, with no sky— exterior rooms. His interiors are Victorian, Biedermeier, Roman, Japanese: of other times and places. His Alps are the Alps of old-fashioned walking tours. Even his most immediate landscapes, the ones done in the fifties at his château in central France, show nature filtered through Cézanne, Bonnard,

and Braque. A good deal of Balthus's career might be described by some words of his mother's close friend and his first mentor, Rilke, in *The Notebook of Malte Laurids Brigge*: "To sit and watch a warm streak of afternoon sun and know many things about girls of bygone days and be a poet."

Like all modern artists with a tale to tell, Balthus has had to come to terms with the crisis in storytelling that's central to the art of the past hundred years. One can imagine that Balthus looks with envy on Renaissance artists such as Carpaccio and Piero della Francesca for whom the pictorial impulse was always a narrative impulse not far divorced from a basic illustrative impulse. The situation in which Balthus finds himself is very different. From an early age he must have known that no modern can tell a story straight. Rilke's *Notebook of Malte Laurids Brigge*, completed in 1910, was unclassifiable, a non-novelistic novel. And in Balthus's first major figure composition, the superbly crafted *Street* (1933)—a picture suffused with the tawny tones of good Biedermeier furniture—the story, borrowed from Seurat's *A Sunday Afternoon on the Island of La Grande Jatte*, is also a non-story. There's no central event, no core, just a batch of elements, street life atomized into little piquant incidents: funny boy, plank-man, horseplay. *The Street* is a light, brilliant painting. It may have too much an air of strategies about it, but the energy with which the figures catapult through the street makes it the liveliest of Balthus's figure compositions.

The year after completing *The Street*, Balthus embarked on a series of illustrations to *Wuthering Heights* that are his most direct assault on storytelling. The appeal of Emily Brontë's wind-battered romance is obvious—it's the archetypal vision of youth seen through the distorting mirror of adulthood. Balthus's illustrations are in a nineteenth-century style, and part of what he wants to tell us about is how much he loves the chapbook illustrations of an earlier age, with their unpretentious country furniture and big-headed figures. Balthus's pen-and-ink drawings shake up the rigid poses, distorted figure proportions, and simple hatching of his nineteenth-century models into an explosive, modern poetry. Balthus obviously sees in *Wuthering Heights* the same primal eroticism that attracted Hollywood to the book; and his protagonists, as much as Laurence Olivier and Merle Oberon

in the 1939 movie, act out their roles according to a contemporary sensibility. Heathcliff is a dark-haired stunner—the artist's stand-in; and he and Cathy, with their triangular faces and slim bodies, become a dream brother-and-sister couple. Balthus fits out Heathcliff and Cathy with simple but well-cut clothes; as they lounge and argue the fabric tightens provocatively around Cathy's chest, Heathcliff's thighs. They're hot little numbers. Brontë's scenes of love and boredom and disappointment are transformed into the sexiest chamber dramas in twentieth-century art.

After finishing the *Wuthering Heights* drawings (actually abandoning them—he illustrated only the first half of the novel), Balthus did a few paintings, such as *The Children* (which Picasso owned) that are based on Brontë themes. In the paintings, though, the motifs lose some of their narrative impulse and most of their amusing naughtiness. Balthus must have had an idea that a painting couldn't risk being too illustrative. When he returned, later on, to large-scale storytelling painting—in *The Mountain* (1937); and in *Le Passage du Commerce Saint-André* (1952–54), which recapitulates the theme of *The Street*—the stories are open-ended, hard to parse. The figures in both of these immense compositions seem a bit drugged, immobilized, and the incidents aren't nearly so witty as in *The Street*. The pictures are a mass of suggestions—storytelling by addition or collage. With their Salon-masterpiece proportions they fit rather uneasily into the galleries and museums of today.

The Mountain presents an alpine outing that has degenerated into something like the narrative informality of movies such as *L'Avventura* and *La Dolce Vita*. (Fellini and Balthus later became friends, and Fellini wrote an introduction for a show of Balthus's work.) Dream and desire hover in the pure mountain air. Figures stretch, sleep, smoke, and explore amid a landscape alive with sexual innuendo. Projected on so vast, so heroic a scale, the pocked terrain and walking sticks plunged into the earth have a startling resonance. I wonder, though, whether ambiguity provides enough of a subject to fill such a great big space. *The Mountain* is a painting without a core, a work of audacious complexity, perfectly finished, but somehow with a lump at its center—the lump of its desperate love affair with the great machines in the Louvre, the Courbets and Delacroix.

Le Passage du Commerce Saint-André, painted fiften years later, is Balthus's farewell to Paris. And here for once the scale jibes with the enormity of the idea. The *Passage* represents an odd little alleyway on the Left Bank, a kind of backwater of the part of the city where advanced literary and artistic taste had been formed for many years. Hélion's rue du Dragon and the studio where Picasso painted *Guernica* aren't far from this wonderful stagelike space, this touching decor made out of the convergence of two tiny alleys lined with worn-out old buildings. Balthus's subject is the life of a city in relation to the lives of eight individuals. His gracefully aging Left Bank is the setting for a twentieth-century meditation on the Ages of Man. The little girl plays with her doll, while the bent-over old woman shuffles by, leaning heavily on her cane.

In an interesting essay on Balthus, the writer Guy Davenport has related how he first saw the *Passage* "at the Centre Pompidou in an afternoon of surprises. I had just seen my first Tatlin and some late Malevitches unknown until then." He continues:

For the first time I remembered how familiar the street was to me, a locale I crossed time and again when I first knew Paris just after the war. The painting did not exist then, though Balthus must have been making studies for it, a picture to epitomize all his work.

Inside the painting's fetching mysteriousness there had been all along a familiarity that I had not isolated until I stood before the canvas itself. A more wonderful way of seeing Proust's theory of the redemption of time in triumphant proof I cannot imagine.

Another surprise was to notice that for all the resonances in this most Balthusian of all Balthus' work (the Rilkean question, as of the *Saltimbanques*, "Who are these people?", its kinship to Beckett and Sartre) it belongs with a rightness to the Paris of Simenon.

There's the same flatness and ordinariness, as if to say: Look, the world is not really a mystery at all. It appears to be, but look again. These eight people, a dog, and a doll are the very essence of a Left Bank backstreet. The fine strangeness of it all is in our minds.

The old woman with her cane, a concierge nipping out briefly to do her shopping, can tell you all about these people. She is the kind of spiteful old soul who gives Maigret and Janvier their best information. Seeing the painting is very like Maigret learning a neighborhood.

The figure we see from the back (a self-portrait, Jean Leymarie says in his introduction to the Skira *Balthus*), who is coming from the baker's, is a standard type in the *quartier*. Maigret would suspect him of all manner of irresponsibility, Bohemian attitudes, and cosmopolitan vice.

The figures in the *Passage* are strangely generalized, rather anonymous. They're seen as if in a haze, the faces not fully realized. They don't give up their private mysteries. They remain distant, circumspect, and the vagueness of it all becomes the measure of our distance from them. The *Passage* is, in some sense, a rather un-French painting: it lacks clarity. It's a vision of Balthus as outsider—as someone whose family came to Paris. The Paris is the city of Rilke's *Notebook*: a northern Paris, ghost-haunted. The clear, foursquare space of the *Passage* doesn't prepare us for a mystery, but the paintiness of the surface functions as the barrage of words does for the modern writer. The medium is the artist's consciousness, and we see through it.

You can still today visit the spot where Balthus found his setting, and despite the general zooiness of the neighborhood (it's like New York City's Greenwich Village on a Saturday night), at dusk the little street takes on the twilight color of the Balthus, and figures walking by acquire the peculiar gravity of Balthus's old woman and baguette-bearing artist.

Balthus, while pursuing his own demons, has at times caught a bit of the spirit of the day. The pictures of the fifties and early sixties (often called the Chassy period after the Château de Chassy in the Morvan region of central France where Balthus moved in 1953), are almost too insistent in their serenity, as if it were necessary to reassure oneself after the war that everything was now all right. In the post-war period the art of Balthus, like that of older artists such as Picasso and Braque, becomes highly ornamental. The pictures

can close up completely, approaching a weird form of obsessional decoration—they're ugly-beautiful.

If some of Balthus's greatness is owed to his refusal completely to abandon the illustrative impulse, he also harbors no illusions about the terrible beating that illustration has suffered at the hands of modernism. With the triumph of decorative coherence over narrative coherence as the guiding principle in Western painting, illustration has become, almost by definition, a violation of high art. The move toward an increasingly decorative organization in Balthus's work of the fifties, and the centrality of decoration in much of his work since then makes this all quite clear. Indeed, the superb poignancy of *Le Passage du Commerce Saint-André*—which is one of the last paintings Balthus worked on in Paris—has to do with the risks the artist takes in telling his story.

It's shortly after leaving Paris, during the Chassy period, that Balthus becomes, more openly than ever before, a modern artist. (He also does some of his least characteristic pictures: a painting of a *Boy with Pigeons*; a male nude; and the women in bathrooms, which are his most self-conscious acts of homage to Bonnard.) At Chassy the surfaces begin to thicken, if not quite to the impasto of the works of the seventies, at least to a rumpled, gravelly density. The color of the earlier works, which always carried in its modelled chiaroscuro a certain tendency toward yellowishness or grayness, gives way to a chalky lightness of close-toned, pastel blues, greens, and pinks. While the subjects—still lifes, landscapes, girls dozing on sofas beneath open windows—suggest informality, they're not really experienced firsthand, but almost ritualistically, with an insistence that transforms them into the most completely designed of all Balthus's works.

The danger of the Chassy style lies in a tendency to overdetermine the composition of the picture. I suspect that in *The Cup of Coffee* (1959–60) and *The Moth* (1959) Balthus has become so absorbed in his new sense of the decorative as an organizing principle that he's failed to leave anything for the viewer to infer. The crisis of the Chassy period lies in Balthus's effort to reconcile the divergent claims of a classical, spatial legibility and a modern surface design while sacrificing nothing on either side of the equation. The pic-

tures sometimes describe a rather fascinating impasse. In *Landscape with a Tree* (1958–60) the candy-color, reminiscent of a Monet of the 1880s, is wed to a Poussinesque geometry to create a striking combination of sweet and sour, tough and pretty elements. This landscape has no easy point of entry; you're drawn in by the outstretched branches of the tree, which create a sort of pinwheel effect. *Landscape with a Tree* is a quietly ecstatic nature poem—a pastoral reminiscent of the mood of the Norman scenes in Gide's *The Immoralist*, where the hero, Michel, leaves the book-learning of Paris behind and spends his days among the farmhands in the fields and forests.

From the fine series of drawings in the Metropolitan show, and even more so from the magnificent album of drawings published by the New York Graphic Society in 1983, it's possible to trace Balthus's development in the sixties and seventies, and see how he's arrived at his current mode. Though he's never been a great draftsman in the sense Matisse is, Balthus's drawings may, like Bonnard's, be great painter's drawings: thinking drawings. (He's also a superb watercolorist, with some of Delacroix's gift for the medium.) Both in the show and in the book, the majority of drawings are from the last twenty-five years. Apparently, in earlier years, Balthus was in the habit of destroying drawings or at least of letting them deteriorate in his studio. (There are stories of his leaving sheets of studies on the floor and walking back and forth over them until they disintegrated.) What drawings there are from the thirties and forties tend to be quite sketchy, which would indicate that at that point much of the actual working out of the figures took place during the painting process. Only in more recent years has Balthus used drawing as a full-blown preparation for painting—as a process of devouring and transmogrifying reality. In the drawings of the sixties and seventies the modelling in broad areas reduces everything to a flattened-out chiaroscuro. There's a velvet-softness. Reality is crushed, and the pulling together of space yields a kind of figure that's neither purely planar nor fully in the round. It's a uniquely Balthusian creation, and it forms the basis for some of his finest paintings of the last twenty years.

The three great paintings of Setsuko Ideta—a Japanese woman whom Balthus met in Japan in 1962 and married in 1967—are Balthus's most rad-

ical contributions to Western tradition. In the *Turkish Room* he picks up on the aspect of Persian miniatures that didn't particularly interest Matisse, their muffled poetry. Here the magnificent arabesque of the figure opens up a bit—the space breathes—but the overall effect is one of suppression and containment. In the next two Japanese figures, which Balthus worked on during half of the sixteen years he was Director of the French Academy in Rome, and finished in 1976, he goes much further afield, embracing a classical Oriental tradition that no other Western artist has even attempted to understand.

From the beginning of European interest in Japanese art in the mid-nineteenth century it was the popular side, represented by the Ukiyo-e prints, that engaged artists. In part this was because Ukiyo-e was the Japanese art most widely available in the West, but an even more important factor may have been that the style of the Ukiyo-e artists, who had been absorbing Western influences into their own work for years, was relatively easy for Frenchmen to make some sense out of. The locked-in, graphic force of Ukiyo-e isn't, in any event, what one feels in Balthus's *Japanese Figure with a Red Table* and *Japanese Figure with a Black Mirror*. These Balthus paintings—with their strict ordering of space and their tawny surfaces punctuated by areas of saturated black or high color—are a gigantic act of homage to the expansive yet disciplined world of the Yamato-e picture scrolls of the twelfth, thirteenth, and fourteenth centuries.

To spend a few hours with reproductions of these great Oriental paintings (they may stand in relation to Japanese art as the frescoes of the High Renaissance stand in relation to Italian art) is to drift into a realm of supreme elegance. A solitary man, eyes closed in pleasure, plays a flute; a woman, her immense kimono and long hair billowing about her, reads a book. The men and women are only half-seen, hidden behind the thin, papery walls of their palace homes. Everything—buildings, objects, figures—is caught in the flow of parallel diagonal planes that move up the surfaces of the scrolls. It's a tilted dreamworld.

Yamato-e is an art whose courtly elegance is surpassed only by its formal rigor. It's the perfect aesthete's art, and when we've realized this and then re-

turned to Balthus's Japanese pictures, it's with a sense of doors opening, of vistas revealed. What Balthus has done is join the Yamato-e tradition to the Western tradition of the female nude. Out of the largely suppressed emotions of these ancient scroll paintings, some of which depict the novelistic memoirs of court ladies, Balthus distills the quintessential image of a figure, light yet earthbound, attached to its palace world so strongly that it seems to crawl through it, as if standing up would represent too active a movement. In coming to the storytelling scrolls of the Yamato-e (some of which have texts) Balthus reveals again his passion for narrative art; in using for the paintings a surface more like a wall than a piece of paper, he proclaims his distance from the Japanese. Rock to their paper, fresco to their scroll.

When the Japanese figures were first shown in 1977, jammed onto two cattycorner walls that could barely hold them in the Pierre Matisse Gallery on Fifty-seventh Street in New York City, the crowds were huge. I believe the sense of wonder felt by many stemmed from a realization that Balthus, working in isolation, had found a form to match the minimalist sensibility so popular in the 1970s. In the two Japanese pictures, and in the 1980 landscape *View from Montecalvello* (which is also pure Yamato-e), Balthus makes of something long ago and far away a new kind of art.

Since the Pierre Matisse show Balthus has produced, in a matter of what is for him a very short time (five or so years), a remarkable new group of paintings. The nudes from the late seventies are honey-toned, gentler in mood that any he's done before. These girls, with their subtle smiles and skin the color of ivory, are the products of a lyric virtuosity that rivals Correggio. In *Getting Up* (1975–78) and *The Cat and the Mirror* (1977–80), the subject is the beginnings of love, a girl's awakening. And if sub-teen beauty is still a turn-on for Balthus—which, of course, it is—he also manages to stand aside a bit, to let her have her relevation. The girls toss off the bed clothes and reach out to the all-knowing cat—the cat who looks into a hand mirror or goes wild-eyed at the sight of a mechanical bird.

In these paintings Balthus achieves a new, angelic lucidity. Theatrical-

ity—one of the keynotes of his art—is thrust aside. Somehow, the unearthly color combinations of green and purple, or tan and gray, are made believable. In the most unusual of the recent compositions, *The Painter and His Model* (1980–1981), Balthus gives us what he's been denying us for decades: an account of his day-by-day life in art. We're in the studio, where the simple lines of the furniture are exactly as they were in the paintings of forty-five years before. The adolescent model, dressed, kneels in front of a chair leafing through some sort of book or album. Behind her, with his back both to her and to us, the painter stands, looking out a window. It's a painting of disaffection, almost of rebellion. Gone are the industrious figures of Velazquez in his *Las Meninas* and Courbet in his *Artist's Studio*. Balthus reveals himself as the prototypical modern artist, separated from the clear demands of vocation, trapped in the perpetual getting-down-to-work. He's like one of his girls—immobilized, caught in a daze.

Balthus's adolescents have little in common with the Lolita of Vladimir Nabokov's novel to which they're so often compared. Balthus's girls aren't placed, Nabokov-style, within a vision that critiques the very desires they arouse. But of course Nabokov's slender girls, like Balthus's, arise out of an eroticized nostalgia, and if Balthus is never the connoisseur of contemporary kitsch that Nabokov is from "Spring in Fialta" to *Lolita*, the two artists are joined as displaced Europeans, looking back to a fantastical lost youth of wooded estates, love affairs, afternoons in the drawing room. In Nabokov's *Ada*, that modernist send-up of the family-chronicle novel, the elaborate filigreed prose of the early sections, describing the beginnings of the love affair between the young boy Van and the young girl Ada, is a good match for Balthus's fin de siècle framing of young sensuality:

> On those relentlessly hot July afternoons, Ada liked to sit on a cool piano stool of ivoried wood at a white-oilcloth'd table in the sunny music room, her favorite botanical atlas open before her, and copy out in color on creamy paper some singular flower. . . . Her flimsy, loose frock happened to be so deeply cut out behind that whenever she concaved her back while moving her prominent scapulae to and fro and

tilting her head—as with air-poised brush she surveyed her damp achievement, or with the outside of her left wrist wiped a strand of hair off her temple—Van, who had drawn up to her seat as close as he dared, could see down her sleek *ensellure* as far as her coccyx and inhale the warmth of her entire body. His heart thumping, one miserable hand deep in his trouser pocket—where he kept a purse with half a dozen ten-dollar gold pieces to disguise his state—he bent over her, as she bent over her work.

Nabokov's Ada, leaning over her "favorite botanical atlas," might be the kneeling girl in Balthus's *The Painter and His Model*. Only her eager young lover is missing, replaced by the artist, a distracted old man.

With Balthus the idea of art as a heaven, an enchanted isle, is carried to extremes. His almost pathological resistance to biographical fact—if he had his way, his birthdate would never be revealed—stems from a desire to resist the trap of historical progression. There's something perverse in an artist so obviously nourished in the Paris of Bonnard and Surrealism and Existentialism encouraging his biographers to slough off history (and he must be the only modern artist who's referred to by a childhood nickname). Still, when the artist's son, Stanislas Klossowski de Rola, denies that the paintings are erotic, or connects them to a tradition of magical and occult signs, there may actually be buried beneath the lordly manner of the prose a genuine desire to reframe contemporary experience in some other terms. Antonin Artaud, who was the first to write about Balthus in a serious way, referred to the supernatural powers of trecento religious art.

The Balthus retrospective of 1983–84 was an event that left many of us energized, optimistic. The American artists I know were—and are—approaching Balthus's work the way they would that of a close friend. They feel in some way a part of it—implicated. At this point the success or failure of any particular Balthus painting is probably less important than the way Balthus lets loose with ideas and goes wherever they seem to lead. What a joy it was to be able to ask ourselves, as we left the Metropolitan Museum of Art in the winter of 1984, when the big banner hanging over the entrance was a Balthus banner, "What will he do next?"

TRANS-
ATLANTIC
RELATIONS

◪

Air travel, which enables us to move from culture to culture in hours rather than days and weeks, may ultimately have the effect of dissolving the very differences that we travel to discover. The central areas of Paris remain a sacred enclave, on certain streets of which one can imagine oneself back in the days of Chardin, or even earlier. And yet the drive in from the airport, through the sort of suburbs Godard used as the setting for the future in his science-fiction movie *Alphaville*, isn't much different from the trip into countless cities in America.

Perhaps the flattening-out of differences between one culture and another is part of the general disappearance of contrast as a principle in social life. The rich and the poor dress more alike than they used to; the city and country dweller share more and more habits; and so forth. The expatriate tourists of Hemingway seem almost impossible today, not because there are no more people with money, but because the reliable waiter, always there with the next glass of wine, and the bank clerk, always there to send the mail on to Cannes, Biarritz, San Sebastian, are now most likely off on vacations of

their own. The setting that created a backdrop for a certain kind of privileged life has disappeared. Mastercard doesn't replace this; it works against the perogatives of the leisure class.

Paris first attracted visitors from America who felt how different the life there was from the life back home. Paris was an inexpensive, marvelous place to go. And the French avant-garde embraced foreigners, in particular Americans, because some of these visitors were responding enthusiastically to everything that was new. When Matisse had his school it was said that there were only Scandinavian and American students (among them Max Weber). Sarah Stein took notes, and Matisse trusted her—he brought his own paintings for her to look at. For Americans the attraction of Paris lay in the audacity with which new art sprang from an ancient soil. This fertility is what Gertrude Stein, too often maligned as a critic of art, understood. In her and Leo's and (later) Alice's apartment things commingled: old furniture and majolica with the very newest paintings.

In her book about Picasso, Gertrude Stein describes how old-fashioned Montmartre had been when Picasso lived there during his early years in Paris. She says the last time she was on the rue Ravignan, the street "still had its old charm, the little square was just as it was the first time I saw it, a carpenter was working in a corner, the children were there, the houses were all almost the same as they had been, the old atelier building where all of them had lived was still standing." She wonders if, since her last visit, the atelier building has been torn down, and continues: "It is normal to build new buildings, but all the same one does not like anything to change and the rue Ravignan of that time was really something, it was the rue Ravignan and it was there that many things that were important in the history of twentieth century art happened." The timelessness of the old square with the carpenter (who could be the Joseph in the Merode altarpiece) is the backdrop against which the Negro Period and the first collages were created. Ironically, the modern world of modern art was invented in a city—Paris—still steeped in the nineteenth century. There is the paradox of several generations' fleeing rigid American conventions to an older world, where one could embrace the new and finally feel free.

Henry James's *The Ambassadors*, a novel played out in the dazzling Paris of the Impressionists, contains the classic exposition of the freedom of the past: the old world as a source of the liberating lessons that art can offer to life. Lambert Strether, the bachelor come to Europe to save his fiancée Mrs. Newsome's son Chad, is brought by the American boy who's been living it up in Paris to the house of the great sculptor Gloriani (said to be modelled on Whistler). The setting is the heart of the Faubourg St.-Germain: "a small pavilion, clear-faced and sequestered, an effect of polished *parquet*, of fine white panel and spare, sallow gilt, of decoration delicate and rare." The atmosphere is perfect for a revelation—in the garden there are singing birds, and, all around, "grave *hôtels*" that stand for "a strong, indifferent, persistent order."

Even before Strether meets the sculptor "he had the sense of names in the air, of ghosts at the windows, of signs and tokens, a whole range of expression all about him, too thick for prompt discrimination." And then there's Gloriani himself—"a face that was like an open letter in a foreign tongue." James is perhaps a bit ironic about the whole thing; the Italian background of the sculptor, who "migrated, in mid-career, to Paris," gives a certain over-rich glow. And yet it is in Gloriani's garden that Strether receives "the deepest intellectual sounding to which he had ever been exposed." He wonders what it is that he's feeling. "Was it the most special flare, unequalled, supreme, of the aesthetic torch, lighting that wondrous world for ever, or was it, above all, the long, straight shaft sunk by a personal acuteness that life had seasoned to steel?" James rushes on to describe the other guests; the plot moves along. In the end Strether goes back to America; but the visit, the afternoon—these redound, and change his view of life.

One continues to hear, as late as the 1950s, of the revelations Paris can provide. The GIs who arrived in the city at the end of World War II, and the many students who came a few years after, often on the GI Bill, may have been the last to experience something like James's "signs and tokens," his "aesthetic torch." Picasso, after welcoming the GIs, pretty much left Paris for good; but one could still meet Brancusi and Giacometti, and study with Léger, while scraping by on almost nothing. "Peace and Paris in the spring-

time of our lives!"—that's how the American sculptor Sidney Geist recalls the fifties in the introduction to a 1986 exhibition of "American Artists in Paris" at the tiny Denise Cadé Gallery in New York City. Geist's couple of pages are a rush of images.

> The Louvre, the Seine, Notre Dame, Montparnasse, Montmartre, Saint-Germain! The little hotels and *baraques* where we lived and worked. . . . *Existentialisme*. Juliette Greco, Gérard Philipe. Dancing into the dawn on *Quatorze Juillet*, the smell of bread baking. It was all delicious then and is still pungent in memory.

Arriving back in the New York of the 1980s after the plane trip from Paris, the shock of return doesn't take hold until the taxi rolls onto the dark, over-burdened streets of Manhattan. The syncopated traffic lights and the hundreds of neon signs are still today something noteworthy, after the relative quiet of central Paris. Zooming by, you can understand what, fifty or sixty years ago, attracted Léger and Mondrian to New York—you feel anew the bumpy rhythms of the city's nights. Colette, giving a radio talk to American audiences in the months before Paris fell to the Nazis, recalled her visit to New York. "At this moment, America is glittering in that multicolored evening glare I once glimpsed on a short trip to New York, the letters of fire, the arrows, the quivering garlands of the advertisements, the cinemas, the big stores. But here, it is two o'clock in the morning, nighttime, wartime. . . ."

Between the forties and the sixties, everything changes in New York-Paris relations. Paris comes to the end of a great cycle, and New York grows older and wiser. The American artist begins to regard the Parisian artist as an equal and then an inferior. If Paris still spells romance, certainly there's no more of the American's agonized yearning, his starry-eyed awe. By the sixties everybody is talking about living in a global village. Its art center is New York. Youth travels to discover its newly found internationalism—the way its habits are the same in Berkeley or Paris, how its confrères take to the streets for more or less the same reasons everywhere.

Paris and New York become a very odd couple—the capitals, respectively, of the early twentieth century and the later twentieth century.

I wish I were reeling around Paris
instead of reeling around New York
I wish I weren't reeling at all.

This is the poet Frank O'Hara, a friend to many artists, and he can't seem to make up his mind where he stands in these transatlantic affairs.

In the sixties Fairfield Porter began a series of very beautiful paintings of New York. Porter doesn't see the city in terms of iconic images like Georgia O'Keeffe's skyscraper, Joseph Stella's Brooklyn Bridge. He comes to the subject with a taste for small, delicate shifts of color and scale that's in essence very European, reminiscent of Vuillard and Bonnard. Porter choses as his subject not the booming public city, but the city of the artists. He paints Astor Place, the hub of the little world where from the thirties through the fifties *Partisan Review* had its offices and the members of the avant-garde rented cold-water lofts along Eighth Street and Tenth Street. He paints Union Square, just above Fourteenth Street, another landmark for the artists, the traditional northern border of the bohemian downtown scene. And he also paints midtown, the section of fancy galleries, of money and success.

In all these canvases Porter catches the open, sprawling character of the city and its high, clear, revelatory light. Though there may be patches of New York where one can find the perfectly composed little square—the street as a theater or a stage that's familiar from Balthus and Hélion—Porter knows this isn't the essence of this city. He avoids the obviously picturesque as unfaithful to New York. Still, Porter reveals it to be a comfortable place; he sees New York through the eyes of artists and poets, of O'Hara announcing "How funny you are today New York/like Ginger Rogers in *Swingtime*."

In Porter's work the city emerges out of great big planes and strokes of color—whites infused with gold or blue; peculiar oranges and greens. The city isn't constructed, block by block. It's formed out of the collision of bulky elements and tiny grace notes, which are scattered almost at random, here and there. Paris, in Balthus's *Passage* and Hélion's *Triptyque du Dragon*, is a

bourgeois capital—perfectly ordered, ordinary; Porter's New York is more like a pioneer outpost—improvised by speculators and con artists.

This is the New York that, in the hagiography of art history, has become the clearinghouse of tradition. *The Triumph of American Painting*, Irving Sandler calls it in the title of his best-selling history. Meanwhile, Paris continues as a living museum, full of extraordinary formulations. We now go to Paris as travelers from Stendhal to Henry James went to Rome. We're enchanted yet critical; we regard the natives as some fascinating endangered species. How wise these foreigners appear—maybe too wise for their own good, too clear on what is possible ever to attempt anything new. And if Paris is no longer a capital to which we go to see new art, this may be because there are today many more studios in New York where Paris is alive than in Paris itself.

To be always the big, brash, hot young city—this is intolerable. New York—oh, yes, triumphant—must still go to Paris at the end of the twentieth century. Whatever New York may have, it lacks the experience of working through history, of keeping tradition alive. Subtle Paris shows us how to unknot the knots, to find our way out of the one-way streets and cul-de-sacs.

Nowadays, an American artist's judgment of the School of Paris is a judgment on the value of certain kinds of feeling, certain aspects of the past. The looking toward Europe—this is a great risk, one involving a considerable leap of the imagination. Paris, to an American's eyes, will always be different from Paris to a Parisian's eyes. Can we know them, ever? Their revolutions become our traditions. But then they can never know us, either. . . . Léger, in America in the forties, goes into a department store where he sees three clerks standing together, one white, one black, one Oriental. They looked, he writes, like three women out of a painting by Watteau.

Illustration Acknowledgments

1. *The Painter and His Model,* Henri Matisse, 1919, oil on canvas (23⅝″ × 28¾″), the collection of Mr. and Mrs. Donald B. Marron.

2. *Portrait of Marguerite Asleep,* Henri Matisse, 1920, oil on canvas (18⅛″ × 28¾″), private collection.

3. *Conversation under the Olive Trees,* Henri Matisse, 1921, oil on canvas (39⅜″ × 33″), Thyssen-Bornemisza Collection, Lugano.

4. *Interior with Phonograph,* Henri Matisse, 1924, oil on canvas (39⅝″ × 31½″), private collection.

5. *Decorative Figure on an Ornamental Ground,* Henri Matisse, 1925–1926, oil on canvas (51⅛″ × 38⅝″), Musée National d'Art Moderne, Centre Georges Pompidou, Paris.

6. *The Kitchen Table,* André Derain, 1924, oil on canvas (47¼″ × 47¼″), Cliché des Musées Nationaux, Orangerie des Tuileries, Paris, collection Jean Walter-Paul Guillaume.

7. *The Massacre of the Innocents, After Breughel,* André Derain, 1945–1950, oil on canvas (38¼″ × 57⅞″), Musée d'Art Moderne de Troyes.

8. *Harlequin and Pierrot,* André Derain, 1924, oil on canvas (69⁵⁄₁₆″ × 69⁵⁄₁₆″), Cliché des Musées Nationaux, Orangerie des Tuileries, Paris, collection Jean Walter-Paul Guillaume.

9. *Portrait of Isabel Delmer,* André Derain, 1938, oil on canvas (18¼″ × 20⅛″), Musée d'Art Moderne de Troyes.

10. *Embarkation for Cythera,* André Derain, 1945, oil on canvas (13″ × 16⅛″), Musée d'Art Moderne de Troyes.

11. *The Gold Orchestra,* Raoul Dufy, 1942, oil on canvas (31⅞″ × 39⅜″), Galerie Tamenaga, Osaka, photograph courtesy Perls Galleries, New York.

12. *Amphitrite,* Raoul Dufy, 1948, tapestry (46½″ × 109″), Holly Solomon Gallery, New York.

13. *Studio*, Raoul Dufy, 1942, oil on canvas (18⅛″ × 21⅝″), Galerie d'Art Moderne, Venice, photograph courtesy GIRAUDON/Art Resource, New York.

14. *Homage to Bach*, Raoul Dufy, 1952, oil on canvas (31¾″ × 39⅜″), Cliché Musée National d'Art Moderne, Centre Georges Pompidou, Paris.

15. *La Fée Électricité* (detail), Raoul Dufy, 1937, oil on board, Municipal Musée d'Art Moderne, Paris, photograph courtesy GIRAUDON/Art Resource, New York.

16. *The City*, Fernand Léger, 1919, oil on canvas (90¾″ × 117¼″), Philadelphia Museum of Art: A. E. Gallatin Collection.

17. *Le Grand Déjeuner*, Fernand Léger, 1921, oil on canvas (72¼″ × 99″), collection The Museum of Modern Art, New York, Mrs. Simon Guggenheim Fund.

18. *The Construction Workers*, Fernand Léger, 1950, oil on canvas (118⅛″ × 96½″), Musée National Fernand Léger, Biot.

19. *The Campers*, Fernand Léger, 1954, oil on canvas (118⅛″ × 96½″), Musée National Fernand Léger, Biot.

20. The Facade of the Léger Museum, Fernand Léger, executed posthumously, 1957–1960, mosaic and tile, Musée National Fernand Léger, Biot.

21. *The Chapel of the Rosary*, Henri Matisse, 1951, Vence, photograph courtesy Hélène Adant.

22. *Peace*, Pablo Picasso, 1952, oil on board (15′5″ × 33′7″), War and Peace Chapel, Vallauris, photograph courtesy Snark/Art Resource, New York.

23a. *Bird Held by Two Hands*, Pablo Picasso, 1950, ceramic (15¼″ × 17¾″ × 7″), The Pace Gallery, New York.

23b. *Lemon and Fish*, Pablo Picasso, 1953, ceramic (1¾″ × 9″ × 9½″), The Pace Gallery, New York.

24. *Large Decoration with Masks*, Henri Matisse, 1953, cut and pasted paper, prepainted with gouache (139¾″ × 394¾″), National Gallery of Art, Washington, Ailsa Mellon Bruce Fund.

25. *The Studio*, Pablo Picasso, 1955, oil on canvas (28¾″ × 21⅝″), photograph courtesy Perls Gallery, New York.

26. *Studio VI*, Georges Braque, 1950–1951, oil on canvas (51³⁄₁₆″ × 64″), Fondation Maeght, Saint-Paul, photograph courtesy Claude Gaspari.

27. *Studio IX*, Georges Braque, 1952–1953/56, oil on canvas (57½″ × 75½″), Mu-

sée National d'Art Moderne, Centre Georges Pompidou, Paris, photograph courtesy S.P.A.D.E.M.

28. *Seashore*, Georges Braque, 1958, oil on canvas (12³⁄₁₆″ × 25⅝″), collection M. and Mme Claude Laurens.

29. *The Mauve Garden Chair*, Georges Braque, 1947–1960, oil on canvas (26″ × 20¹⁄₁₆″), collection Mr. and Mrs. Jacques Gelman.

30. *On the Wing*, Georges Braque, 1956–1961, oil on canvas (44⅞″ × 66¾″), Musée National d'Art Moderne, Centre Georges Pompidou, Paris, gift of Mme Georges Braque.

31. Plate from *Suite 347*, Pablo Picasso, 1968, etching (6″ × 8″), Louise Leiris Gallery, Paris.

32. *The Kiss*, Pablo Picasso, 1969, oil on canvas (38¾″ × 52″), Gilbert de Botton Collection, Switzerland.

33. *Cavalier with Pipe*, Pablo Picasso, 1970, oil on canvas (57⅛″ × 44⅞″), Musée Picasso, Paris, photograph courtesy S.P.A.D.E.M.

34. *Mother and Child*, Pablo Picasso, 1971, oil on canvas (63¾″ × 51¼″), Musée Picasso, Paris, photograph courtesy S.P.A.D.E.M.

35. Installation View of the Picasso Exhibition at the Palais des Papes in Avignon, 1970, photograph courtesy Alain Keler from Editorial Photocolor Archives, Art Resource, New York.

36. *City Square*, Alberto Giacometti, 1948, bronze (8½″ × 25⅜″ × 17¼″), The Museum of Modern Art, New York.

37. *Walking Man 1*, Alberto Giacometti, 1960, bronze (71¾″ × 38″ × 10½″), The Carnegie Museum of Art, Pittsburgh, Patrons Art Fund, 1961.

38. *Portrait of Annette*, Alberto Giacometti, 1961, oil on canvas (21⅝″ × 18⅛″), Hirshhorn Museum and Sculpture Garden, Smithsonian Institution, Washington, gift of Joseph H. Hirshhorn, 1966.

39. Plate #17 from *Paris sans fin*, Alberto Giacometti, published posthumously by Teriade, 1969, lithograph (16¾″ × 12¾″), Spencer Collection, New York Public Library, New York.

40. Plate #123 from *Paris sans fin*, Alberto Giacometti, published posthumously by Teriade, 1969, lithograph (16¾″ × 12¾″), Spencer Collection, New York Public Library, New York.

41. *Standing Figure*, Jean Hélion, 1935, oil on canvas (51¼″ × 35¹⁄₁₆″), Albright-Knox Art Gallery, Buffalo.

42. *A Rebours*, Jean Hélion, 1947, oil on canvas (44⅞″ × 57½″), Musée National d'Art Moderne, Centre Georges Pompidou, Paris.

43. *La Grande Mannequinerie*, Jean Hélion, 1951, oil on canvas (50⅞″ × 63½″), Musée d'Art Moderne de la Ville de Paris.

44. *Triptyque du Dragon*, Jean Hélion, 1967, acrylic on canvas (108¼″ × 344½″), Fonds Régional d'Art Contemporain, Rennes, photograph courtesy Jacqueline Hyde.

45. *The Last Judgment of Things*, Jean Hélion, 1979, acrylic on canvas (78¾″ × 332¾″), Estate of Jean Hélion, Paris.

46. *The Game of Patience*, Balthus, 1943, oil on canvas (63″ × 65″), The Joseph Winterbotham Collection, photograph courtesy of The Art Institute of Chicago.

47. *Landscape with a Tree*, Balthus, 1960, oil on canvas (51¼″ × 63¾″), Cliché Musée National d'Art Moderne, Centre Georges Pompidou, Paris, photograph courtesy S.P.A.D.E.M.

48. *Le Passage du Commerce Saint-André*, Balthus, 1952–1954, oil on canvas (115″ × 130″), Cliché Musée National d'Art Moderne, Centre Georges Pompidou, Paris.

49. *Japanese Figure with a Black Mirror*, Balthus, 1967–1976, oil on canvas (59″ × 77″), the collection of Mr. and Mrs. Donald Newhouse, New York.

50. *The Painter and His Model*, Balthus, 1980–1981, oil on canvas (89″ × 91″), Cliché Musée National d'Art Moderne, Centre Georges Pompidou, Paris, photograph courtesy S.P.A.D.E.M.

Design by David Bullen
Typeset in Mergenthaler Granjon
by Wilsted & Taylor
with Perpetua Titling display
Printed by Malloy Lithographing
on acid-free paper